Ether

Ether

The Nothing
That Connects Everything

Joe Milutis

University of Minnesota Press
Minneapolis
London

Published by the University of Minnesota Press
111 Third Avenue South, Suite 290
Minneapolis, MN 55401-2520
http://www.upress.umn.edu

Library of Congress Cataloging-in-Publication Data

Milutis, Joe.
 Ether : the nothing that connects everything / Joe Milutis.
 p. cm.
 Includes bibliographical references and index.
 ISBN-13: 978-0-8166-4644-9
 ISBN 10: 0-8166-4644-9 (acid-free paper)
 1. Ether (Space)—Philosophy. I. Title.
 QC177.M569 2006
 530.1—dc22 2005032149

Printed in the United States of America on acid-free paper

The University of Minnesota is an equal-opportunity educator and employer.

12 11 10 09 08 07 06 10 9 8 7 6 5 4 3 2 1

Historically long perspective
Suggests it as possible
That many of the intriguing
Yet ineffable experiences
Which humanity thus far
Has been unable to explain,
And, therefore, treats only superstitiously,
May embrace phenomena
Which in due course
Could turn out to be complexes
Of physically demonstrable realities
Which might even manifest
Generalized principles of Universe.

—R. Buckminster Fuller

There is nothing in the world more helpless and irresponsible and
depraved than a man in the depths of an ether binge.

—Hunter S. Thompson

Contents

Introduction
Superflux of Sky

Every culture has its own name for this nothing. Kundalini and anima,
Ein Sof and mana, the orgone, the lapis, akasha, chi and prana. The
ether is the superflux of sky, triggering a plenitude of thought, even
though the word stands in for the void. The narcosis of such a far-
flung and far-flinging thing is bound to send the initiate on an ether-
binging tour that might include cartoon characters floating in a blue
haze, lithe creatures dancing under fountains to Debussy, and mystic
envelopes of heavenly wind coursing the planets and cradling them
in their orbits. The ether is at once the attic of the universe in which
antique and broken, unrecorded, or unheard transmissions can be
found, and it is the misnomer for the wireless-seeming tangle of ports
called the "Ethernet" that resides in the basements of institutional
space and facilitates local area networks. To speak of the ether, I could
talk of radiant yogic third eyes, of forgotten models of physical real-
ity, of mesmeric revelations and other electromagnetic juju. But no
sooner, I have found, do I speak of the ether than I encounter blank or
suspicious looks, as if I had truly partaken of sweet vitriol (the early
name for the anesthetic also called "ether"). It has become helpless
and irresponsible and even depraved in our materialist intellectual
context to write about something so immaterial, so beyond local

knowledge, not to mention so without disciplinary location. Ether is all over the place, and that place is nowhere to be found.

Admittedly, this is so. The ether is immaterial, and without disciplinary location. Thus eye to sky, one tends to speak the word blithely and sometimes rhapsodically, but never with history in mind. When I hear or read the word "ether" or "ethereal" in contemporary discourse, there is consequently a sensed offhandedness, as if higher powers are finally available at bargain-basement prices. Lately, the ether has gone directly from the ineffable to the fashionable, denoting everything technological and stylish from hip boutiques (Etherea, a DJ shop in the East Village, and Ether, a twenty-first-century curiosity shop lit entirely by LEDs in the NoLIta area of New York City) to new trends in electronic art (a recent *New York Times* profile of new media art is entitled "Out of Ether, a New Continent of Art Comes into View").[1] Taken out of cosmological context, perhaps the novelty of this new ether is its status as "floating signifier."

Though there has been, since the 1990s, a resurgence of interest in all things ethereal—from the long-awaited legitimization of the immaterial or dematerialized art object by major museums to the corporate embrace of the mystically informed idea of "convergence," from the Clinton-era popularity of the waif to Madonna's liaisons with the Hindu pantheon and Kabbalistic lore—contemporary readers might be hard pressed to describe exactly what the ether is, or rather, what it was. If anything, the adjective "ethereal," like the word "idealist," has mostly become a term of both opprobrium and wonder, and usually, again like "idealist," the "ethereal" has signified something that, while admirable or fantastic, is not really part of the game. However, now, when business reporters say that Amazon.com creates its value out of pure ether, it is clear that whatever this ether is, it is a substantial part of the game. The drama of the computer interface—mediating the rarefied substance of bits streaming even to the earth's antipodes and creating megacorporations out of thin air—has, in obviating the need for "brick-and-mortar," sparked the ethereal imagination on a national level. In more avant-garde circles, the ethereal has also had a currency, especially with the reinvigoration of the art of radio—ethereal medium par excellence—and the mapping and construction of cyberspace by technopagans and electronic-age shamans.[2] The ubiq-

uity of computer communications has popularized the spiritual beliefs of old-school Californian computer culture, based, in part, on the thought of the great twentieth-century American corporate transcendentalist Buckminster Fuller, as well as more ancient spiritual thought. Cyberculture leaders like John Perry Barlow, lyricist for the Grateful Dead, and Mitch Kapor, designer of Lotus 1-2-3 and transcendental meditation instructor, have ensconced the guru in the boardroom.

What is clear about the ether is that it is a mediating substance between technology, science, and spiritualism, and the historical relations between these three terms determine its perfume. Far from timeless, the ether is a placeholder of sorts, expressing these relations as they shift and transform, century after century. Three hundred years ago this general concept of ancient cosmology entered into scientific discourse just as science was becoming a rational pursuit divorced from the mystical and philosophical. Less than two hundred years after that, however, because of the ether's pre-Enlightenment roots, it was found to be ultimately incommensurable with twentieth-century physics. The ether thenceforth came to be known as the epitome of the irrational and was thrown out of scientific discourse for good, even though it remains dear to the hearts of quantum field theorists. In the last one hundred years, what may be called the postmodern rescue of the ether, in the face of its demise as a term of science, was effected in divergent quarters. This rescue attests to some deep cultural usefulness that transcends the scientific. Even some scientists are still hard pressed to leave it behind, regardless of the fact that it was Einstein himself who dispensed with the ether. Why, when it has been so definitively debunked, does the ether continually reemerge in public as well as scientific consciousness?

One reason might be that while it might refer to the idea of God, it is not about God per se and his institutional locations but about how humans contribute to their total mystic environment through their technological extensions and scientific advance. It is a sphere of intelligence that Newton called "God's sensorium" and Teilhard de Chardin called the "noosphere." If one conceives of God as a field of emanations, or a presence at the juncture where mind meets the end of matter, this concept overlaps with the cultural imagination of the unseen powers of electromagnetic and electronic technologies.

From early radio on, ether became the context of the network universe—a space that has always been half fantastic, erected in the hopes of creating global simultaneity and cultural all-at-oneness. In effect, the fantastic conquest of the ether through twentieth-century media technology would involve debunking Einstein and returning to a dream of Newtonian absolute time and absolute space.

The idea of the ether as both a powerful and vague term is not merely a recent historical shift. The ether has always existed relatively free of gravity, even as it also had a tendency to buttress political and spiritual structures, scientific institutions, and the very shape of Empire. Just as nature abhors the void, power adores the protean, cryptic ubiquity of the ether. In the premodern era, when the ether actually "meant" something, it was variously located in rigid systems of world meaning and order, determining, through the immaterial alchemy of ideas, what could transpire on the dusty earth. At the same time it was vague enough to inspire lengthy, contradictory exegeses throughout the medieval and Renaissance eras. Our ether is not so different. While the ether has always demarcated the limits of longing and the frontier of consciousness, it also, as Marx started to perceive in the *Grundrisse*, transcendentally guaranteed commerce. In Marx's time, it would even become a "place" of commerce on its own as telegraph communications exploded common business interactions by harnessing the mercurial simultaneity of thin air. Precisely because our electronic systems have taken the telegraphic etherealizing of business to a new level, if ether means less now, it also means more. With commerce so radically etherealized in our historical moment— but nevertheless material in ways that we can only begin to understand—there can be no question of the commensurability of the ether to analysis. The more technomorphic the ether becomes, its continued status as a timeless substance warrants this analysis.

The writer who takes on the task of historicizing the ether, however, is constantly faced with impossibilities, lacunae, and loss of words. The irrational is behind every cloud. To give a faithful description of this irrational supplement of capitalist rationality, we must keep in mind that most systems of mystical thought maintain the ether in a place of absolute exteriority to human device, in some way safeguarding a truer ether not only from the extension of technologi-

cal perception but also from projects such as this at hand. The true meaning of the ether, if there is one, may have been one of those secrets that, thousands of years ago, would have been safeguarded by Pythagorean hit men. (We do know that those who revealed certain secrets of mathematics to the general public were to meet strange ends.) When the ether was brought down to earth and made democratically available during the introduction of the electrical sciences to the modern world, there was always the question, active in the occult mind, of whether humanity had finally evolved to a point where the everyman was proximate to the ether or whether this enlightened ether was an illusory double of an actual ultimate substance. With its fashionability in technoculture, and its transmutation into cultural currency, without certain referent (thus ethereal in more ways than one), the ether now more than ever opens up questions germane to the history of transcendental thought. Do the unprecedented abstraction, speed, and intelligence of computer communications mark our arrival in ethereal culture, with its attendant spiritual and social rewards? Do we now live the life of angels? It may be that we just inhabit a heightened instance of what nineteenth-century sociologist Georg Simmel calls the "aesthetic cosmos" of invisible culture.[3] The shape of this cosmos is determined by the abstraction of money.

While Simmel may have been cranky about both "aesthetics" and "cosmos," a look back into ancient history reveals that the term "aesthetic cosmos" may be a tautology. Since medieval times, regular folk have tended to leave questions of the cosmos or the ether to the philosophers, theologians, or scientists, when in fact it may be part of everyday sensibility. While aestheticizing the absolute may seem contradictory, for the ancients the absolute was always commensurable to beauty—a simple thing, after all. The idea of cosmos was one of aesthetic rightness, and the ether was perhaps just a beautiful idea in a cosmos irrevocably aesthetic.

Ancient Ethers

But lest I get ahead of myself, and even though my account will be circulating around the ether's past three hundred years, I would like to sketch out, by way of introduction, a brief prehistory of the modern

ether. It is a prehistory that will return to the beginning both literally and figuratively, and even deconstructively, since not only does the ether (and similar concepts) fascinate ancient adepts from the very moment that looking up into the sky inspires feelings of unknowing. The ether, above all, is beginning itself, *arche*, or the source of all things. It is that vitalistic principle which holds the whole together. Whether as some stoic "ever-living fire," the "central fire" of the Pythagorean, or more airy notions such as *anima mundi* or the fifth element, the ether is foundational to questions concerning nature and its elemental composition. Call it a supernatural environmentalism, if you will, which would be as germane to Plato as it is to Buckminster Fuller. The charm of ancient cosmology, and what distinguishes it, is a kind of blue-skyism, unencumbered by the profusion of metaphors that characterize a technomorphic cosmos—from the medieval "great chain" metaphor to postmodern *kosmoi* of data (the metaphor of the universe as a computer). We can imagine that ancient philosophy began the beguine in a sort of perceptual ingenuousness, in a time when most human thought was determined by meteorology and, soon enough, writing—that ultimate rainy-day technology for the peripatetic philosopher.

But writing, of course, opens up the Pandora's box of alienation from immediate nature. As John Durham Peters, in his wide-ranging analysis of the myths of communication, says of one ancient, "Writing on papyrus, as opposed to writing on souls, is for Socrates a kind of cheating eros. It pretends to be a live presence but in fact is a kind of embalmed intelligence, like the mummies of ancient Egypt, whence writing supposedly came. As with all new media, writing opens up a realm of the living dead."[4] The provisional answers to questions like "What's beyond the clouds?" or, as they ask in the Valley of the Dolls, "What's in back of the sky?"[5] would, through writing, pile high in the sarcophagi of the centuries, facilitating an ascent to no place in particular, and perhaps missing the point, even as we were eventually able to send out probes to some exact locus beyond the blue. The paradox of new media—promising both new crypts for dead voices and perceptual vital innocence—is encapsulated at the origins of writing and exemplified by the attempt to represent the elusive ether. While every new medium proffers another substitute for that

original mythical innocent look up (even as it facilitates a "looking up" that has always been the "looking down" of a researcher), the ethereal ur-medium holds out the fantasy (or dare we say "possibility") of return to something immediate that has been lost but is not irretrievable. Ether holds out a prehistoric reset button for civilization, a button that paradoxically jump-starts history. Approximating this immediate experience through technological means has been the ultimate fantasy of representation—which always wends its way between necromancy and vitalism.

While it is tempting to take into account tales of ether personified—notably the erotic, vital, and oftentimes violent exploits of the randy Ouranos and his upstart descendant Zeus, or the parallel histories of non-Western anthropomorphic absolutes—the history in which I am interested starts with ether and absolute space figured as something inhuman. This history, outlined in M. R. Wright's *Cosmology in Antiquity*, provides a prelapsarian analogue to modern scientific and technological abstractions. In Greek thought, the abstract absolute is first sketched out by the Ionian philosophers, mostly island dwellers whose daily experience of sun and sand would eventually nurture the mind of Heraclitus, who wanted nothing more than to paint the cosmos as a burning ring of fire (one of ether's etymological roots is from the Greek verb "to burn" or "to shine"). With Anaximander came the first idea of a primal substance in all things having infinite extension. This substance he called *apeiron*, or the indefinite. The indefinite of Anaximander would lose its abstract quality with Anaximenes, who said the stars were nailed onto a transparent crystalline sphere. This conception of the limits of space would reign into the next millennium. It is also with Anaximenes that the ether starts to take the "shape" to which it has remained accustomed. With him air, not fire, becomes the prime element, the single substrate of reality. With Anaximenes as well, *kosmos* means not just beauty or rightness but an abstract concept of "world order," as when he writes, "As our soul, which is air, maintains us, so breath and air surround the whole cosmos."[6]

While for Anaximenes, ether was only rarefied air, it would soon start to take on more fantastic qualities. For example, in the work of Anaxagoras, while "water, earth and stones were formed by an

Anaximenes-type compacting of the air, . . . the aither that surrounded the *aer* 'by virtue of the tension of its whirling motion, snatched stones from the earth and set them ablaze so as to form stars.'"[7] This dramatic separation of air (as earthly) and ether (as astral) would determine the shape of the ether as an eternal zone beyond the moon. Perhaps more literally down-to-earth, the idea of *pneuma* as the prime element also held sway. The *pneuma*, or air mixed with heat, is probably most like the ether of Indian philosophy, in which the heat of the body is one with the heat of the living universe. This more animated substrate informs Pythagorean mysteries ("I am child of earth and starry sky"), as well as the Platonic project to attain cosmic perfection through love. A love supreme is the ether, too, and for this insight we have Empedocles to thank. In addition to formulating Love as nature's fifth element (with Strife its antithesis), Empedocles began to ally the universe to intellect, a theory that remains operative from Newton all the way to Buckminster Fuller. For Empedocles, "the *kosmos* is brought together by mind alone, holy and inexpressible, sweeping across the whole *kosmos* with swift thoughts."[8]

The pneumatic, animistic versions of ethereal consciousness form the original "spiritualism," linking breath (or *spiritus*) to fire and mind in a circuit of total sympathies. The medieval rediscovery of Aristotle, with his sempiternal extralunary zone, abstracted the *anima mundi*, sundered its interconnections, and inspired debates about the number of heavens and crystalline spheres. At the same time that the medieval Aristotelians imagined man abjectly absent from cosmic bliss, they allied the monarch to the motionless, luminous purity of "outer space." Thus, guaranteeing the divine right of kings, as well as an intricate system of worldly correspondences, the medieval hermeneuts of the Aristotelian system regimented politics and signification. In fact, the ether is perhaps the original "transcendental signified,"[9] since cosmic order has throughout history situated all ritual events, from the simple act of speaking to the high drama of coronations, treaties, and beheadings. Greek theater always had one eye on the limitless ether, located as it tended to be in view of sea and sky, and the Method acting of the past century was taught early on by way of the theosophically inflected Stanislavski system. Through mastery of immaterialities, the "magic if" could more readily inhabit the acting

body. These cosmologies of the actor, promulgated in the Method theories of Richard Boleslavsky and Michael Chekov, in turning attention to the materially imperceptible, returned acting to its ritualistic origins. It is as if acting "naturally" were not unproblematic, as if the casual performances of Brando or Newman were only guaranteed by a secure grasp of the order of even the remotest occult influences. While I will not make a detailed analysis of these acting theories, theater will be, as we shall see, an active locus for conserving the idea of the ether. I will show how in the work of Strindberg—playwright of ethereal dysfunction—theater can play out the disjuncture between cosmos and reality. Artaud too, in his idea of the alchemical theater, places the theatrical between the cosmos and the magic of representation. He cites the Platonic prehistory of theater, which

> brought to a climax that nostalgia for pure beauty of which Plato, at least once in this world, must have found the complete, sonorous, streaming naked realization: to resolve by conjunctions unimaginably strange to our waking minds, to resolve or even annihilate every conflict produced by the antagonism of matter and mind, idea and form, concrete and abstract, and to dissolve all appearances into one unique expression which must have been the equivalent of spiritualized gold.[10]

Indeed, from Juliet's sigh, "Alack, alack, that heaven should practice stratagems / Upon so soft a subject as myself," theater creates a microcosmic critique of the social cosmos that guarantees the play. A poorly conceived ether is the equivalent of a stage set for tragedy. Our social actions are no less determined.

Technology and the Ether

The first telescope (Galileo's *perspicillum*) is generally considered the scientific device that challenged the cosmic zoning laws of the Aristotelians. While the "technology" of writing has always puzzled out ethereal distinctions, the *perspicillum* instituted new forms of instrumental realism into cosmic science. The paradox is that this realistic extension of the human eye into vast, angel-less space did not kill spirit but plugged it back into the human patch bay. The ether was suddenly (again) not absolute outside but an abstract everywhere.

One of the early philosophers to dwell on the implications of this shift, the Platonist Henry More, embraced the animistic worldview of infinite extension that would be the model for ethereal science to come: "The parts of a *Spirit* can be no more separable, though they be dilated, than you can cut off the *Rayes* of the *Sun* by a pair of Scissors made of pellucid Crystall."[11] The technological extension of man into the universe through the science of optics would have as its analogue this omnipresence (which for some was a heretical placelessness) of God.

Roughly contemporaneous with Galileo's experiments, Robert Fludd introduced an image of the cosmos that would seem at odds with this new appreciation of the void. His *Integrae Naturae Speculum, Artisque Imago* schematizes all the realms of the world, from *animiculae* to the realm of angels, in an image that is indebted to earlier Ptolemaic systems. Yet, perhaps influenced by the "heresies" of Galileo and Giordano Bruno, Fludd's vision of cosmic holism, made possible through the new technology of copper-plate printing, gives a sense that everything is no longer so rigidly determined. While an astral ape representing the mimetic "aping" of art is enchained to a cosmic virgin (who is in turn chained to the puppet-master hand of a Kabbalistic divinity), rays and vibrations imply a vibrational continuity intermixed with the creative act of forging connections. Inassimilable levels of "reality" are juxtaposed, their meaning assessed. The form of thought exemplified in the Fludd print is called *analogical*. The initial break from the analogical, alchemical worldview to what may be called the rational or the taxonomic occurs at the crucial cultural shift that I situate as the beginning of this study, when rational science, in embracing a globally agreed-upon immateriality, broke definitively from the analogical arts of creative connection.[12]

Yet it is not an altogether clear break, and in the underground of cosmic speculation, where there is no clear distinction between science and art, the creativity and idiosyncrasy of analogical thought, imbued with a multitude of ethers and ethereal concepts, continually haunt the progress of the rational. For example, when Newton kicks off modern physics, he contextualizes his theories within an ethereal medium, the "boundless uniform Sensorium" of an absolute intelligent Agent.[13] Newton's ether would henceforth allow for practical, empiri-

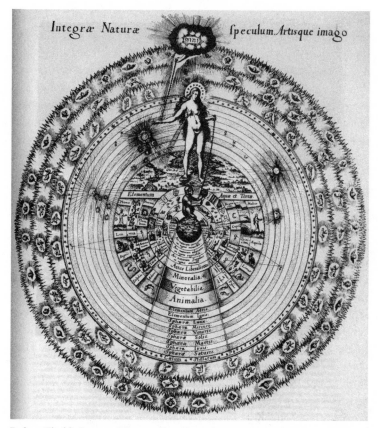

Robert Fludd's *Integrae Naturae Speculum, Artisque Imago* (1617).
Frontispiece of *Utriusque Cosmi*.

cal experimentation, yet the ghost of the alchemical still remained.
We see an allegory of the consequences of science's imperfect dis-
avowal of an irrational past played out in Mary Shelley's *Franken-
stein*. The autodidact Frankenstein's first initiation into the mysteries
of life was through a youthful poring over of alchemical texts, which
his later teachers encouraged him to abandon in the pursuit of more
modern thought. Frankenstein's derangement results from repressing
the origins of his uncommon genius, and the monster could be taken
as a symbol of analogical structures exploding the even grid of rational
scientific thought. The problem of Frankenstein is the same problem

for those who wished to rid the ether of its occult meanings. It is no surprise, then, that since the ether maintained deep allegiances to the premodern, it would soon lose its scientific currency altogether, having become a monstrous abstraction. The real surprise is, however, that almost two hundred years would pass after Newton's embrace of the ethereal sensorium for it to be trashed, and only after it enabled many of the discoveries, movements, and inventions that keep us in the ether today.

Chapter 1 has, as its backdrop, the fascinations and discoveries of this first two-hundred-year period. This ether period, extending from the beginning of the eighteenth century to the end of the nineteenth, had at its heart the introduction of the science of electricity. The ether—conceived as the impalpable magnetic context of electrical action—became a veritable democratic force. Through the practices of Anton Mesmer, it also became recharged with occult meaning. But this historical drama is merely the backdrop. Since the place of the ether has had tremendous, if unconscious, effects on the representational practices of a culture, I have chosen throughout to concentrate on the artworks and literature that specifically, if occultly, thematize the fascinations of certain historical ether systems. Thus chapter 1 centers on Mesmer, as well as mesmeric revelations in the work of Poe, Deleuze, Fellini, and others. Each ether period has its artistic legacy, which I would like to begin to describe. My endeavor is not a simple one. If it is attractive and indeed common to embrace notions of the ether that are long outdated, the question of placing an artistic text in a scientific or spiritual context is not a task for mere historicism, but one as well for occult interconnections and leaps of logic.

In this spirit, chapter 2 brings together the ethereal impulses of August Strindberg, Japanimation, Henri Bergson, and Bill Viola (among others) and networks them across the void that marks the period of the ether's disappearance, from 1880 to 1905. As the world came to know itself through increasingly globalizing technologies, conflicting cosmologies that had accreted in far-flung locales were to enter Western consciousness, confounding the comforting Aristotelian apothegm "There is but one sky." This period marks the collision of

Western culture and Eastern philosophy (most particularly yoga), the latter used by theosophists as an ethereal system that would combat the forces of industrialization with a pro-science program of mystical materialism. The sociologist Georg Simmel, writing in this period, said, "The cultural process, as the supra-natural growth of the energies of things, is the manifestation or embodiment of the identical growth of *our* energies. The borderline at which the development of specific life-content passes from its natural form into its cultural form is indistinct and is subject to controversy."[14] The conflict between the impulse to abstract all energy in terms of work, money, and the commodity versus the theosophical and vitalist insistence on a kind of inalienable bioenergy (the etheric aura) is waged on a variety of intangible borderlines in this system of ethereal crisis.

Radio communication, industrializing the ether at the very moment when the ether no longer existed, is the subject of the third chapter. Both chapter 3 and chapter 4, while relating specific ethereal moments in technology (radio and the space program, respectively), are concerned more with avant-garde media and literature that were inspired by the mystical promises of these industrialized technologies. Chapter 3 maps out the relation of the ether to the avant-garde of radio, from the Russian and Italian futurists to the present. Chapter 4 takes as its subject both mainstream and countercultural films about going to the moon, and the conflicts between the aesthetic cosmos of outer space and the hermetic powers of "inner space." It is there where we come full circle, as the intelligent agent of Newton meets the idea of a universe as an artificial intelligence, and I will conclude with a meditation on the application of this ethereal prehistory to the dreamworld of the Internet.

While it is fashionable to talk about technology as human prosthesis, the ether—as a technological reality that is more about mind than limb—transforms the agglomeration of all technology into what Teilhard de Chardin calls "a mechanized envelope ... appertaining to all mankind." This "vast, organised mechanism" that he calls "the noosphere" extends the drama of machines from the merely somatic to some sort of superintelligent etheric double of mankind: "Just as the individual at the outset was enabled by the tool to preserve and

develop his first, elemental psychic potentialities, so today the Noo-sphere, disgorging the machine from its innermost organic recesses, is capable of, and in process of, developing a brain of its own."[15]

Thus, while Ionian philosophers once looked to the sky in pursuit of self-knowledge, the cybernetic philosopher also looks to the sky, but with a difference. As Buckminster Fuller says in his introduction to Gene Youngblood's *Expanded Cinema*:

> It is possible that human eyes operating as transceivers, all un-beknownst to us, may be beaming our thoughts out into the great night-sky void. . . . Such eye-beamed thoughts sent off through the inter-celestial voids might bounce off various objects at varying time periods, being reflectively re-angled to a new direction in Universe without important energy loss. A sufficient number of bouncings-off of a sufficient number of asteroids and cosmic dust could convert the beams into wide-angle sprays which diffuse their energy signals in so many angular directions as to reduce them below receptor-detection level. Eye-beamed thoughts might bounce off objects so remote as to delay their 700 million mile per hour travel back to Earth for a thousand years, ten thousand years, a hundred thousand years. It is quite possible that thoughts may be eye-beamed outwardly not only from Earth to bounce back to Earth at some later period from some celestially-mirroring object, but also that thoughts might be beamed—through non-interfering space to be accidentally received upon Earth—from other planets elsewhere in Universe. There is nothing in the data to suggest that the phenomenon we speak of as *intuitive thought* may not be just such remote cosmic transmissions.[16]

The absolute intelligent sensorium, active in the most outer alien regions, is commensurate with human biofeedback. Thus, looking up at the sky and building radio telescopes have evolutionary impor-tance, connecting us to something that pulls us, willy-nilly, onward. As early as 423 BC, overconcern with this "something" was a subject of ridicule, as perhaps it still is. At that time, Aristophanes' *Clouds* travestied cosmological speculation or "arse-stronomy" by placing the stargazing activities of ancient academia next to the vain attempts of a father trying to survive the debt racked up by his profligate son. The father attempts to enter school in order to learn how to avoid his creditor but is instead introduced to the charms of the clouds, "magnificent goddesses for men of leisure":[17]

STREPSIADES: I thought they were just a load of old vapor, all drizzle and fog!

SOCRATES: Exactly, because you were unaware that they cultivate a slew of sophisticated scholars; Prophets from the colonies, atmospheric therapists, long-haired loungers with jangling jewelry, creators of complex, convoluted compositions, ethereal, immaterial, vacuous visionaries! Intangible, insubstantial idleness sustained by waxing lyrical about the Clouds![18]

In tepid defense of the all-out dive into immaterial "frivolities" to follow, there is still something to this nothing-something, something other than the nether, either inner or outer, neither together nor apart, father nor feather, earth nor theater. This something is nothing but the great and irreal ether.

Part I

Radiance and Intellect

THESEUS: The poet's eye, in a fine frenzy rolling,
Doth glance from heaven to earth, from earth to heaven;
And as imagination bodies forth
The forms of things unknown, the poet's pen
Turns them to shapes, and gives to airy nothing
A local habitation and a name.

HIPPOLYTA: But . . . all their minds transfigured so together,
. . . grows to something of great constancy.

—*A Midsummer Night's Dream*

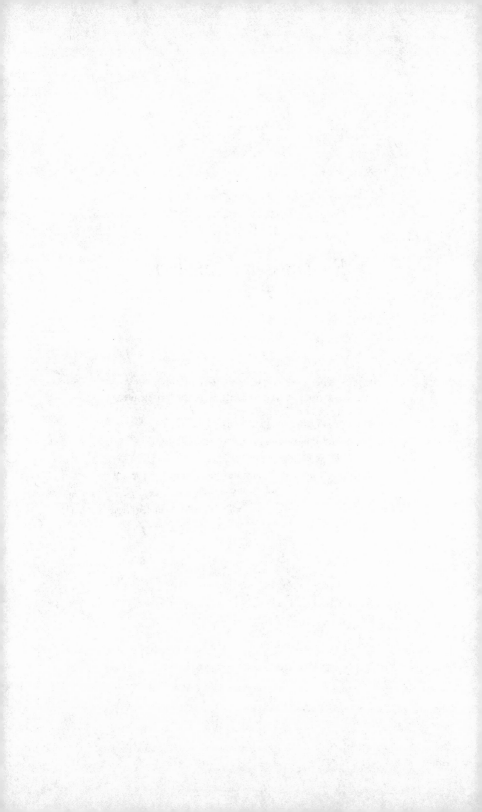

1

Paradigm Lost: Ether and the Metaphysics of Pop Science

P. Is not God immaterial?

V. There is no immateriality—it is a mere word. That which is not matter, is not at all—unless qualities are things.

P. Is God, then, material?

V. No. [*This reply startled me very much.*]

P. What then is he?

V. [*After a long pause, and mutteringly.*] I see—but it is a thing difficult to tell.

—Edgar Allan Poe

Revelations of the Luminiferous Ether

We are eavesdropping on Poe's quasi-scientific dialogue with a mesmerized patient in his 1844 tale "Mesmeric Revelation." A lot of history would intervene between this dense, obscure interview about the uninterviewable and, say, Yves Montand and Barbra Streisand cooing across the centuries in the mesmeric musical *On a Clear Day, You Can See Forever*. And it's a long way from the initial revolutionary

3

impact of the mesmeric rapport to the cheap bedazzlement of hypnotic suggestion, typified in the timeless image of a borscht belt magician proclaiming "you are a chicken" to an obliging volunteer from the audience, who proceeds to cluck, peck, and squawk. Somehow the mesmeric, which at one point had the potential of facilitating alternative medical cures, became, through its more anxious affiliations with demagoguery and radio waves, an explanation of fascist power.

If mesmerism has fallen into such disrepair, it is because a whole system of thought out of which it, albeit unconventionally, emerged, has disappeared. Thomas Kuhn calls systems of thought on which scientific consensus is built "paradigms."[1] The ether paradigm through which mesmerism emerged (along with, as we shall see, other movements and obsessions) was a paradoxical one, in that it still held to the untamed conditions of *non- or preparadigmatic* thought that characterized natural philosophy and alchemy—the occult precursors of modern science.[2] After more than a millennium of variable and idiosyncratic ethers formed themselves in the thoughts of philosophers, alchemists, natural scientists, and other disconnected illuminati, a global, consensual, and properly scientific ether started to take shape in the eighteenth century, disengaging itself from the magic-suffused involucrum of pre-Enlightenment thought. While facilitating the inquiry of the more progress-driven investigations of an elite scientific culture (e.g., "electricians" of this period), the ether paradigm, however, also facilitated popular speculation on the very supernatural ideas it had seemed to have left behind. Scientific concerns about the nature of electricity, light, and magnetism blurred with questions of metaphysics that were germane to a wider public. The irrepressible supernaturalism of the ether, encouraging popular speculation on the absolute, is precisely what would make phenomena like mesmerism, and later American spiritualism, develop as noisy supplements to scientific and technological advances in the modern period.

Unconventional interpretations of the ether were typified by the controversial work of the eighteenth-century Viennese physician Anton Mesmer, whose idea of a fluid, undulatory medium that bathes all objects derived from scientific conceptualizations of the ether and electricity while providing the basis for many New Age spiritualities

of the nineteenth century. The ethereal universe of electrical events provided an apt metaphor for his more occult ideas of cosmic cure through universal harmony and vibration, but in the practice of Mesmer there was never a clear distinction between vibration as metaphor and as reality, ether as science and as fiction. While he used magnets in a quasi-scientific manner, his mesmeric salon, as we shall see, seemed to gain power more from its relation to theater than to science, if only because the legitimization apparatus of science abandoned him. Nevertheless, this affiliation of the theatrical with the scientific is, I think, what the ether encourages, and it is perhaps why, after so long a run, the ether was closed down in the late nineteenth century, when industrial-scientific forces became more and more rationalized.

While deeply attached to scientific progress, the ether—as the waveform plane out of which everything comes into being—also encompasses the entirety of human action and thought. As such, the ether became, in an era that witnessed the decline of both the charm of the *lapis philosophorum* and the power of the monarchy, a democratic medium as well as a scientific concept.[3] The picture of a universe powered by mutual electromagnetic influence was a far cry from the hierarchical Great Chain of Being in Elizabethan times. This democratic aspect of the electromagnetic ether was hinted at when the sixteenth-century medical mystic Paracelsus called the magnet "the monarch of secrets," since, as both he and Mesmer knew, the use of the magnet to manipulate ether waves for the purposes of healing implicitly decentered monarchical power.[4] It was not only because faith healing remained part of the divine right of kings through the tradition of the "royal touch,"[5] but also because monarchical power schematized itself into the natural order of things much more easily when the cosmos was Ptolemaic and hierarchical. Instead, the cosmos of ubiquitous electric energies resonated more with the new position of a growing commercial class.[6] From this challenge to absolute authority, it would be no great leap to reinvent the idea of an absolute god.

But this new god of the Enlightenment, which would in a sense become the god of number, table, and classification, would continually be called into question, up until the present day, precisely because in its name, the mathematizing of the individual's relation to human

congress would undermine the powers of more inalienable ethers
(not to mention create an elitist notion of the global community of
"Man").[7] Poe would complain about this shift in his ethereal dialogue
"The Colloquy of Monos and Una," condemning the penchant for
abstraction in the face of cosmic gradation and true nature:

> Man, because he could not but acknowledge the majesty of nature,
> fell into childish exultation at his acquired and still-increasing
> dominion over her elements. Even while he stalked a God in his own
> fancy, an infantile imbecility came over him. As might be supposed
> from the origin of his disorder, he grew infected with system, and
> with abstraction.[8]

In addition, this impulse toward more systemic thought inspired
a "frenzied hatred of contemplation."[9] Writing of this period as a
response to the fallout of European fascism, Adorno and Horkheimer
in 1944 would dramatically assert, "The fully enlightened earth radi-
ates disaster triumphant."[10] Situating the break between natural phi-
losophy and the beginnings of modern science as the source of global
fascism, their analysis of Enlightenment thought posits that it is the
idea of a world without irrationality, magic, and myth that is in itself
mythical, magical, and irrational, fraught with taboos and fetishistic
powers. For them, "The pure immanence of positivism, . . . [the En-
lightenment's] ultimate product, is no more than a so to speak univer-
sal taboo. Nothing at all may remain outside, because the mere idea
of outsideness is the very source of fear."[11] Ultimately, Promethean
chutzpah becomes fascist nightmare, when positivism discontinues
obsolete ethers and regiments rigid conformity of an idealized citizen
to more scientific and technological absolutes.

But why, up until the analysis of the Frankfurt school, was mes-
meric thought—which had for over a century provided a challenge
to the myths of scientific progress—the spook that more effectively
induced fears of protofascist demagogues and other forces of nefarious
mind control? We will probably not be able to answer this question
until we establish some of the tensions and contradictions within the
mesmeric ontology. The legacy of this ontology in work ranging from
Poe to Fellini will aid the discussion as we zip back and forth across
the telepathic networks that span centuries. But if we are to get to
the heart of the noise that invades our dreams whenever we think of

the possibility of mind linking with mind without any mediation but for a single, subtler air, then we have to return to the haunted origins of modern technoscience.

Technological Involution and the Specter of Animality

Mesmerism emerged, through the infamous practice of Anton Mesmer, out of the paradigm-shifting work of Newton and Ben Franklin. All three conceived of an ethereal fluid that bathed all things. Yet, starting from this given, Newton and Franklin would establish a paradigm that would become the basis of further scientific investigation, while Mesmer would establish a basis for popular speculation, New Age practice, and artistic investigation. At points, however, these divergent interpretations of the ether maintain uncanny resemblances, testament to the ether's ability to thwart the very futurity that it enables, and to blur the distinctions made while swimming in it. For example, Newton's theorization resembles Mesmer's more wild interpretations of cosmic holism, since for Newton, all action of the senses, including the will, is a product of vibrations in an aethereal fluid. The finer matter of the ether impels the grosser, and all action is the product not of some god-driven mechanical apparatus like a clock (as is usually the interpretation of Newton's cosmology). Rather, from the final queries of Newton's *Opticks,* there emerges an irresistible image of telepaths in God's sensorium. Newton here turns from his mechanistic study to speculate on the existence of a vibrational plane, where humans are played like aeolian harps by an ether wind:

Qu. 23. Is not Vision perform'd chiefly by the Vibrations of this Medium, excited in the bottom of the Eye by the Rays of Light, and propagated through the solid, pellucid and uniform Capillamenta of the optick Nerves into the place of Sensation? And is not Hearing perform'd by the Vibrations either of this or some other Medium, excited in the auditory Nerves by the Tremors of the Air, and propagated through the solid, pellucid and uniform Capillamenta of those Nerves into the place of Sensation? And so of the other Senses.

Qu. 24. Is not Animal Motion perform'd by the Vibration of this Medium, excited in the Brain by the power of the Will, and propagated from thence through the solid, pellucid and uniform Capillamenta of the Nerves into the Muscles, for contracting and dilating

them? I suppose that the Capillamenta of the Nerves are each of
them solid and uniform, that the vibrating Motion of the Aethereal
Medium may be propagated along them from one end to the other
uniformly, and without interruption.[12]

It is for the purposes of finding a mechanical way to describe immate-
rial forces that Newton maintains this medium; nevertheless, the
supernatural remains an irrepressible surmise. Compare the following
unconventional interpretation of Newton's work in an extended pas-
sage from Poe's "Mesmeric Revelation." Poe almost directly para-
phrases Newton's queries in "Revelation," yet he exploits the uncanny
implications that traditional science represses, by channeling the
ghost in the paradigm.

You will have a distinct idea of the ultimate body by conceiving it
to be entire brain. This it is *not:* but a conception of this nature will
bring you near a conception of what it *is.* A luminous body imparts
vibration to the luminiferous ether. The vibrations generate similar
ones within the retina; these again communicate similar ones to the
optic nerve. The nerve conveys similar ones to the brain; the brain,
also, similar ones to the unparticled matter which permeates it. The
motion of this latter is thought, of which perception is the first
undulation. This is the mode by which the mind of the rudimental
life communicates with the external world; and this external world
is, to the rudimental life, limited, through the idiosyncrasy of its
organs. But in the ultimate, unorganized life, the external world
reaches the whole body, (which is of a substance having affinity to
brain, as I have said,) with no other intervention than that of an
infinitely rarer ether than even the luminiferous; and to this ether—
in unison with it—the whole body vibrates, setting in motion the
unparticled matter which permeates it.[13]

The body connects up with the cosmos and superconsciousness through
this Aethereal Medium, the irrational element of Newton's rational
universe, productive of a secret history of philosophic holism, radiant
bodies, universal energy, and deterritorialized flows. Newton's "place
of Sensation," into which all is delivered, becomes infinite. His aether
is what connects the place of the body to ur-space—absolute space
and time. Somehow, through the subtlest of vibrations, bodily sensa-
tion partakes of other bodies, objects, and the outer reaches of God's
sensorium.

In many ways, Newton was an eye of calm between the manic polymathia of the Renaissance and the orgy of spiritualism and scientific wizardry of the nineteenth century. His work is full of ambiguities, however, because he grappled with extrasensory forces. He was like Dr. Frankenstein—an autodidact schooled in the outmoded intricacies of the Book of Nature, suddenly born again into the scientific era. James Gleick describes Newton writing the *Principia* of 1687: "The alchemical furnaces went cold; the theological manuscripts were shelved. . . . He promised a mechanical program—no occult qualities. He promised proof. Yet there was mystery in his forces still."[14] Like Frankenstein, Newton was unable to rid himself of alchemically inspired insight,[15] which will prove more productive for his work and future science than for his more neurotic, monster-making heir. Nevertheless, with Newton's first principles, he would create, in addition to a program for strict empiricism, an idea of absolute time and space—imperceptible, incorruptible, and divine. While it is this very absolute that would motivate and guarantee future scientific achievement, it would also derange progress into infinite unthinkable matter.

Ben Franklin extended Newton's vision of the Aethereal Medium into more pedestrian territory and transformed the ether—as the fluid through which electricity travels—into a reality commensurable with the goals of the Founding Fathers. Douglas Anderson says of this revolutionary-era correspondence "between a natural and a moral architecture" that "Franklin—like many of his contemporaries— came to recognize [a conceptual relationship] between vast natural systems of physical balance or imbalance, on the one hand, and human character and institutions, on the other."[16] Franklin, the inventor of the lightning rod and leading figure in early electrical experimentation, was said to have "snatched the lightning from the sky and the scepter from the tyrants,"[17] dramatizing the idea that the beginnings of the science of electricity went hand in hand with the revolutionary transformation of power from god-guaranteed monarchy to secular American democracy.[18] Even more than Newton—who desired to keep aethereal hypotheses to a minimum—Franklin was unwilling to leap to philosophical conclusions, and the airy realm of contemplation was valuable for him only to the extent that it inspired experimentation that he could prove.[19] Yet even though Franklin

exemplified a cosmopolitan pragmatism instrumental in the consolida-
tion of elite societies of natural philosophers (foundations of the later
professionalization and militarization of science), he stood on the
shoulders of a more loosely defined community of amateurs whose ex-
perimentations seemed more like elaborate play than rational science.

In fact, from the initial experiments of Stephen Gray (1666–1736),
who began to define an ever-expanding list of "electrics" (substances
capable of channeling immaterial fluid), electrical science resembled
something akin to present-day circuit bending, the subculture of elec-
tronic musicians whose *prima materia* is discarded electrical toys, the
circuits of which are reworked to created unexpected noise. Forging
strange circuits, which for Gray included ox gut, leather, hair of dog's
ear, an eight-year-old boy suspended from the ceiling, sirloin steak
held aloft by silk ribbon, teakettles, stockings, sulfur, and beeswax,[20]
the electricians of the eighteenth century seemed also like Deleuzian
philosophers experimenting with circuits, assemblages, intensities, little
machines. Franklin himself was not immune to whimsy and theatri-
cality; a Heraclitean trickster, he set rings of golden floral patterns on
china and gilt inlay of book bindings aflame with electrical fluid and
encouraged colleagues to literally let sparks fly between each other by
giving "electrical kisses," in order to demonstrate the fire immanent
in all things.[21] He also constructed an elaborate philosophical toy
that consisted of a highly charged electrical source done up in the
image of the king. While demonstrating the force of electricity, the
game served up a moral regarding the power of the new technocratic
elite: the machine treated casual observers to a sizable shock when
they approached the battery, but the technical expert could topple
the monarch with aplomb.[22]

If play with ethereal forces as a way to reroute established power
seemed to be the rule of the day, why is it that Franklin himself
denounced Mesmer's highly theatrical form of electrical science? More
than anything, Mesmerism challenged the rationality, the theater of
rationality, of the classical age as well as its definition of the human.
Mesmer's wild paradigm, suggested by a more poetic ether than
Franklin's, is about the fluid force that bathes subject and object to
such an extent that they lose their coherent status, a substance span-
ning the borders between man and animal, and even between life

and death. Mining the metaphysical implications of Newton, and retrofitting them with Paracelsus's medical mysticism and Descartes's theory of vortexes—"which explained the movements of the heavenly bodies in terms of currents permeating the atmosphere of the universe"[23]—Mesmer conceived of the fluid universe in terms of a universal, vital force: the Fluidum. This "Fluidum" was the magnetized medium through which planets exert control on the human body, and through which humans could discover ways to control each other, by activating innate reservoirs of "animal magnetism."

Mesmer's manipulation of animal magnetism, unlike Franklin's activities with Leyden jars and kites, was widely attacked, even as the scientific community (which consisted of the newly forming societies of natural philosophers) could not ignore Mesmer's large following. To Mesmer's credit were hundreds of testimonials of mesmeric cure, in an era when standard cures much of the time proved deadly. Mesmerism, well after the decline of Mesmer's orthodox practice in the 1780s, had a serious role in American medicine until the use of anesthetics—a more industrialized ether—became common. Even today, the legacy of mesmerism remains formidable as a noted precursor to psychoanalysis but, if anything, is most remembered less felicitously as the precursor to the tawdry spectacles of the hypnotic trance. While the Food and Drug Administration in 1956 swiftly curtailed Mesmerism's modern return to the American scene in the guise of Reichian orgone therapy, it survives in the practices of polarity therapy, Reiki, and hypnotherapy.

What caused Mesmerism to be so disreputable was more than anything the "scene" it encouraged, and Mesmer's salon in Paris was a lively one. Heavy damask curtains kept out all light, as high society collectively remagnetized around the *baquet*—a tub of magnetic filings, glass, and water. From the *baquet* extended multiple rods by which dubiously ailing groups of socialites hung, creating human circuits while Mesmer—wearing a purple gown—permeated the room by playing a glass harmonica. Mesmer's assistants whisked patients off to a "crisis room" when their sudden exposure to ethereal influences brought on fits or fainting. The combination of women made highly suggestive and vulnerable by means of the ether trance and the proto-Svengali-like charisma of Mesmer led to allegations of sexual

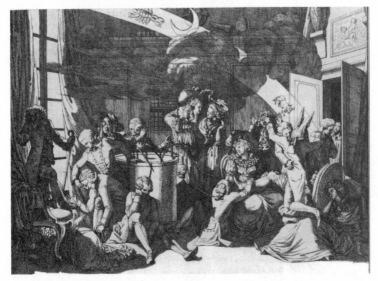

Cartoon image of Mesmer's salon. Collection Vinck, Bibliothèque
nationale de France. Reproduced with permission.

misconduct. Cartoons parodying the salon transformed the locus of
animal magnetism into a theatrical bestiary. There donkey men with
powdered wigs, tailcoats, and buckled shoes lounged among damsels
with low décolletage.

Within this notion of animal magnetism, emerging from the work
of Luigi Galvani, who considered "nature . . . a cosmic animal,"[24] the
animal is ultimately the point of greatest contention in an era obsessed
with the creation of a new man. Satiric songs and cartoons conse-
quently and perhaps predictably latched onto negative connotations
of the "animal" in "animal magnetism." Yet, while it was perhaps
only Mesmer's detractors who imagined such unchecked transmogri-
fications into animal form, consider that most traditions that embrace
forms of healing concerned with the electromagnetic sources of bodily
energy actively encourage animal *asana*. See Mesmer's salon today in
the yoga and qigong studios of the world, where channeling ethereal
energies requires that practitioners merge into downward-facing
dogs, goldfish wiggling tails, paired swallows skimming over water,

reversed swans, balancing bears, and colored butterflies dancing in air. Think of Dracula, alternately using mesmeric suggestion and transforming himself into creatures of the night; or even of Nam June Paik, who in *Global Groove* has Charlotte Moorman in video bra and electrified cello play "The Swan" from Saint-Saëns's *Carnival of the Animals* as an anthem of media transformation. The Enlightenment *philosophes* strove to situate man as an object, while the animal exists without that self-knowledge and is more apt to take advantage of whatever circuits might connect its energies to the totality in which it frolics.[25]

In contrast to the ideal of Enlightenment Reason, Mesmer's salon responds to a more archaic unconscious, even while it points onward to Kantian notions of the perceiving body and starts us on our way toward the Nietzschean superman or Kubrickian starchild. In the crisis room and salon of Mesmer, everybody is intermixed, heaving, breathless, and semiconscious. The positive and negative ions of this *camera* are sexually charged. Both the borderline between subject and object (the impresario is almost lost amid the salon's ensemble of characters), not to mention between animal and human, has been broken in this return to a space that, unified by the ether, unifies all things and all thoughts in the embrace of nature. A more Philadelphian self-authorization would excise the subject from an ancient network of nature to a self-propagating center without model. Mesmer's salon, in contrast, marks a return to a universe of analogy and natural magic. This return would have wide-ranging consequences for philosophy, literature, and theater. In fact, it would posit those endeavors as possibilities within the gridded thought of rational discourse that threatens to close them down. In them, one would hope for a return to "an absolutely primal discourse ... the enigmatic, murmured element of language."[26]

We can see the desire for this return in experimental theater itself, starting with the magnetic stages of the futurist Prampolini and the hypnotic chambers of Strindberg, but reaching full flower in Artaud's 1938 collection of manifestos *The Theater and Its Double*. His "Theater of Cruelty" is precisely a return not only to the analogical cosmos of the Renaissance but also to the salon of Mesmer in its

desire for the "deeper intellectuality which hides itself beneath gestures and signs."[27] The ultimate cure for a dying system of representation is magnetic: "Our long habit of seeking diversion has made us forget the idea of a serious theater, which, overturning all our preconceptions, inspires us with the fiery magnetism of its images and acts upon us like a spiritual therapeutics whose touch can never be forgotten."[28] This "alchemical theater," as Artaud calls it, is less a dramatic stage than a structure of knowledge. Mesmerism, even as it looks to the future for a state of being yet to be understood, harks back to the "theatrical" traditions of the *ars memoria* and *clavis universalis*, the sixteenth-century ideas of theater as a technique of thought rather than an entertainment. As described in Jean Bodin's 1590 *Universae Naturae Theatrum*, this theater "allows one to discover 'the indissoluble coherence and complete consensus of the elements of the real' in which everything corresponds to everything else."[29]

An image from the period shows Franklin entering from the wings of a cavernous theatrical space with a shining copy of the "Rapport des Commissaires"—a document drawn up by a prestigious committee of French and American scholars, scientists, and statesmen, officially denouncing Mesmer. The document bears the powerful light of disenchantment, breaking the spell of the Mesmerists, whom the cartoon depicts as showmen and hucksters engaged in subterfuge before the raid. The light from the "Rapport" does not merely kill the enchantment of a darkened theater. It also explodes, as both word and weapon—ostensibly a reference to the advances of the dean of phlogistic science and father of modern explosives, Lavoisier, who flanks Franklin. Blind justice tumbles from an exploded *baquet*; Mesmer and his cohorts are revealed as animals, demons, and witches. They escape in flight, transmogrifying into a monstrous owl, butterflies, and horses and donkeys on brooms, while innocent victims remain on the stage floor in disarray. Long before electromagnetic spectrum allocation, science would have to exorcise this staged air of conflicting ethereal systems before progress could continue. This stage is nothing less than an image of the baroque—which filled emptiness with a glut of scientific cosmologies, putti, and ribbons—cleared for classical and, later, modernist concerns. The art and literature with

The Denunciation of Mesmerism. Collection Vinck, Bibliothèque nationale de France. Reproduced with permission.

which most of the rest of this book will deal is both an attempt to call back Mesmer's routed entourage and to reestablish a forgotten system of intellection.

Dissatisfaction with the legacy of Franklin and the Enlightenment project generated within American literature an ambivalent relation to democracy as the system that supposedly best channels ethereal energies. At once characterizing the power and energy of the relatively new nation and presaging a loss of older forms of knowledge, democracy was not a simple given for writers attempting to rescue ancient ethereal insight while still embracing forward-looking, populist principles. Walt Whitman paradoxically conceived his vital democratic energies as products of a predemocratic cosmos: "While how little the New after all, how much the Old, Old World!"[30] Emerson

sought an intuitive grasp of things, which had been lost not only to the materialism of the day but to the filters of accumulated European thought, and went back into the ethereal dustbin for inspiration. The oversoul of the transcendentalists is precisely the American ether, inflected by a "more perfect Indian wisdom"[31]—sometimes aboriginal, sometimes Hindu (in the almost willful misrecognition of this movement's thought, as if replacing Columbus's geographical discombobulation with an actual mystical affiliation). Barnstorming through cosmic history, the poets of this era could rescue the pith of mystical insight from ancient systems while leaving their earthbound elements in the dust. Piecing together fragments of lost systems to create a spiritual milieu, Emerson and other writers chanced upon new combinations that would ensure an "original relation to the universe."[32] Nineteenth-century movements and figures disaffected by systemic reason took part in this "sacred drift,"[33] creating new God-assemblages or erasing the very idea of God in pursuit of more abstracted natural energies of the ethereal sort. Not only the transcendentalists and their forebears in America but also the entire romantic movement, German *Naturphilosophie*, the work of Rilke, and the period's ubiquitous supernatural literature in the penny press advanced the immaterial as a zone of poetic wandering, novel sensation, and theoretical acrobatics immune to the encroachment of industrialized time-space.

Out of this matrix of influence arises the contrarian figure of Poe, the most energetic transponder of the premodern ether, who cast its occult waves well into the twentieth century. His ethereal dialogues—"The Mesmeric Revelation," "The Conversation of Eiros and Charmion," "The Colloquy of Monos and Una," and "The Power of Words," among others—present conversations not only between disembodied entities but also between the author and the absolute. As precursors to fin de siècle armchair cosmologies, as well as to the twentieth century's mass-market successes of books such as *The Tao of Physics* and *The Dancing Wu Li Masters*, Poe mixed particle theory with metaphysical sentiment, causing some of his pieces to be published simultaneously in scientific and literary journals. But these were not mere hoaxes, as some would claim, but rather testaments to the in-

stability of ethereal knowledge. Poe's ethereal dialogues force us to become aware of space and time in a way that is alien to properly scientific paradigms and is more a function of art.[34] The nineteenth-century Swedenborgian minister George Bush, in his review of Poe's swan song, the lecture "On the Cosmogony of the Universe" (later to be published as *Eureka*), described Poe's derangement of the mechanistic notion of the universe as "poematic."[35]

Poe, however, was suspicious of the ethereal holism of the transcendentalists, for to him, such "Frogpondian" views of the ubiquity of the absolute immanent in the organization of nature represented a spurious unity.[36] He continues to open the wound that makes such unities actual impossibilities. As he says in *Eureka* of the concept of infinity:

> But it is in the act of discontinuing the endeavor—of fulfilling (as we think) the idea—of putting the finishing stroke (as we suppose) to the conception—that we overthrow at once the whole fabric of our fancy by resting upon some one ultimate and therefore definite point. This fact, however, we fail to perceive, on account of the absolute coincidence, in time, between the settling down upon the ultimate point and the act of cessation in thinking.[37]

Yet while he remained cynical to any cosmic unity that, in ceasing to think itself through, could become the source of a popular movement or scientific truism, he was not cynical to the combinations of mysticism and science that characterized the renegade practice of Anton Mesmer—whose ideas were still current. While his famous mesmeric tales, "Mesmeric Revelation" and "The Facts in the Case of M. Valdemar" (appearing in 1844 and 1845 respectively), were published long after the official discrediting of mesmerism, the scientific and popular inquiry that mesmerism's demise could not put down was still lively, at least in America, where the full dose of revolutionary-era French mesmerism did not reach New England until Charles Poyen, a "self-proclaimed professor of Animal Magnetism," introduced it there as late as 1836.[38]

For Poe, mesmerism signals a mode of thinking that has been lost, a mode of thinking that continues to think even after it has landed on a "finishing stroke" or supposed certainty: "The mesmeric exaltation

enables me to perceive a train of rationcination,"[39] says the mesmeric
patient Vankirk before undergoing the ether trance. This restless
impulse toward infinite thought (as opposed to a thought of the infi-
nite) is precisely the force that would complicate an easy understand-
ing of mesmerism, even as the mesmeric trance encourages this con-
dition of thought. Poe's manic version of "not-this" easily sunders
the very connections that a casual session under the ether immediately
brings to mind. For example, in "Mesmeric Revelation" we are warned
from beyond the grave not to conflate scientifically knowable ethers
and some vague idea of spirit, even though this analogy derives pre-
cisely from Mesmer's heady combination of electrical science and
prescientific mysticism:

> When we reach the [luminiferous ether], we feel an almost irresist-
> ible inclination to class it with spirit, or with nihility. The only
> consideration which restrains us is our conception of its atomic
> constitution; and here, even, we have to seek aid from our notion
> of an atom, as something possessing in infinite minuteness, solidity,
> palpability, weight.... Take, now, a step beyond the luminiferous
> ether—conceive a matter as much more rare than the ether... and
> we arrive at once... at a unique mass—an unparticled matter.[40]

In refusing to land on a knowable truth, Poe prepares us for this
impossible journey across infinity through science, language, and
the knowable ethers to the unthinkable substance of what he calls
"unparticled matter." It is not here, however, where we find spirit
after all, for "the truth is, it is impossible to conceive spirit, since it is
impossible to imagine what is not."[41] Instead, in the face of impon-
derably rarefied matter, we have returned to "thought."

In Poe's cosmology, when the absolute turns in on itself, it's not a
solipsistic gesture. Rather, as a thought at the end of space-time per-
forms its involution into the brain's imploded matter, we have reached
thought beyond thought. The patient Vankirk in "Mesmeric Revela-
tion" defines this "thought" in ways that will be repeated in the other
ethereal dialogues, *Eureka*, and Poe's personal correspondences.
Vankirk of "Mesmeric Revelation" says, "The ultimate, or unparti-
cled matter, not only permeates all things but impels all things—and
thus *is* all things within itself. This matter is God. What men attempt

to embody in the word 'thought,' is this matter in motion."[42] This
ultimate matter is not the ether, although the ether may be as close
to it as we can imagine while limited to what Poe calls the cage of
our organs.

> v: I perceive external things directly, without organs, through a
> medium which I shall employ in the ultimate, unorganized life.
>
> p: Unorganized?
>
> v: Yes; organs are contrivances by which the individual is brought
> into sensible relation with particular classes and forms of matter,
> to the exclusion of other classes and forms. The organs of man are
> adapted to his rudimental condition, and to that only; his ultimate
> condition, being unorganized, is of unlimited comprehension in all
> points but one—the nature of the volition of God—that is to say,
> the motion of the unparticled matter. . . . In the ultimate, unorganized
> life, the external world reaches the whole body . . . with no other
> intervention than that of an infinitely rarer ether than even the
> luminiferous; and to this ether—in unison with it—the whole body
> vibrates, setting in motion the unparticled matter which permeates
> it. It is to the absence of idiosyncratic organs, therefore, that we must
> attribute the nearly unlimited perception of the ultimate life. To
> rudimental beings, organs are the cages necessary to confine them
> until fledged.[43]

Presaging Deleuze and Guattari's "body without organs" in his mes-
meric and ethereal texts,[44] Poe sketches out an entity that can receive
sensations not accessible to the standard matrix of being, time, and
representation.

This supersubtle body has direct access to the vibrational source
of thought and language.[45] Poe's disembodied, mystical dialogues
are about the destruction of appearances and the attainment of this
anterior mind space. Unencumbered by scene, stage, and to a certain
extent action, the dialogues attempt the impossible interiorization of
a vast unincorporable infinity. This dematerialization of plot is dra-
matically evident in "Mesmeric Revelation," which starts as does a
traditional tale, only to become a transcript of a metaphysical conver-
sation between the author-scientist and a man mesmerized *in articulo
mortis*.[46] In "The Power of Words," "The Colloquy of Monos and
Una," and "The Conversation of Eiros and Charmion," both the frame

of the story and the bodies of the speakers are entirely dematerial-
ized, angelic—a close approximation of pure thought in the ethereal
sensorium.

Inventors, visionaries, or leaders, as well as large sectors of popular
culture in moments of history such as revolutions, have had a taste of
this ultimate, unorganized body. But if the visionaries and the leaders
of any revolution have been inspired by political and economic theory,
or inventors by scientific ideas, it's through the vehicle of what we
can generally call "the spiritual" that revolution has taken hold on a
cultural level. Robert Darnton has described how, while Rousseau's
Social Contract bombed with the general reading public, the "jungle
of exotic *systèmes du monde*" that readers encountered in various sci-
entific and pop-scientific literature of the day was their clearer inspi-
ration for a reorganization of the material world.[47] Mesmerism at the
time was the most attractive and scandalous system, and thus a locus
for radical ideas. Ultimately, though, Enlightenment thinkers dis-
avowed and closed down this source of inspiration as both politics
and science progressed. A common story. The so-called materialist
revolutions of the mid-nineteenth century, and the ones that started
the twentieth in Russia, were all powered not so much by invisible
masses as by the invisible, mystical substance that was the material
out of which the masses would reinvent themselves for the future.
The history of invention itself is a veritable hagiography from Edison
and Bell, whose desires to contact the dead through tele- and stereo-
phonics are by now well known, to Nicholas Negroponte, who, in
the acknowledgments of his 1995 book *Being Digital*, describes the
foundation of MIT's Media Lab as emerging out of an attempt to
"create a random access multimedia system that would allow users to
hold conversations with famous deceased artists."[48] Reinvention of
the social realm has always gone on with the blessings of the "famous
dead," as well as the unknown dead, who are part of the ultimate body
of consciousness that Poe, as well as Deleuze and Guattari, describe.
However, as I will show in chapter 2, the anti-spiritualist Theosophi-
cal Society saw communication with the dead as a low form of ethereal
experience, which needed to be avoided in order to reach higher levels
of vibrational consciousness.

Deleuze and Guattari, in describing reinvention as involution, also have some caveats regarding patching into the energies of super-humanity. While it is clear that for them it is a good thing to become-animal or become-machine in the experience of an invisible, ultimate body, they were aware of the dangers of idealizing the addictive force of the body without organs that allows for such transformations and becomings. They also considered the danger of suicide (which haunts idealistic embraces of their theory) or the possibility of becoming-fascist or becoming-junky in the disorganized sensorium of the ether binge.[49] Poe's narrator alter ego in "Mesmeric Revelation" claims, however, that in the mesmeric state his patient "perceives, with keenly refined perception, and through channels supposed unknown, matters beyond the scope of the physical organs; that, moreover, his intellectual faculties are wonderfully exalted and invigorated; that his sympathies with the person so impressing him are profound."[50] If this is so, can we still believe, along with Poe and Mesmer, that the ether still holds out a powerful creative and curative force, as well as the possibility of reinvention?

Mesmeric Experience, Fellini, and Film

At a certain point, one makes one's way through an airspace crowded with competing ethereal systems only at one's peril. The task of thinking through infinite absolutes is ultimately unbearable, requiring correspondingly infinite reserves of energy perhaps best spent elsewhere in the twentieth and twenty-first centuries. But regardless of whether we live in an age where the absolute is obsolete, we still have the responsibility of negotiating immaterial abstractions, which determine any real action—whatever may constitute that elusive thing, ethereal in itself. To seek and forever differ the end of seeking knowledge, one uses rationalism as a vehicle while nevertheless keeping it from driving up over the curb and into the duck pond like an SUV on a rampage after the country club garden party of the Enlightenment. But if for Poe, the Frankfurt school, and others, systemic rationalism, when driven out of control, led us to fates far worse than the duck pond, why is it that the mesmeric system—a radical challenge to

institutionalized rationality—more effectively stood in for the powers of evil unleashed by modernity?

In Poe's time, mesmerism in America became a household word through its evolution from etheric cure to popular spectacle. As R. C. Fuller says, "The American strain of animal magnetism had been injected into the lives of a large middle class. . . . Quick to capitalize on this latest sensation, enterprising showmen drew large crowds to witness what amounted to little more than stage hypnotism. Mesmerism was for them nothing more than mass entertainment."[51] At the same time, mesmerism would still remain of interest to scientists, albeit in a new guise; in 1842 the Manchester surgeon James Braid redubbed it "hypnotism" as a way to purge mesmerism of its occult connotations. By the late nineteenth century, as a result of the work of the French neurologist Jean-Martin Charcot, high suggestibility to hypnotism was linked to hysteria, a linkage that enabled many early psychologists to explain the suggestibility of crowds and political unrest among the masses as a form of pathological derangement. Of course, the idea of the masses is quite different from the unified, global brotherhood of the Enlightenment, and it may be that this displacement of mesmerism—the idea that Enlightenment thought could not retain because it was deemed irrational—into the realm of social psychology was a way to rationally understand unruly social phenomena by codifying them as essentially irrational. The effect of this displacement would be to make it difficult for powerful social forces to have an effective voice, even more so since Charcot and others enabled the linkage of crime and politics through recourse to ideas of dangerous ethers that motivated both. More extreme theorists of crowd psychology even believed that everybody walked in a permanent haze of suggestibility, unable to waken from a communal trance.[52]

This more radical notion of the totality of hypnotic suggestion perhaps unwittingly turned the scientific back into a spiritual concept. As one theosophical writer wrote in 1890:

> The facts of hypnotism prove a Hidden Self. Dr. Charcot does not
> go as far as this, but the variety and peculiarly occult character of
> numerous facts daily brought to light by other investigators will raise
> such a mountain of proof that hardly any one will be able to over-
> come it or deny its weight. Once they begin to admit a Hidden

Self,—using, indeed, the very words long adopted by many Theoso-phists and constantly found in the ancient Upanishads, they allow the entering wedge. And so not long to wait have we for the fulfill-ment of the predictions of H. P. Blavatsky made in *Isis Unveiled* and repeated in the *Secret Doctrine*, ". . . and dead facts and events deliberately drowned in the sea of modern scepticism will ascend once more and reappear upon the surface."[53]

A more contemporary commentator puts it thus:

> We live in the world of suggestion and under the magic spell and influence of hypnotism. Hypnotism is a mighty power in the world. We are all hypnotised by the spell of Maya. We will have to de-hypnotise ourselves to obtain a knowledge of the Self.[54]

Rather than criminalize the suggestible, these commentators describe suggestibility more as a primal alienation from the higher absolute of the true self—for example, the Hindu *atman*. Kiyoshi Kurosawa's 1997 detective thriller *Cure* underscores the spiritual thematics latent in the criminological aspect of mesmeric suggestion, while, in a more Zen fashion, not resorting to a hidden essence behind mesmeric con-trol.[55] It's a tale about a disaffected medical student who, having immersed himself in the ideas of Mesmer and psychoanalysis, becomes a serial killer once-removed. *Cure*'s Zen-master hypnotist-killer claims to have found the secret of life by emptying himself, and frus-trates his interrogators because he has no knowledge of anything but the present moment. By constantly asking them, as if in reproach, "Who are you?" he weakens their identity and opens them up to mur-derous desire; the dark comic message of the film seems to be that openness to the suggestion of murder holds the path to happiness, and the attainment of Zen mind.

In the work of Fellini, who constantly thematizes hypnotists, séances, and other spiritualist kitsch, there is, as with Poe, a constant interrogation of mesmeric and ethereal states and a search for some concept of clarity. Fellini's 8½ begins with a director, Guido, seeking a cure, which is perhaps a cure from representation itself, since his sickness seems to be only tangentially related to his liver and is more a question of his inability to finish a film.[56] Somewhere on the grounds of the fashionable spa that he attends is an outdoor nightclub, where Guido and his entourage are treated to staged mind reading by a

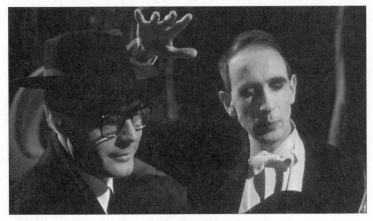

Guido and the mesmerist in Federico Fellini's 8½ (1963).

magician and his assistant, who happens to be named Maya. There
seem to be implicit connections made between these types of mes-
meric tricks and the making of a film, and it's as if the magician
knows the simple secret that the director Guido cannot uncover—
that filmmaking, like life itself, requires a control of immaterial forces
in which one can easily get lost. Fellini's openness to the creative
energy of the mesmeric continuum distinguishes him from other film-
makers who, encouraged by the intellectual desuetude of actual mes-
merism, have tended to represent mesmeric savants as sleazy enter-
tainers, charismatic criminals, or mastermind fascists.[57]

For some, the cinematic *Gesamtkunstwerk* ontologically partakes
in nefarious, even fascist, control of a vulnerable audience. This idea
was an irresistible one for Italian filmmakers of the 1940s who saw
how the spectacular films of the 1930s—for which they themselves
were sometimes responsible—distracted people from the rise of fas-
cism. One common account of neorealism is that it is a reaction to
the "unreality" of fascism—its dependence on hallucinatory states
facilitated by the spectacular multimedia penetration of film, with
the broadcast of radio, the performance of mass rallies, and the
appearances of Il Duce. Neorealism was perhaps the first film move-
ment vigilant to media's hypnotic powers, haunted as were its practi-
tioners by the memory of a traumatic period in Italian history that
for "intellectuals amounted to a collective amnesia regarding their

participation in fascist culture," as if "they had lived the duration of the dictatorship in altered states which were impossible to recall or verbalize."[58] Neorealist antispectacularism created an impossible ideal of media without suggestibility, in effect media without media, and it was Fellini's eventual rebellion against these ideals that led him to rediscover the "realism" of spectacularism;[59] through his spectacles, the ritualistic origins of entertainment intersect with the healing practice of Mesmer. Film is unavoidably transformative—for good or evil—in ways that elude our shot-by-shot analyses, and perhaps, through the work of Fellini, one can appreciate the ethereal powers of the cinema without falling into naive notions of media manipulation, or rationalized notions of irrationality.

Fellini's films create space-times through which his characters detour, atmospheres and evanescences, assemblages of pieces of things and temporary theaters that threaten to crumble when human inspiration and energy leave the scene. In an interview with the BBC, Fellini (speaking in English) describes this assemblage: "I have the feeling when I make a picture that I am looking around just to find little piece of something who was broken, and my effort is to put— try to put together all the little pieces of those statues, for example, who in my mind is the picture."[60] The ubiquitous wind sound of his films, many times created by the director merely blowing into a microphone, creates the feeling of the unity, but also the fragility, of this mess forged into cosmos. On the one hand, the wind implies emptiness, desuetude, a failure of human society to connect with the lifeworld. On the other, it is the "spirit" of the ancients that literally breathes life into things; it is the director taking these fragments up into his own ethers. It seems, however, that it is precisely this ability of the director to create these convincing realities that is at issue, and in a cosmos of blowhards it is hard to distinguish inspiration from wind.

Accordingly, his heroes negotiate a social realm polluted with conflicting *systèmes du monde*. The character Guilietta Masina generally plays is an exemplar amid those who have lost themselves in the magnetic storms of modern life. What arises for a character such as Cabiria, Juliet, or Gelsomina is the question of responsibility to something not necessarily present, perhaps ghostly, which inspires

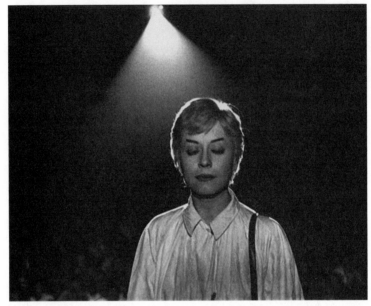

Cabiria under mesmeric control in Fellini's *Nights of Cabiria* (1957).

her nonconformism both to those who are dramatically losing their integrity, and becoming something monstrous, and to those who are forever unable to change.

In a crucial scene of *Nights of Cabiria*,[61] Cabiria crosses the barrier between audience and performer to undergo a staged hypnotism. She had entered through the derelict theater's seedy atmospheres, past a man smoking outside, past a ticket salesman in his undershirt scratching himself indifferently, whom she badgers—"Is it beautiful?"— through rowdy men smoking and heckling a magician well beyond his prime, and finally to her seat in the smoky, vaudevillian theater. It is a testament either to the magician's secret powers or to Cabiria's sensitivity that he is able to hypnotize her and bring her fully onto the veranda of the Italian estate that is just canvas and paint, in order to enact a touching love scene with an invisible courtier. As with the movie star she meets earlier in the film, she is brought into the inner sanctum of fantasy, only to be disabused of its actuality (however paradoxical any "actuality" of fantasy may seem). It is in the

scene at the theater that the fantasy—touching as the mesmeric rapport may be—is ultimately conceived of as a magnetic invasion and sexual harrassment. As in 8½, the hypnotist-magician has an undeniable sweetness; yet he ultimately produces fear and anxiety. In 8½, when its hypnotist, who greets the director Guido as an old friend, approaches one of Guido's female companions, she yells, "I don't want you to do it to me! No! You're disgusting me! Leave me alone! . . . I can't stand it! This man crucifies me!" Both *Nights of Cabiria* and 8½ resurrect eighteenth- and nineteenth-century fears of mesmerism as not only politically but also sexually manipulative. Cabiria wakes from her dream to find herself suddenly in the middle of the spectacle, no longer consoled by the sweet fiction the magician spins, but assaulted by lights, smoke, and the laughter of men.

In contrast to the unpleasantness of this rapport, and while Cabiria suffers within the spectacle, she also at times seems to have some perception of the happiness always on the other side of the image. She will even pick up on the sound track's orchestrated music as if it were the music of the universe or the music of her happiness. The nondiegetic music of Fellini's films at times is veritably transmitted to the characters, who, with utter clairvoyance, will dance, move, and walk to this music as if they are human radios who have perceived the jazzy rhythms of a modern cosmos. (Fellini generally shoots to music, creating what he calls in an interview with Hans-Erik Philip "a pantomime with all the actors moving at a certain tempo.")[62] Cabiria's destiny is to go beyond what the image presents and tune into the elusive ether that Fellini represents as sonic. Like Gelsomina of *La strada*,[63] who in becoming the pure music of a disembodied trumpet solo completely and tragically merges with the ether of the sound track, Cabiria is also a point of transmission for the film's music, remaining ultimately in the spectacle (while Gelsomina, on the other hand, becomes an *acousmêtre*).[64] Even in her final moment of desolation, Cabiria is consoled by a group of young people who circle her in a lullaby of accordion, guitar, and vespa. Cabiria and this group approach a country road from two different sides, as if from happiness and despair, only to merge on the same road like heavenly bodies in the same ether. The musicians not only orbit her solemn

trajectory but spin on their axes like musical planets. The attempts to communicate with her literally evolve from a boy barking at her like a puppy, to another singing with longing "la-la"s, to a full and genteel "buona sera." The moment does not fail to be a tearjerker, for she is finally, within this nomadic band, at home. Paradoxically, though, while she is at the nomadic fringes of the spectacle, she is also at center stage. Everybody, including the audience, is suddenly brought into a harmonic alignment by the grace of the sound track. Following the redubbed and close-miked "buona sera," which can be interpreted as directed to both Cabiria and the film audience (they are the last words of the film), the film music rises, drowning out the folk music of the teenagers. She ultimately turns her gaze to nod at the camera, ensuring the final victory of this double world that overcomes the divisions and alienations implicit in the spectacle.

If *Cabiria* is more generally about the powers of the cinema, with metaphorical connections to the mesmeric underwritten by a crucial scene, Fellini's *Juliet of the Spirits* explores similar themes in a film almost entirely about spirit communication. Masina's role in *Juliet of the Spirits* places her at the center of a society in which table tapping, *darshan*, and psychoanalysis have become parlor games to excite a leisure class. She also inhabits a society of people who look like nothing less than dog and cat people, true to the theme of animal magnetism gone awry. The voices of these irresponsible or childish models and showbiz types are almost interchangeable with the spirit voices, and Juliet confronts a system of communications that is of dubious use to her. (Similarly, Guido, of 8½, calls for guidance from the spirit world in the film's final scenes, but his inability to make sense out of the multiple voices that assail him causes him to opt for suicide.) Even Juliet's doctor, Don Raffaele, gives out fairly useless information and is just another hanger-on, telling people they shouldn't smoke, and reflecting on voices in space, electromagnetism, and spirit communication as scientific phenomena. His is just another voice that crowds Juliet's head and makes it impossible for her to distinguish real from imagined, material from spiritual.

In this chaos, she finds some comfort watching TV, and the show that always seems to be on is one that literally hypnotizes the view-

Hypnotism on television: Fellini's *Juliet of the Spirits* (1965).

ing audience. The women of the house enjoy watching this show, as if the domestic sphere were just another form of hypnotic energy in conflict with her husband's magnetic coterie of television's castaways, clairvoyants, and bon vivants. Between these two forces—the mesmerism of the television that bathes the home and that which produces her husband's infidelity to the home—Juliet must find her way. Again, it is through sound that Fellini represents these ethereal forces working on her. Rota's use of the Farfisa organ, or even, in one notable instance, the mantric hum of an electric fan, produces a sound that bathes, vibrates, or hyperextends the visual into some realm of the absolute (*Juliet of the Spirits* also seems to be the first Fellini film, apart from the spaceship scenes in 8½, in which Rota is extensively using early electronic-synthesis techniques). In contrast to these entropic sounds, the house of Juliet is visually conceived as a surreal parody of the perfect home, ordered and clean, patterned with artichokes, perfectly landscaped—a complete opposite of her neighbor's Arabian nights realm, the grounds of which are overgrown with strange Martian weeds and feature half-human, half-animal statues. Inside the walls, dreamlike spaces, dominated by a beehive motif, encourage a society to which Juliet is unaccustomed, with the voluptuous Sandra Milo as Suzy playing queen bee to a menagerie of sexual adventurers. In contrast, Juliet maintains her house and privacy

as an illusory barrier erected to keep out the spirit world and every-thing else that can occur only at and beyond its periphery—sexual encounters, animal life, Dixieland music.

Fellini seemed to be quite aware of the ethereal aspect of sound in relation to the space of the cinema. His characters move constantly through derelict theaters, circuses, and other spectacles that, on the surface, no longer have the potential to fascinate but are, rather, chaotic gathering places for the lower classes; the legacy of the silent cinema is these spaces full of noise. However, his films intensify a sound that, coming no longer from the rinky-tink bands in the diege-sis, but from some elsewhere, bathes and entrances and reinvents the space.[65] In typical films, this orchestrated, dubbed, nondirect sound merely attests to the manipulative force of the sound track, the clini-cal release of the gas, the administration of the Dolby. For Fellini, it signals that his heroes have given themselves over to the rinky-tink band, the incidental music of the streets, or a rhythm that is entirely phantasmatic. The elsewhere that the sound represents is a mental space where each of his heroes figuratively exits the theater and enters into an ethereal, transformative experience.[66]

Sound, however, is not the only locus for an aesthetic representa-tion of an ethereal medium in which social life occurs. For example, while the domestic imagery of *Juliet of the Spirits* is in strict contrast to the ethereal, the white mise-en-scène of the house, when echoed by the white clothes of Juliet, creates harmonies—what Deleuze calls "spiritual conjunctions"—that leap out of continuity and transform the image to another power, which is Deleuze's "impower" of thought. At times, she is taken up into the white, as when, demurely lowering her white hat (while dressed all in white), her face disappears. One is reminded of Carl Dreyer's use of white space in *The Passion of Joan of Arc,* which theorist and filmmaker Paul Schrader cites as a model of a "transcendental aesthetic" in film.[67] While the world of judges and priests belongs to some continuous space known to anybody inti-mate with the conventions of the realistic film, Joan's face floats in blank, placeless space—a spiritual continuity, estranged from all craft. Deleuze says that this blank zone, outside traditional continuity, forms the locus of cinematic mysticism:

[It] testifies to a more disturbing presence, one which cannot even be said to exist, ... a more radical Elsewhere, outside homogenous space and time. ... [It] introduc[es] the transspatial and the spiritual into the system which is never perfectly closed. Dreyer made this into an ascetic method: the more the image is spatially closed, even reduced to two dimensions, the greater is its capacity to *open itself* on to a fourth dimension which is time, and on to a fifth which is Spirit, the spiritual decision of Jeanne.[68]

It is probably Antonioni in *Red Desert*, or Jacques Demy in *The Umbrellas of Cherbourg*, who, through the use of color, has more of an affinity for Dreyer's aesthetic than Fellini does. For while Fellini's color schemes allude to the absolute, they constantly call the meaning of the absolute into question. The whiteness of Juliet's clothes and home could emerge from a mistaken attempt to visualize transcendental goodness, which is parodied in the house (again, a comparison with 8½ is instructive—the white-clad figure of Claudia Cardinale is a parody of the cinematic representation of innocence and purity). This breakdown of the codes of color, in pursuit of some wavelength beyond the code, becomes evident when Juliet visits a nymphomaniac sculptor friend, who is also dressed in white. The sculptor greets the similarly dressed Juliet while surrounded by her white statues, which are her own personal manifestations of the transcendental. As the profusion of white strains to place completely incompatible subjectivities in the same force field, an aesthetic of spirituality is called into question when the nymphomaniac describes her sculpture:

My art is deeply spiritual. I want to restore God's physicality. I used to fear him. He crushed me because I thought of Him abstractly, but He's really the most beautiful body, so that's how I try to show him. A perfectly formed hero, a body I can desire or take for a lover.

Juliet's emergence in her own negative space is offset by the positive darkness that her husband's friends literally pull her into. Throughout the film, during mesmeric scenes, and other scenes of potential transformation, faces are obscured, allowing one to reflect on the erasure of subjectivity in a magnetic, spiritual system. When the lights come on, the meretricious color, as well as the shocking uniqueness

of each face, jolts one back into a parody of individuality, personality, and property. Two versions of the absolute—on the one hand, whiteness, television, and order, facilitating the sainthood of the housewife; and on the other, darkness, animality, and chaos, facilitating the husband's infidelity—war with each other. The fickle absolute is dramatized both in these uncertain absolutes of color and in the uncertain status of the spirit voices that Juliet hears. How can one tell friendly from unfriendly, trustworthy from false? At one point, almost all the characters trot out in random black-and-white outfits, parading the uncertainty of the color code and celebrating another dimension. In the end, Juliet's responsibility rests in a form of indifference, as the final scene is described in the screenplay:

> Juliet smiles, bends her head and continues to sway on the swing, in the rustling of a light wind. It is as if she no longer cares about the origins of the sounds, the images she has seen, whether they be part of a natural mystery or part of a supernatural secret. Everything in her is now anchored in peaceful harmony, beyond the mystifying ghosts that have until now besieged her; she is concerned with the daily miracle of simple reality.[69]

In effect, Juliet gives over her mediumship—a role that is frequently reserved for women, based on their heightened sensitivity, but, as the history of mediumship in the nineteenth century shows, frequently got them committed to asylums. Yet Masina, in her simple indifference, actually exemplifies what Deleuze calls the "actor-medium" who no longer acts but negotiates a superconsciousness implicit in the "pure optical and sound situations" of the film, in which "something has become too strong in the image,"[70] inaccessible to interpretation:

> A new type of actor for a new cinema. . . . What happens to them does not belong to them and only half concerns them, because they know how to extract from the event the part that cannot be reduced to what happens: that part of inexhaustible possibility that constitutes the unbearable, the intolerable, the visionary's part. A new type of actor was needed: not simply the non-professional actors that neo-realism had revived at the beginning, but what might be called professional non-actors, or better, "actor-mediums," capable of seeing and showing rather than acting, and either remaining dumb or undertaking some never-ending conversation, rather than of replying or following a dialogue.[71]

Think of Marilyn Monroe, playing Rosalind in *The Misfits*, who is
"hooked into the whole thing," exemplifying a sensitivity that is
almost preternatural; dwarfed in a landscape that has become unbear-
able, between sky and moonlike flats, she screams, "Killers! Killers!
You're all dead men!" (a scream that, by the time the public heard it,
was already haunted by her death, and Gable's).[72] It's a scream that
is indebted to the psychological techniques of the Actors Studio,
another mesmeric legacy, which helped film further develop an aes-
thetic of consciousness, which resonated in the family melodramas of
Cinemascope and chatters on in the never-ending coffee klatches
that are the séances of the soap opera. Paul Newman's role as Chance
in *Sweet Bird of Youth* comes to mind as another example of the
mediumistic: torn between the magnetic forces of a veritable holy
war, raging around the possession of his girlfriend "Heavenly" and
the seductions of an ether-bingeing aging starlet Alexandra Del Lago,
aka Princess Cosmonopolous, he can do nothing but be an impatient
witness to an unbearable situation.[73]

In the context of early electronic mysticism's legacy to the aesthetic
of the absolute, however, no film reveals more surprising insights than
the 1985 teen coming-of-age film *St. Elmo's Fire*.[74] There's a glib mys-
ticism in the film that begins with a car crash that Rob Lowe's char-
acter calls "metaphysical." There's a nod to the "mystical space where
all lost socks go." There's also a character who calls her ex-boyfriends
her "two miracles" and postpones sainthood (presumably achieved by
attaining the implied "third miracle"). More importantly, Saint Elmo's
fire—a mythical notion concerning excessive electrical discharge on
ships' masts and the like—is both a space (the bar) and a unifying
force. Like the ether, which finally explained phenomena like Saint
Elmo's fire (by means of a further fiction), it serves as a provisional
backdrop that, when seen as such, opens up multiple transformations
and becomings of postgraduate life.

The general aesthetic of the film is somewhat hard to bear, but I
have come to feel that the mysticism emerging timidly is based on
the possible desire to negate not only the aesthetic itself but the un-
satisfactory world that the mid-eighties presents to these characters.
When forced outside the inner circle of mystical energies facilitated
by the space of the bar, the characters experience the pull of a variety

of unsatisfactory becomings or unplanned materializations. It's a story, really, of the metaphysical love that magnetizes them all and that they fail to realize through the methods with which culture provides them, such as coupling and materialism; the film shows them "after the fall," as they react individually to the unbearable situation of choosing a future. The film culminates in a scene that seems like pop-Antonioni, negating the unbearable aesthetic by the use of negative space. Creditors have emptied the apartment of Demi Moore's character (Jules), and she rocks back and forth against the stark, red walls that fill most of the frame. Ice blue curtains billow as Rob Lowe comforts her:

> Jules, you know, honey, this isn't real. You know what it is. It's Saint Elmo's fire. Electric flashes of light that appear in dark skies out of nowhere. *(He lights a lighter and sprays an aerosol can on the flame, creating a burst of fire.)* Sailors would guide entire journeys by it, but the joke was on them, there was no fire. There wasn't even a Saint Elmo. They made it up. They made it up because they thought they needed it to keep them going when things got tough. Just like you're making this up. We're all going through this. It's our time at the edge.

This abstraction of the image brings about "virtual conjunctions" outside continuous space and offers up a luminous address to an absolute space, or, in Deleuze's terms, the time-image. The characters come to see their limited perception of time, as it opens up onto uncertainty and infinity; space-time was bearable within the ethereal space of the bar, but that version of space-time is no longer operable. "I always thought we'd be friends forever," Emilio Estevez says, as he stands outside the bar, looking in as if through Citizen Kane's snowglass to a past that never was. "Yeah, well, forever got a lot shorter suddenly, didn't it."

In many ways, this forever, when transformed into representation, does become a little less than it was before. The cinema of the absolute, however, actualizes images in the medium of some eternal, open space, not accessible to direct capture. Fellini is cognizant of this absolute space, saying in an interview, "I don't make a picture but I *remake* a picture that existed before in another dimension."[75] As medium of this remake, the director is directed and is the creator of a ritualistic space for its realization. "I create an atmosphere in which a thing can

burn... to prepare the artistic oxygen in which your creature can breathe.... To make a picture can become yoga."[76] It is to the maintenance of this artistic oxygen—this ether of yogic communication and discipline—in the face of its possible disappearance that the cinema of the absolute directs its exercises.

2

Holy Science, Film, and the End of Ether

The Era of Disappearing Ether

Of the heady mix of historical transformations in the nineteenth century's fin de siècle, admittedly the least influential—at least at the time—was an exotic physics experiment conducted in 1881 and 1887 by Albert A. Michelson and Edward W. Morley. In their "ether-drift" experiment, they set out to measure the ethereal wind in which the earth traveled. At the time there was no question as to the ether's existence; what they were looking for was the quantity of its aerodynamic resistance, if you will. By gauging this resistance with a highly sensitive contraption of Michelson's making, called an "interferometer," Michelson and Morley would be able to establish a cosmic standard for the measurement of the earth's movement—in effect, a "speedometer for the earth."[1] The exceptional data they derived were so puzzling as to be almost ignored for over twenty years, at which point this absurdity of data to the right of the decimal place would finally attain an epic visibility in the theories of Einstein. For Michelson and Morley, though, the experiments not only failed to find the earth's speed in absolute space but also failed to find the cosmic wind itself, against which they were to measure this speed and the speed of

light. A poet friend of Michelson's described the event much later, in 1923, well after its significance had been established:

> But when from the plunging planet he spread out a hand to feel
> How fast the ether drifted through flesh or stone or steel
> The fine fiducial fingers felt no ethereal breath.
> They penciled the night in a cross of light and found it still as death.
> Have the stars conspired against him? Do measurements only seem?
> Are time and space but shadows enmeshed in a private dream?[2]

The ether, which had been a given for some of the most important advances in scientific knowledge and metaphysical speculation, suddenly did not exist.

I would like to ascribe great importance to this experiment within its contemporary moment, but I ultimately cannot; its implications would not manifest themselves culturally until the early 1900s. The ether-drift experiment acts almost like a trauma that disappears into the structure of history. Not attracting the wide attention of intellectual and artistic circles as did the later theories of Einstein,[3] Michelson-Morley evades historicism through the very logic of the *horror vacui* that its implications encourage. In mathematics, for example, whether or not the advances of Michelson and Morley were felt, speculative geometries began to proliferate. Speculation did not stop at the academy; with the violent transfigurations of space and time that characterized the late nineteenth century, and as the Euclidean universe became less tenable, it is clear that armchair cosmology would become popular practice. As the historian Anson Rabinbach says, "The question of what constituted the 'true' nature of time and space was already hotly debated in the Parisian intellectual reviews in the 1880s, often finding its way into the popular press. . . . Defenders of the traditional Kantian view of time and space as stable, innate, *a-priori* concepts increasingly found themselves on the defensive as new ideas of 'curved space,' 'four dimensionality,' and higher orders of space perception gained currency."[4] In the English-speaking world, Charles Hinton, a theorist of the fourth dimension, published what he called *Scientific Romances,* a series of pamphlets written from 1884 to 1886. In this series, intended for popular intellectual consumption, he described the ether alternately as a trembling and quivering, yet rigid and unshatterable bubble and, most fantastically, as a phonograph record on which

the past, present, and future will ineluctably play: "The history of nations, stories of kings, down to the smallest details in the life of individuals, [may] be phonographed out according to predetermined marks in the aether. In that case a man would, as to his material body, correspond to certain portions of matter; as to his actions and thoughts he would be a complicated set of furrows in the aether."[5] While normal thought runs smoothly along predetermined "corrugations," there is a potential, by effort of thought and will, to warp the furrows infinitesimally, thus gradually exerting pressure on neighboring furrows and, in the end, changing the fate of the universe. The proliferation of popular, crackpot cosmographies such as this concept of a transgalactic Victrola served to hide the possibility that space was a terrible, empty place.

In addition, by 1887, Hertz successfully demonstrated Maxwell's electromagnetic theory; the findings of this highly publicized experiment ran completely opposite to those of Michelson and Morley, since many scientists, such as Helmholtz, tended to conflate electromagnetic waves with aethereal oscillations. So while the ether silently disappeared in one modest quarter of the scientific community, Helmholtz claimed to the world, "There can no longer be any doubt that light waves consist of electric vibrations in the all-pervading ether, and that the latter possesses the properties of an insulator and a magnetic medium."[6] Laying the groundwork for the future of radio communications, and ensuring the ether another heyday, Hertz and Helmholtz found the ghost of the visible-light spectrum and translated the luminiferous ether of the nineteenth century into the electromagnetic spectrum of the twentieth. Far from eliminating the ether, this cultural and scientific search for the heart of space in the period from Michelson and Morley's experiments to Einstein's papers on special relativity encouraged a multiplication of ethers such as the world had not seen since mesmerism.

This early modernist desire for higher orders of space perception manifests itself in the form of a profusion of dream times, hallucinatory ontologies, intellectual-mystic revelations and theaters of the mind. The cultural and artistic scene from 1880 to 1905 is quite different from what has become the legacy of artistic modernism. In the period before Joyce, Woolf, Picasso, and others would popularize

the official version of new space-time conceived by Einstein, a form of wild modernism sought out homegrown versions of space and time, an ethereal super-relativity. In excess of the mathematicians and the physicists, theosophists and yogis, symbolists and decadents vied for real estate in the void during ether's crisis period; all became fascinated by the powers of inner space as the gateway to the ether. The perfumed chambers of Huysmans's hero Des Esseintes, Debussy's proto-ambient environmental scores, Strindberg's intimate theater, and Satie's furniture music each created a hermetic, personally magnetic space—the avant-garde version of the bourgeoisie's "phantasmagoria of the interior," which Walter Benjamin defined as the cocooning reaction to urban shock.[7] Whether ironically or seriously, these artists perceived an inward "music of the spheres" attuned to the occult dimensions of private life; their idiosyncratic phantasmagoria developed as a reaction to the impossibilities of harmony in the public sphere, in which—through a series of rapid, interlocking, industrial disruptions—time and space had lost their relation to cosmic rhythms.

This construction of a moral idea of time and space—perhaps an early source for the concept of "environmentalism" and definitely the wellspring of New Age and ambient music—rests in the belief in dimensions that can be perceived through the body's ethereal double, more commonly known as the sixth sense. Through the ensemble of mechanical relations that in the nineteenth century tended to discipline the senses for industrial ends, there still existed, it was believed, a more rarefied sense that could pick up the vibrations to which the industrial had no access (at least at that time), vibrations that most likely conditioned human destiny. This sense establishes rapport not strictly between body and nature but between a supersubstance common to both—a commonality that engenders an ethereal responsibility even though it drifts precariously through the zones of super-structure and false consciousness.

In effect, the sixth sense is that faculty which is able to perceive what Aristotle called "the fifth element" or *quintessence*—from which the premodern idea of ether derives—precisely because both sixth sense and fifth element are composed of the same imponderables. (It is only in the quasi-mystical space of TV's *$25,000 Pyramid* that "the sixth sense" and "the fifth element" could have materialized their

correspondences as Bruce Willis movies, and this is not unimportant; I will turn to the implications of a recycled ether in the Bruce Willis vehicle *The Fifth Element* in the last section of this chapter.) In anticipation of the philosophic trends surrounding superconsciousness in the 1880s, Poe describes the emergence of the sixth sense in an angel's first-person account of his (her?) previously decaying body in "The Colloquy of Monos and Una":

> No muscle quivered; no nerve thrilled; no artery throbbed. But there seemed to have sprung up in the brain, *that* of which no words could convey to the merely human intelligence even an indistinct conception. Let me term it a mental pendulous pulsation. It was the moral embodiment of man's abstract idea of *Time*. By the absolute equalization of this movement—or of such as this—had the cycles of the firmamental orbs themselves, been adjusted. By its aid I measured the irregularities of the clock upon the mantel, and of the watches of the attendants. Their tickings came sonorously to my ears. The slightest deviations from the true proportion—and these deviations were omniprævalent—affected me just as violations of abstract truth were wont, on earth, to affect the moral sense. Although no two of the time-pieces in the chamber struck the individual seconds accurately together, yet I had no difficulty in holding steadily in mind the tones, and the respective momentary errors of each. And this—this keen, perfect, self-existing sentiment of *duration*—this sentiment existing (as man could not possibly have conceived it to exist) independently of any succession of events—this idea—this sixth sense, upspringing from the ashes of the rest, was the first obvious and certain step of the intemporal soul upon the threshold of the temporal Eternity.[8]

Poe most likely found this idea of duration—that which exists beyond mechanical abstraction, sensation proper, and mere human intelligence—in Newton's attempts to understand the limitations of relative perception. And Poe's "duration"—used in a moral sense—predates the intellectual popularization of the same term in the philosophy of Henri Bergson. Bergson rescued "duration" by endowing it with an obscure moral value, just as its scientific value was on the way to bankruptcy; as for what Newton called "God's sensorium," it was steadily turning into what Walter Benjamin called "a machine ensemble."

Bergson, whose work I will discuss in more depth later, wrote amid a plague of irregular abstract times that could not easily be put down by the establishing of Greenwich mean time in 1884. He also wrote as cinema was emerging not as an entertainment but as part of the scientific, rational understanding of body power along temporal axes. With the steady weathering of absolutes in the fields of mathematics and physics, less speculative and more industrial efforts were turned toward the filmic analysis of the body in motion. Muybridge's zoopraxiscope experiments led directly to an effort to understand labor power in scientific rather than religious or ethical terms; through the "kinematic" science of time-work studies, elaborate biotechnical complexes would abstract and quantify the body's resources. Anson Rabinbach describes how in the protocinematic time-work studies of Etienne-Jules Marey, "the body was the focal point of the scientific dissolution of the space-time continuum."[9] Science and labor would fuse, Rabinbach continues, in this sensorium in which "recourse to 'vital substance,' 'incalculable fluida,' 'irritation,' or any other 'imponderabilia of nature,' was no longer required to explain motion."[10] Instead, a form of materialism emerged from the intersection of the body and the cinema, one based on work or *Kraft:* "The new scientific materialism was predicated on a single, indestructible, and invisible *Kraft*."[11] Henceforth the cosmos would be perceived primarily through the biotechnical alliance of labor power and the cinema.

One can imagine that the other side of *Kraft*, practiced in the various spirit movements of the nineteenth century, encouraged an overthrow of this biotechnical worldview. But from 1880 to 1905— in counterpoint to the anarchist bombings of the time—there was a popular rapprochement between technoscience and renegade mystical energies. Visions of a biotechnology of the spirit and an absolute cinema engendered paradoxes of transcendence that remain fairly novel solutions to this closed system. That is, if industry could learn from the cinema, so could spiritualism—specifically the theorists of duration and the fourth dimension; in fact, the list of theorists of mystical sciences who use cinematic metaphors for the elucidation of higher-space perception is a long one, including Bergson, Ouspensky, Bohm, and Yogananda. They will reveal paradoxes of the visual that

Chronophotographic image and diagram of portable device for recording time-motion studies from Etienne-Jules Marey's *Animal Mechanism: A Treatise on Terrestrial and Aërial Locomotion* (1886).

encouraged the nonrepresentational images of abstract art. By exploring certain ontological absolutes of cinema, these unwitting granddads of avant-garde film theorized an illegitimate line of inquiry toward something beyond the image, or even in the image, that activates thought beyond thought—what Deleuze calls the image's "elusive impower." The *via negativa* of this technologically induced spiritualism runs through the beginnings of abstract film (early lost futurist and Dadaist experiments, Fischinger, Ruttman), to absolute cinema, flicker films, expanded cinema (Kubelka, Belson, the Whitneys), and winds up in the video art of Bill Viola.[12]

But even before film was considered art, it was theory, and philosophers of the late nineteenth century, and their heirs, founded a discourse of the supersenses in dialogue with the rapid evolution of media culture's image sensorium. Both aestheticist and antiaestheticist at once, the philosophy of Bergson has affiliations with the madness of the theater of Strindberg, who was never sure if the image should be destroyed, or if it was an instrument of higher thought. These intellectual trends were also implicated in the new syncretisms that the theosophists forged by introducing yoga to the American shores. And this paradoxical alliance of science and spiritualism, cinema and higher vision, will dramatically resurface at the end of the twentieth century in the military-ethereal complexes of Japanese anime. This chapter will map some provisional links between, most centrally, theos-

ophy, Strindberg, and Japanimation; the coherence of this endeavor is guaranteed by an atmosphere of ethereal science and philosophy that the texts at hand share.

The overall impulse of this period of a paradoxically disappearing ether (paradoxical because this substance is always, by "nature,"

without appearance) seems to be toward the development of a spiritual positivism that is not at odds with science but rather uses the objects and ideas of technoscience as one would a philosophical toy, helping people perceive the ultimate, rarefied matter of life, "the moral embodiment of man's abstract idea of *Time*," and the mysteries of space. It was as if people were becoming aware of the status of ether—as well as science and spirituality—as fiction, or, in Hinton's term, as romance. This was serious fiction, driving scientific inquiry, but also warranting a variety of popular and artistic reformulations that continue to this day. Michelson-Morley failed to cause panic because, while it was a symptom of the rationalization of all space and time, Western culture rallied around nothingness, about to create countless new ethereal territories.

Theosophy, Bergson, and "Flickering Consciousness"

It is theosophy and yoga that will provide the West's first concerted effort to make this contradiction between technological and spiritual perception of the absolute moot on a more popular level. Indeed, before the Theosophical Society of America was founded in 1875, there had been a seemingly irreconcilable conflict between the scientific materialists and the transcendental spiritualists; and materialism, through the new "metaphysics" of *Kraft*, was winning out. By the 1880s, mesmerism—which had become at midcentury a powerful anesthetic technique and curative method in the emerging science of medicine—was entirely pushed out of the industrial sensorium, to be displaced by the development of a more predictable chemical anesthetic ironically called "ether." The various spirit mediums (mostly women), who had fueled the spiritualist movement that began in 1848 when the Fox sisters heard various disembodied tappings in their home in upstate New York, were either forced into asylums (as part of the newly developing industry of psychiatry) or were earning a wage in the entertainment world—as part of the developing popularity of the magic show.[13] But as mesmerism, seeking a more hospitable environment, migrated to medical communities in colonial India,[14] and as spiritualism became the memory of a cultural fad, yoga came West, primarily through the efforts of founding theosophists

Helena Blavatsky and Colonel Olcott, who, in 1878, left the founder-
ing Theosophical Society of New York in the hands of Abner Double-
day, inventor of baseball, and made for India.
Their choice of Indian religion was inevitable in the context of
increasing scientific rationalism. Yoga has been called "the Science
of sciences," or "the Holy Science" by its practitioners and as such
could provide a formidable challenge to the industrial-scientific world-
view without seeming entirely escapist. As the historian Peter Wash-
ington says of the engagement of theosophy with the standards of
rationalism and science of the time: "On the one hand Olcott and
Blavatsky were attempting to operate with these standards; on the
other they were trying to restore just the sense of mystery that
the insistence on such standards had allegedly banished from the
modern world."[15] The theosophist Annie Besant, whose concept of
the thought-form—a type of supersensory auratic emanation—is
highly indebted to the yogic notion of the chakra, shot through with
the science of electromagnetism, describes the prime difference
between yoga and other forms of spiritual communion thus: "'Yoga' is
the seeking of union by the intellect, a science; 'Mysticism' is the
seeking of the same union by emotion."[16] Yoga was in this way attrac-
tive to the theosophical project, which grew out of dissatisfaction
with spiritualism and spirit communication's excesses. While still sus-
picious of "mere intellectual enlightenment,"[17] Blavatsky and her heirs
took on the intellectual project of creating a bridge between ancient
mysteries and modern science: the substance of this bridge, was, not
surprisingly, the ether—the polymorphous history of which Blavatsky
traces for purposes of another cultural and philosophic unification,
not unlike that which the ether underwent in the Enlightenment.
But instead of erasing the occult history of the ether for the purposes
of creating a scientific paradigm, Blavatsky's holy science rescues
these lost histories. For her, the plurality of occulted or abandoned
ethereal systems is in no way incommensurable with future progress:

> There has been an infinite confusion of names to express one and
> the same thing.
> The chaos of the ancients; the Zoroastrian sacred fire, or the
> *Antusbyrum* of the Parsees; the Hermes-fire; the Elmes-fire of the
> ancient Germans; the lightning of Cybelè; the burning torch of

Apollo; the flame on the altar of Pan; the inextinguishable fire in
the temple on the Acropolis, and in that of Vesta; the fire-flame of
Pluto's helm; the brilliant sparks on the hats of the Dioscuri, on the
Gorgon head, the helm of Pallas, and the staff of Mercury; the πυρ
'ασβεοτον; the Egyptian Phtha, or Ra; the Grecian Zeus Cataibates
(the descending); the pentecostal fire-tongues; the burning bush of
Moses; the pillar of fire of the Exodus, and the "burning lamp" of
Abram; the eternal fire of the "bottomless pit"; the Delphic oracular
vapors; the Sidereal light of the Rosicrucians; the Akasa of the Hindu
adepts; the Astral light of Eliphas Levi; the nerve-aura and the fluid
of the magnetists; the od of Reichenbach; the fire-globe, or meteor-
cat of Babinet; the Psychod and ectenic force of Thury; the psychic
force of Sergeant Cox and Mr. Crookes; the atmospheric magnetism
of some naturalists; galvanism; and finally, electricity, are but various
names for many different manifestations, or effects of the same
mysterious, all-pervading cause—the Greek Archeus, or 'Αρχαιοσ....
What is [this] primordial Chaos but Æther? The modern Ether; not
such as is recognized by our scientists, but such as it was known to
the ancient philosophers, long before the time of Moses; Ether, with
all its mysterious and occult properties, containing in itself the germs
of universal creation; Ether, the celestial virgin, the spiritual mother
of every existing form and being, from whose bosom as soon as
"incubated" by the Divine Spirit, are called into existence Matter
and Life, Force and Action. Electricity, magnetism, heat, light, and
chemical action are so little understood even now that fresh acts are
constantly widening the range of our knowledge. Who knows where
ends the power of this protean giant—Ether; or whence its mysteri-
ous origin?—Who, we mean, that denies the spirit that works in it
and evolves out of it all visible forms?[18]

The ether acts like the purloined letter of not only the last three
hundred years of history but all human civilization; follow it, and
over time, as Blavatsky shows, one will find that what has always
been "in the air" is the hermetic key to the past and the future.[19]

But why exactly do the spirit mediums of the mid-nineteenth cen-
tury fall out of this grand catalog? Even though she defended them
publicly against the attacks of materialists, Blavatsky was a strong
opponent of spiritualism, perhaps because she saw what was happen-
ing to the women who were involved in it. Advances in paranormal
communication encouraged a form of "séance-mongering . . . dangerous
to all concerned and eventually ruinous to the medium."[20] Medium-
istic practices—even though they were important to the emerging

feminist and socialist movements in America—were widely held to be responsible for everything from general lassitude to alcoholism and insanity. These spirit guides that the mediums channeled were, Blavatsky claimed, immature and destructive and did not connect the mediums to the powers of the "celestial virgin" and "spiritual mother" that was the Ether.[21] Alvin Boyd Kuhn describes Blavatsky's position on voices from the dead:

> They were mostly, she said, the mere "shells" or wraiths of the dead, animated not by their former souls but by sprightly roving nature— spirits or elementals, if nothing worse,—such, for instance, as the lowest and most besotted type of human spirit that was held close to earth by fiendish sensuality or hate. There were plenty of these, she affirmed, in the lower astral plane watching for opportunities to vampirize negative human beings. The souls of average well-meaning or of saintly people are not within human reach in the séance. They have gone on into realms of higher purity, more etherealized being, and can not easily descend into the heavy atmosphere of the near-earth plane to give messages.[22]

Blavatsky would develop a philosophical spiritualism that, using yoga as its ideal, placed knowledge in the living body, not in a longing for, or sentimentalism about, the dead. Yoga's form of ethereal communication was not dependent on the objective manifestation of spirit emanations but resided in the maintenance and upkeep of these auratic presences in their proper bodily locations.

What Blavatsky was contending with, well before Walter Benjamin did, was quite literally the loss of aura. That is, to objectify spirits for public consumption, the medium had to exteriorize her aura (often relying on trick photography and other technological ruses). The aura, more commonly known in theosophical circles as "the etheric double," is a form of bodily envelope—the displacement or bilocation of which cannot be maintained for long periods, lest the physical body become mortified. As the twentieth-century theosophist A. E. Powell says of the medium's dangerous relation to this double:

> A medium is an abnormally organized person in whom dislocation of the etheric and dense bodies easily occurs. The Etheric Double, when extruded, largely supplies the physical basis for "materialisa-tions." . . . The condition of mediumship is, on the whole, dangerous, and fortunately comparatively rare: it gives rise to much nervous

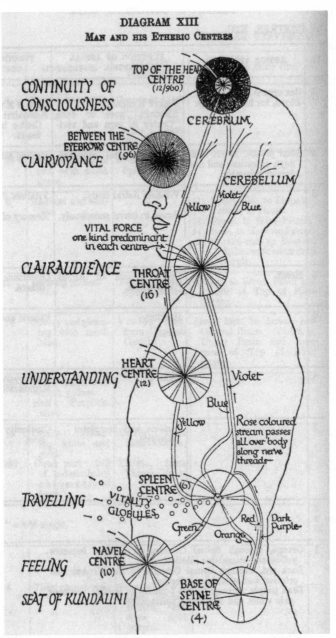

Ethereal centers in the body (1925). From A. E. Powell, *The Etheric Double: The Health Aura of Man*, copyright 1969. Reprinted with permission of Quest Books/The Theosophical Publishing House, Wheaton, Illinois. www.questbooks.net.

strain and disturbance. When the Etheric Double is extruded, the double itself is rent in twain; the whole of it could not be separated from the dense body without causing death, since the life-force, or Prâna, cannot circulate without the presence of etheric matter.[23]

In addition, the cultural desire to see this etheric double, in tandem with the birth of photography and cinema, was bound to produce a number of misrecognitions and misunderstandings, if not outright hucksterism.

In many ways, the theosophical anxiety about the exteriorized natural radiance of the body prefigures anxieties about film's potential to alienate humanity from its ethereal double on the screen, a process of bilocation that Benjamin says is productive of fascism: "Mankind['s] . . . self-alienation has reached such a degree that it can experience its own destruction as an aesthetic pleasure of the first order."[24] Yet the difference between theosophy and Benjamin (however much they share occult influences) is that, for the theosophists, this self-alienation was a total condition, of which the cinema was only the best evidence, and thus a good guru.[25] For Western students of yoga and theosophy, the popularization of the Hindu concept of Maya—or primal illusion—coincided with the first intellectual receptions of cinema in the 1890s, thus creating a link between the form of self-consciousness available through detached cinematic awareness and the superconscious discourses of the holy sciences.

This link was an uneasy but productive one, because while cinema was an object of spiritual pedagogy—providing a tangible example of primal spiritual alienation from wholeness and duration—it was also a vehicle of the industrial forces to which spiritualism was reacting. That is, while cinema was used to show how all consciousness was, in a sense, cinematic and self-alienating—thus opening up a spiritual perception of the illusory nature of time and space—cinema was also an extension of what Rabinbach calls "the crisis of all perceptual systems" that threatened to infinitely analyze all life processes into questions of quantity.[26] The theorists of the fourth dimension that this era produced—notably Henri Bergson, P. D. Ouspensky, and Charles Hinton—transformed early cinema into a philosophical tool for analyzing this crisis of perceptual systems and envisioned that it was both the barrier and aid to evolution onto higher planes of consciousness.

On the one hand, cinema was an emblem of the reigning materialism, but on the other, cinema was an example of what Bergson describes as "intellect and matter... progressively adapt[ing] themselves one to the other in order to attain at last a common form."[27]

More than anything else, the idea of the cinema would enliven the notion of time and present—if only by negative example—an alternative time-space of which the cinematic unraveling was only a deceptive analogue, what Deleuze calls a "false ally" in the conception of a lost absolute.[28] Rabinbach describes the nature of Bergson's uneasy alliance with early nonartistic, scientific cinema:

> For Bergson, chronophotography became a metaphor of our objective knowledge of consciousness. The memory of the eye is an invention, like time itself, an artificial image. We "bring back continuity" by producing stable images of bodies from multiple objects in time, a single image in space. In short, "The mechanism of our ordinary knowledge is of a cinematographical kind."[29]

Bergson's concept of duration or the *élan vital* is in conflict with this ordinary, cinematographic knowledge, which interrupts the true rhythm of things. In Deleuze's "Fourth Commentary on Bergson" he schematizes the Bergsonian notion of duration and its double in cinematographic time. These two flows, two time-images, consist of the "presents which pass" and the "pasts which are preserved," corresponding, respectively, to the real and the cinematographic, the true past and the recollection-image, absolute and relative, virtual and actual.[30] Cinematic time and its spiritual double work together, the spiritual "virtuality" generating the sense of captured frames and providing a space for their unfolding—since the imperceptible fourth dimension powers the cinematic becoming. But the distinction is not merely between reality and the technological perception of it, but rather between a virtual space and the material interface of human and cinematic perception potentiated by it.

"The material universe, the plane of immanence, is the *machine assemblage of movement-images*," Deleuze says in his "Second Commentary on Bergson," pointing to Bergson's notion of "the universe as cinema in itself, a metacinema."[31] Deleuze says that Bergson was "startlingly ahead of his time,"[32] but in many ways I would argue that Bergson is very much *of* his time, since this philosophy of cinema

without the cinema or beyond the cinema was a product of the collision of early film and yoga, both introduced to the West while Bergson was writing. Charles Hinton, theorist of the ether-phonograph and roughly Bergson's contemporary, also alludes to a primal cinematography when he conceives of

> some stupendous whole, wherein all that has ever come into being or will come co-exists, which passing slowly on, leaves in this flickering consciousness of ours, limited to a narrow space and a single moment, a tumultuous record of changes and vicissitudes that are but to us. Change and movement seem as if they were all that existed. But the appearance of them would be due merely to the momentary passing through our consciousness of ever existing realities.[33]

As in Bergson, a form of cinematographic perception plucks instants out of duration—as of film passing through the gate of the projector—while we are unable to perceive its stupendous whole. The flicker-effect of consciousness is just a ticking, a tickling, a tintinnabulation on the edge of our perception of a whole that is ethereal, virtual.

The Russian mathematical mystic P. D. Ouspensky, in his *Tertium Organum: A Key to the Enigmas of the World,* posits a similar durational whole, "a *Great Something,* possessing self-consciousness" with respect to which "we are the rays . . . conscious of ourselves but unconscious of the whole."[34] As well, he presents a cinematic metaphor for understanding how we are alienated from this whole:

> Imagine a man in an ordinary cinema theatre. Let us suppose that he knows nothing about the workings of a cinema, is ignorant of the existence of a projector *behind his back* and of small transparent pictures on a moving strip. Let us imagine that he wishes to *study* the cinema and starts by studying what he sees on the screen—taking notes and photographs, observing the sequence of pictures, calculating, constructing hypotheses, and so on.
> To what conclusions can he come?
> Obviously to none at all until he turns his back on the screen and begins to study the *causes of the appearance of pictures on the screen.* The causes are in the projector (i.e., in consciousness) and in the moving strips of pictures (our mental apparatus). It is they that should be studied if one wishes to understand the "cinema."[35]

Once this union is made between the consciousness in cinema and the consciousness of the eye, the cyborgian or yogic union facilitates

the knowledge that either eye misconceives reality—which is only accessible to the third eye in the fourth dimension through the medium of the fifth element by way of the sixth sense, unless, that is, you are a devotee of the seventh art.

Debunking the image production of the mediums on a more primal basis, theosophy, Bergson, and their followers would start to turn their investigations and desires beyond consciousness and the phenomenal world, if only to return to this world with a heightened sense of its *science*.[36] Film will be the philosophical toy that will get them there. Its elusive materiality enables a vision of all consciousness as false, of light as some kind of cinematic ruse; or rather, cinema gives neither a false nor a true image of life, but one that, like life, exists in and of itself, and that humans should experience in a detached way if they are to continue thought and creation.

This mystic inexpressibility that accrues to the notions of time and the virtual may seem strange to those who think that the fourth dimension is simply "time" and the "virtual" just another term for a heightened multidimensional cinematic dreamworld. The "virtual" in this context is not a reproduction of the actual, with data gloves and headsets enabling ever more immersive representations. Rather, the virtual, in the cosmologies of Bergson and Deleuze, is the elusive quality that enables representations, recollections, and 3-D dataspaces to *cohere*. For virtual art and its thriftier elder sibling, installation art, what this would imply is that the "art" is not necessarily about immersion in another space but rather somehow about an absolute space that activates all others. In this way, Peter Kubelka's *Arnulf Rainer* is more "virtual" than anything Jaron Lanier can cook up.

Not that many installation artists or their VR counterparts aren't attuned to this elusive slipperiness of what they are calling "real," "space," or "representation" as it interfaces with experience. In fact, given the emphasis on the durational experience of the viewer—whether it is in the ether space of telepresence or the embodied experience of more grounded artificial environments—the Bergsonian virtual may still be kicking around.[37] It is undoubtedly easier to return to the Bergsonian vital force in those spaces in which a deliberate evacuation of spectacular content allows for attention to rhythms less constrained by temporal, cinematic rationality. There are the

more "showy" artists of the ethereal underground, like Mariko Mori, who in the 3-D video portion of her installation *Nirvana* attempts to realign the Bergsonian or Zen *durée* with the attitudes and needs of a more poppified consciousness. Yet the rule, rather than the exception, to countering the bilocation of aura wrought by commercial media seems to be more along the lines of Ann Hamilton's *corpus*,[38] which, while grand in its scale, returns aura, breath, and time to its origins in the body and ritual—if only to launch from that locus to points unknown.

Hamilton's newest work, temporarily housed in an immense space at MASS MoCA, gives one the feeling that representation and thought come from a machine that is a little absurd, like the pneumatic devices arrayed on the ceiling that with every *pffftt* disengage a blank translucent sheet of paper that falls, with thousands of others, at regular intervals; or like the bullhorns descending and ascending on pulleys, randomly and one by one giving off snippets of dialogue, some of which is unintelligible because either the emitting horn is seventy-five yards away, at the top of the ceiling, or pressed down into the papered floor; or like the speakers fixed to the ends of long revolving spars, spinning dervish-style over your head, low enough to knock out a tall person. For all the folderol, the ultimate effect is a space that is intimate and meditative. In an odd way, the mechanical-pneumatic blurs into the natural, as walking through the installation's first room covered with the fallen and falling papers reminds one of nothing less than the unmediated charm of a walk in fall leaves. The difference, however, is that this "natural" event has been transformed into something ritualized in the space—an industrial space of a defunct factory transformed into museum transformed into a "corpus" communicating with the virtual.

The work of Bill Viola provides some of the most dramatic examples of such experimentation with the other virtual reality of ethereal duration. Bill Viola's installations *The Stopping Mind* (1991)[39] and *Room for St. John of the Cross* (1983)[40] dramatize the tensions between the time flows of the recollection image and the ineffable fourth dimension, between the distractions of the very media he uses and the true time that the body experiences but only rarely feels. His anti-sensational sensationalism consists in these pieces of placing intimate

interior monologues, reminiscent of both radio dramas and medita-
tion, in counterpoint to blurred images, wind rushing—representing
the chaos of the mind that is unstill, distracted, and deluded. *The
Stopping Mind* literally interrupts the (videographic) disruption of
consciousness with an intimate monologue that takes over when the
fast images and blasting sound suddenly and intermittently stop:

> Outside this there is nothing only blackness nothing but silence I
> can feel my body I see nothing there is no light there is no darkness
> only a silent voice ringing in the blackness I can feel my body there's
> nothing there's nothing there's no body no distance a voice ringing
> in the blackness I move my hand across my face there is nothing
> there is nothing no darkness no light silence is everywhere I imagine
> my body I imagine my body in this dark space everything's closing
> down everything's closing down around my body I am like a body
> underwater breathing through the opening of a straw I let that go
> I let that go.

As viewers of the installation, we align ourselves with this mono-
logue by standing under the speaker that focuses the monologue in
an exact and small point at the center of the room, or move in and
out of it, playing with our own states of awareness. *Room for St. John
of the Cross* is set up similarly. A handheld video image of a mountain
dominates the room, a pixelated fury accompanied by rushing wind
sounds, while inside a small cubicle a perfectly still image of the same
mountain appears on a small Japanese television set. In a somewhat
more invasive move than *The Stopping Mind* invites, one must stick
one's head into the chamber of the saint's martydom in order to align
oneself with the calmer sounds of his poetry read softly in Spanish. In
the work of Viola, you synchronize your own body with his pieces in
infinite ways, but the sync to which most pieces draw you is the sync
of mind with mind, interior consciousness to interior consciousness.
It may be an effect much like old-time radio drama's ability to com-
municate the interior, narrating monologue to the mind of the lis-
tener, but in this case, Viola has evacuated narrative, traditionally
representational content. He has replaced it, in *The Stopping Mind*,
with Beckettian monologue, and in *Room for St. John of the Cross* with
the murmurs of a mystic. With the channels clear, mind can link with

mind, granting temporary access to states to which technology has no access. The importance of sound to this experience is paramount. The powers of sound have always been known, but the philosophical and artistic ruptures described in this chapter—exacerbated by the popularization of the Hindu notion of Maya as the goddess of image and delusion—were further accompanied by the new scientific understanding that light constituted only an infinitesimal percent of the vibrational universe. In intellectual circles of the late nineteenth century and the early twentieth, the discovery of an electromagnetic spectrum opened up the possibility for strong alliances between the idea of superconsciousness and radio waves. Spirit communication, no longer valid when channeled through embodied mediums, again became plausible through Helmholtz's ether, the emanations of which were available to the supersenses; if the dead spoke at all, they spoke to our astral brains, and we could never perceive or remember it: "Through this wireless circuit [with supermundane entities] we sometimes drink in emanations, radiations, thought effluvia, so to speak, from the disembodied lives."[41] In many ways, these conceptualizations of a vibrational universe have nothing to do with actual radios and what one could hear over them. These vibrations went far beyond those picked up by the human ear. In fact, they were the ones that linked ear and eye in their synesthetic extremes, and, further, in the superconscious dissolution of all sensation. But the alliance of this immaterial substance of a vibrational universe and the new technology of the radio became irresistible. Thus, while film became a metaphor for the eye's self-alienation, radio was slowly becoming the reigning metaphor for transcendence, and the inspiration for the beginnings of a vibrational modernity to be found in the work of futurist, symbolist, and other early avant-garde movements.

While challenging objectivity by exploring the inner side of nature, the vibrational modernists, like the theosophists, espoused a form of new electromagnetic materialism that would not overthrow materialism but transform knowledge of the material into something more commensurable with human spiritual and scientific progress. For example, symbolist theater presented objects and characters on the stage

that were not meant to be interpreted as much as they were called on to exert their own occult radiances. Props, words, settings—in some ways dramatically inscrutable—were believed to be vibrational hieroglyphs, histrionic-semiotic radios playing out supersensory emanations that engaged in mystical harmonies. This radiance of "the thing itself" engendered a form of dramaturgical responsibility, since in the space of the theater, a forgetfulness of drama's mesmeric powers could lead to a spiritual Three Mile Island. The theater of Strindberg remains the period's most interesting case of an awareness of the responsibility toward organizing what Deleuze calls a "plane of immanence," an undulatory space in which there is no longer the possibility of history, or up or down, or time and space, or coherent meaning, but rather the organization of radiophonic sensations playing directly to an empty house: "The theatre full—and no one there! No one there—and the theatre full!"[42]

Love and Anarchy in the Floating World

Between Strindberg's early plays, which interrogated materialism and social inequity, and his later chamber plays, which tended in a mystical direction, was his pivotal *Dream Play*. In some ways, *Dream Play* marks the point where the interrogation of reality becomes so incisive that it punctures theatrical surfaces, detours through dream substance, and emerges on the brink of madness. "In it one finds," Artaud says, "both the inside and the outside of a thought.... In it the highest problems are represented, evoked in a form that is concrete as well as mysterious. It is truly the universality of the mind and of life whose magnetic shudder is offered us and grips us where we are most specifically and most productively human."[43] It is, in a way, the endgame of traditional theater for Strindberg—the whole arsenal of stage mechanics is used to collapse theater into a mesmeric assemblage. *Dream Play*'s seamless progression of spaces peel from one another to give a vision not of theatrical space-time, with coherent acts and atria, nor of its destruction per se, but of a theater straining to represent interspaces and imponderables.

Strindberg's dream theater, inaugurating the trajectory of avant-garde and traditional psychological theater to come, was conceived,

he says (in his introduction to *Dream Play*), in a world in which "time and space do not exist. Upon an insignificant background of real life events the imagination spins and weaves new patterns."[44] For many symbolist playwrights of the 1890s, this absence of absolute time and space—or correspondingly the disappearance of the communal ether—contributed to the feeling that "theater has been erased from the human brain."[45] For example, Leonid Andreyev's *Requiem* starts by making clear, as a sort of essential given before the staging directions, "It all takes place in the void."[46] His metatheater is one with rouged wooden puppets for spectators, undulating wraiths for actors, extras who are "absolutely identical human beings with gray faces devoid of expression, so alike as to be ludicrous"[47]—all subsidized by a masked, awful beneficiary, who may be Death itself. In a theater convinced of its own evacuation, the actor became unfamiliar, depersonalized, playing out insignificance through a congeries of empty gestures in homage to an as yet unformulated repetition compulsion.[48] Yet in contrast to some of his contemporaries, Strindberg's "new patterns" attempted to reclaim the lost aura of theatrical ritual through a reformation of theatrical space-time.

His aestheticization of the absolute took on three major, at times troubled, manifestations: creating plays without interruption so that no one could "escape the suggestive influence of the author-hypnotist";[49] thematizing the perversion of cosmography as a cautionary tale for ignoring the stars; and recognizing the mesmeric powers of his female actresses, who constantly exceeded his authorial control. Instead of embracing the meaninglessness of theatrical ritual in the face of lost unities, Strindberg would have to re-create the universe within the space of the theater as a prerequisite of theatrical meaning. This reinjection of meaning into the meaningless, and the attendant desire to see oneself as Creator, is a potentially mad undertaking, as implied in another dream play, *To Damascus I*:

STRANGER: What is it you are crocheting? . . .

LADY: It is . . . it is nothing but a piece of needlework. . . .

STRANGER: It looks like a network of knots and nerves, in which your thoughts are being woven. I imagine that is how the inside of your brain looks. . . . This is what I call living—yes, now I am living—in this very moment! And I can feel my ego swell—stretch

itself—become rarefied—and take on infinity.... I am everywhere; in the sea, which is my blood—in the mountain ridge, which is my skeleton—in the trees—in the flowers . . . and my head reaches up into the heavens—I can look out over the universe, which is I—and I sense the full power of the Creator within me—*I am the Creator!* I feel an urge to take the whole giant mass in my hand and knead it over into something more perfect, more lasting, more beautiful.[50]

However mad this desire may be to encompass and control Creation, it attests to the growing belief in the potential interiority of the super-conscious. That is, somewhere, "trapped in that labyrinth of fatty coils in [the] brain," among "those devious turns, those secret paths,"[51] or in the interstices of the needlework replicating these tortuous patterns, lie "my thoughts, my bright airy thoughts," and somewhere among them is the source of all Creation—nonrepresentation, Brahma or the absolute. Although going beyond the ether might entail for the imagination a voyage beyond the possible extensions of technological man, this voyage to the source is possible right here and right now, since the ether fills all interspace. While in *Dream Play* the main character, the daughter of Indra, literally descends from "the highest ether"—a realm penultimate to superconsciousness (even the Gods have limited access to ultimate reality)—the idea of a "higher realm" contradicts the placelessness of the absolute, a contradiction of which, as we will see, Strindberg was aware. From Poe to the theosophists, but also in the whole ascetic tradition of the *via negativa,* cosmography became imploded into something like the mind—otherworldly intellect; the theater of the mind had the potential to reach this monistic source of all creation, abolishing all contradiction at the oceanic limit of consciousness. Charles W. Leadbeater, coauthor with Annie Besant of *Thought-Forms,* describes elemental kingdoms in the "Solar Logos," which exemplifies the reigning metaphysic in intellectual circles at the turn of the century. His revision of cosmography does not strictly move from low to high but moves from base matter to physical aether to the sea of astral matter and then finally to a mental ocean.[52]

Dream Play is the first full realization of this latent project in Strindberg's work to reestablish theater in this no-place between base matter and mental ocean. Its action plays out midway between the

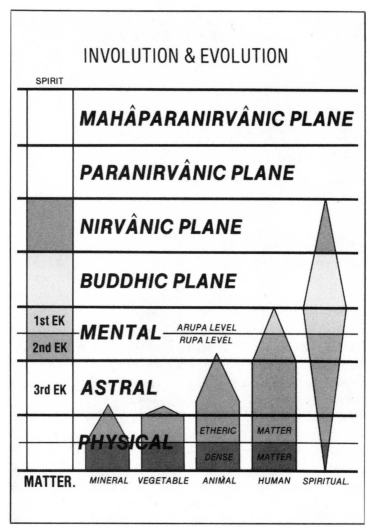

Involution and evolution (1902). From Charles W. Leadbeater, *Man Visible and Invisible: Examples of Different Types of Men as Seen by Means of Trained Clairvoyance*, copyright 2000. Reprinted with permission of Quest Books/ The Theosophical Publishing House, Wheaton, Illinois. www.questbooks.net.

meaninglessness of daily life and the possibility of meaning guaranteed by a Neoplatonic superstructure. On the one hand, meaningless quotidian toil goes on ceaselessly under an atmosphere polluted by the earth's lower spheres; the characters live in a "globe of dust" in which there is a constant lack of air.[53] The earthbound are complicit with this primal suffocation:

> KRISTINE: I'm pasting, I'm pasting!
>
> DAUGHTER: You're cutting off all the air. I'm suffocating...
>
> KRISTINE: There's only one little crack left.
>
> DAUGHTER: Let in some air! I can't breathe!
>
> KRISTINE: I'm pasting, I'm pasting!
>
> LAWYER: That's right, Kristine. Heat costs money.
>
> DAUGHTER: Oh, it's as if you're pasting my mouth shut![54]

Ritual has turned to obsession without "a new spiritual order given to the ordinary objects and things of life."[55] What is the breath when it lacks a ritualistic meaning? It may as well be suffocation, which explains the hysteria of the passage. It's not as if the daughter is without air, but she is slowly sundered from air's nourishing enchanted double. One does not cut off oxygen by obsessively pasting cracks in the wall, but one may be doing much worse. In this scene, any human potential for realizing mystical energy, known in different contexts as Prâna or the ethereal double, is given over to another kind of energy (Kraft) that is powered by "lower" forms of perception ("Heat costs money"). As I have shown, the Kraft paradigm guaranteed a mode of production that would replace the ether as an organizing principle. It is, as Marx says, the "specific kind of production which predominates over the rest, whose relations thus assign rank and influence to the others. It is a general illumination which bathes all the other colours and modifies their particularity. It is a particular ether which determines the specific gravity of every being which has materialized within it."[56]

Strindberg was always keenly aware of this assignment of rank stemming from a perversion of cosmic order, a usurping of a more just ether. As early as his 1888 play Miss Julie—in which a forgetfulness of rank, under the planetary influences of midsummer's night, causes tragedy—there is a sense of lost mystical harmony. Diana, the god-

dess of the moon, is the name of Julie's dog, while Julie—the bitch goddess—makes her fiancé do a dog's trick. Strindberg's message would seem to be a conservative, even hysterical, reaction to the power of women—as indeed it sometimes is. However, his insight is that these role reversals and power transferences are meaningless without a change in the "particular ether which determines the specific gravity of every being which has materialized within it." Instead and without this change, the world has become a strange body. In *Miss Julie* a failed aristocrat who gives orders from above through a primitive intercommunication device guarantees meaning. Between his empty boots waiting to be shined and the bell of the intercom that rings is the low and the high, the alpha and the omega, of their cosmos—a body without organs in which Julie and Jean are a part. The play exposes this idiosyncratic mesmeric system from which there is no escape.[57]

In *Dream Play*, an avatar from outside space and time perceives this world of rank. Through her perspective, the relative spaces of the play do not structure the tragic and ineluctable; rather, they appear absurd and contingent. (There is even the possibility that all spaces are the same: "I was thinking that this door resembles..." "No, it doesn't! Absolutely not!")[58] The avatar—the daughter of Indra—holds out the possibility of meaningful theatrical communication through a direct wireless connection to the absolute: "Child, human thought needs no wires to travel on.... The prayers of the faithful penetrate all worlds.... It's definitely not the Tower of Babel. If you want to storm heaven, do it with your prayers!"[59] Having herself penetrated impossible worlds, she inspires the earthbound to do the same in the space of the theater, which is "not the Tower of Babel" and hence holds out some remaining possibility for speaking the lost language of the godhead. Attempts to piece together this lost language and establish a dialogue between the poet with the ether, appear, as I have shown, in the astral communiqués of Poe, but also are a general symbolist theme exploring the precarious purity of Platonic love and the potential crisis of the august concept of the muse. For example, in Alexander Blok's *The Stranger*, the phantasmic poet figure Azure seduces an astral woman to earth:

AZURE: Like dreams the centuries have passed.
I waited long for you on earth.

STRANGER: Like flashes centuries have passed.
A star, I skimmed from space to space.

AZURE: From on your heights you gleamed
Upon my azure cloak.

STRANGER: You saw your image in my eyes.
At heaven do you often peer?

AZURE: I cannot raise another glance;
My gaze is bound by you, a meteor.

STRANGER: Can you not tell me earth-born words?
Why all in azure are you clad?

AZURE: Too long at heaven have I looked:
That's why I've eyes and cloak of azure.

STRANGER: Who are you?

AZURE: A poet.

STRANGER: Singing what song?

AZURE: Always in your name.

STRANGER: Have you been waiting long?

AZURE: Many a century.

STRANGER: Are you dead or alive?

AZURE: I don't know.

STRANGER: Are you young?

AZURE: Beauty I have.

STRANGER: A virgin falling star.
Longs for earth-born speech.

AZURE: The words I know touch mysteries,
Ever solemn is my speech.

STRANGER: You know my name?

AZURE: I know it not—and better not to know.

STRANGER: You see my eyes?

AZURE: I see your eyes. Like stars they are.

STRANGER: My shapely figure do you see?

AZURE: Yes. Dazzling you are. (*Earth-born passion begins to awaken in Her voice.*)

STRANGER: Do you long to hold me close?

AZURE: I dare not touch your hand.

STRANGER: You may touch my lips.[60]

This seduction that Azure initiates causes the astral woman to materialize on earth, thus robbing the real poet and the astronomer of the vision that powered their creativity and sinking all in dreary materialism. While the psychosexual aspects of these dialogues with a possibly absent ether will be touched on later, at this point I want to note their status as a typical trope, of which the daughter of Indra in *Dream Play* is an exemplary example. The purpose of all these figures within the theosophical context of the time was to train the earthbound to realize a lost impulse, what Bachelard calls the *"instinct for lightness* ... one of the most profound instincts in life."[61] This training is not even necessarily spiritual, even though the language of religion is used. Rather, it is intimately tied to a Bergsonian ideal of human progress. As Bachelard says:

> The realism of psychic becoming needs ethereal lessons. It even seems that, without aerial discipline, without apprenticeship in lightness, the human psyche cannot evolve. At least, without aerial evolution, the human psyche understands only the evolution that creates a past. Establishing a future always requires the values of flight.[62]

In *Dream Play*, the poet, who "understands best how to live," "hovering on ... wings above the world" only to "plunge to earth from time to time, but just to brush against it, not be trapped by it," is presented as the best student of these ethereal lessons.[63] His relation to the daughter is the Platonic version of the relation of Jean to Julie in *Miss Julie*: the man wants to learn to experience the heights, and the woman wants to know more about the depths of human experience. In *Dream Play*, these lessons undergo the complications inherent in the dream, for example, when the daughter suddenly realizes she has become too earthly:

> My thoughts no longer soar: they have clay on their wings, earth on their feet ... and I—(*lifting her arms*)—feel myself sinking, sinking. ...
> Help me, Father, Lord of Heaven! (*silence*) I can't hear his answers any more! The ether no longer carries the sound from his lips to the shell of my ear. ... The silver thread has snapped. ... Alas! I am earthbound![64]

The problem of the poet is also the earth. Bereft of radio towers and launchpads, his wish to "find words luminous, pure and airy enough to rise from the earth" might never make it past research and development. However, his intent is not to launch thought-forms into outer space but to "translate our lament into language the Immortal One understands."[65] Again, the idea of an oceanic mind appears, interiorizing the romantic discourse of heights and depths with an image of an interior immense radio—offering readily accessible, but by no means easy, communication to the Godhead. Strindberg uses the image of the shell—the sound of which resembles the sea but is actually the sound of your own body—to dramatize the repressed or occulted nondifference between interior and exterior, human and divine, states of consciousness:

> DAUGHTER: Didn't you ever as a child hold a seashell to your ear and listen . . . listen to the bussing of your heart's blood, the murmur of thoughts in your brain, the bursting of thousands of tiny threads in the fabric of your body. . . These things you could hear in a little shell, imagine what you'll hear in one this big!
>
> POET (listening): I hear nothing but the sighing of the wind . . .
>
> DAUGHTER: Then I'll interpret it for you! Listen![66]

Both prayer—the activity of the poet who sings "a petition from mankind to the ruler of the world, drawn up by a dreamer"[67]—and translation or interpretation (the activity of the daughter) involve a sort of degradation of original oceanic substance into less threatening forms. It is an analytic process, as in the relation of dream-work to dream-thought. Translation and prayer, imploding toward a similar source, inevitably fail to reach it.

But this quixotic attempt to touch the elusive origin of language itself is powered—Strindberg has said it outright—by love. The instinct for love is constantly at odds with Strindberg's accompanying desire to destroy the theater altogether, a manic attitude that mirrors his relations to women. In a diary entry written while writing *Dream Play*, Strindberg says:

> Am reading about Indian religions.
> The whole world is but a semblance (= Humbug or relative

emptiness). The primary Divine Power (Maham-Atma, Brama), allowed itself to be seduced by Maya, or the Impulse of Procreation. Thus the Divine Primary Element sinned against itself. (Love is sin, therefore the pangs of love are the greatest of all hells.) The world has come into existence only through Sin,—if in fact it exists at all—for it is really only a dream picture. (Consequently my *Dream Play* is a picture of life), a phantom and the ascetic's allotted task is to destroy it. But this task conflicts with the love impulse, and the sum total of it all is a ceaseless wavering between sensual orgies and the anguish of repentance.

This would seem to be the key to the riddle of the world.[68]

The riddle of existence, confounding the conflicting energies of creation and destruction, is also, for Strindberg, the riddle of man's relationship to woman. While he talks of a Divine Primary Element (the ether), he is really talking about some presexual, "uncorrupted" state of harmony between the sexes, the "celestial virginity" to which Blavatsky alluded. The actual passage in the play, inspired by this journal entry, makes it clear that Maya is "the world mother,"[69] while "Brahman, the divine primal force, [that] allowed itself to be seduced by Maya," remains an "it," not a sexual being.[70] The relation of some absolute "it" girl to real women is drawn in more pained detail in *From an Occult Diary*, which is comprised of journal entries written while Strindberg was married to, directing, and finally divorcing his wife and leading lady Harriet Bosse: "I feel that my spirit is bound down to the lower spheres of activity where my wife now operates. . . . It was my soul that loved this woman and the brutalities of marriage disgusted me. For that matter, I have never really been able to understand what the not very elegant act of procreation has to do with love for a beautiful female soul."[71] At times he encounters this beautiful soul, through vague telepathic experiences (documented in the diaries) and in the theater where he has her play the preternaturally sensitive Elenora of *Easter* and the goddess-messiah of *Dream Play*.[72] This psychosexual dynamic is nothing new—in some ways just a northern European manifestation of the Madonna-whore complex. However, this convergence of anxieties about time and space and anxieties about the nature of woman produces a new mythology of the ethereal woman.

Mariko Mori, *Pure Land* (1996–98). From the Nirvana series. Courtesy of the artist and Deitch Projects.

Heavenly Bodies and "Girl Power"

In the final scene of Walter Lang's *The Blue Bird*, a Shirley Temple vehicle of 1940, which flopped in trying to emulate *The Wizard of Oz*, Temple is brought to the halls of Time himself, where the future is about to unfold.[73] There, unborn boys and girls in blue and pink togas frolic in a neoclassical agora. But all is not well in this heaven, for while some ingenues strive to be born, even before their time, materialization in the present is undoubtedly traumatic for some. An unborn Abraham Lincoln ponders his melancholy fate, and two lovers in this eternal realm rebel against being born, since they will not be able to love each other in the real world. Yet despite the presence of these specters of sex, race, age, and violence, this version of the absolute grants us a theoretical respite, a world without brooding, a world in which we know, but all the same.... Forget Einsteinian space-time. Here is a cosmos of love, in which a ship full of singing children is drawn to earth by the voices of their mothers—a vision preferable to more tortured notions of the terrible void. As love beckons the future into the present, across bubblegum ethers, we are assured that regardless of the pains of earthly materialization, we can have the absolute whenever we want it. Whatever our setbacks, the adventure of life is to get back to this source of all creation.

Michael Atkinson has invented the generic term *film enchanté* for such children's films, which he describes as "blithely metaphysical . . . commix[ing] the Christian, Freudian, mythic, transcendental, pagan, and occult however they see fit . . . fabricat[ing] their holy systems from scratch."[74] For him, films such as *The Blue Bird* channel sexual impulses and anxieties into a baroque, pre-Oedipal cosmos. Of them, he says: "The unmappable, terrifying country of sexuality is itself converted into an abstracted, cosmic mystery, a romantic matter upon which angels and moons ponder, and which can, seemingly for mystic reasons all its own, penetrate the veil between life and death."[75] For *film enchanté*, the metaphysical powers of women penetrate this veil, although one wonders why they can only activate their powers in a fantastical space-time of innocence and purity, or in the guise of the maternal. In *The Blue Bird*, this image of the maternal is exemplified by the character Light, who ends the film with a bit of Saturday matinee pantheism, assuring the children of her ubiquity in every bit of moonlight and every good thought. As adults we might have a hard time taking Light seriously, as she now seems to us nothing less than some Busby Berkeley doyenne in a Wagnerian getup. But while we can see in her sunny countenance the signs of life and sex and history, to children she is heaven, beauty, and love incarnate. What children lack in experience, they gain in the pure energy of belief, while we make do with cheap imitations, fleeting glimpses, and perhaps, along the way, forget heaven entirely.

Or do we? For it seems these films have a double address, both to children and for the adults who would wish to return to the energetic belief of children, knowingly to translate sexual anxiety into a mappable cosmos. Spiritual traditions bricolaged and surrounded in perfumed whiffs of mysticism, powered by sexual fascination, and laced with symbolist kitsch emanate especially and prolifically from Japan in the 1990s. While Atkinson attributes the popularity of bricolaged ethers to nostalgia for childhood and a desire to refigure the riddle of sexual difference into something more palatable, I would add that, in the Japanese scene, this nostalgia for the presexual and presocial is combined with nostalgia for a pre-Einsteinian form of space-time. It is this desire to turn the technological clock back, combined with an

active struggle with sexual energy, that links *film enchanté* to theosophy and very popular, theosophically inspired Japanese science fiction.

But first, to round out the ethereal narrative, let me explain that, after twenty years in which the fate of what Mach called "the conceptual monstrosity of absolute space" hung in the balance,[76] Einstein stepped forward and in 1905 proffered his more elegant formulations of space-time and relativity to rectify the quandaries of the Michelson-Morley experiments. Einstein's theory was in some respects based not in mathematics and physics but on a brilliant semantic shift, demolishing, with the change of a word, the cathedral of "the ether" and re-erecting in its place the edgy, International Style "space-time." Beyond its cultural and semiotic value, however, Einstein's famous three papers of 1905 (which completed the vision of the mechanical universe inaugurated by Newton while demolishing that vision by a subtle insight into the photoelectric effect that would lead the way to quantum physics and television) would eventually allow for atom bombs. This nostalgia for ether science and ether culture, then, is a longing both for the scientific and philosophical polysemy of the ether in the pre-Einsteinian period—an era of innocence when Mendeleev had considered putting the fifth element on his periodic table—and for a time when the twentieth century's most terrible machine could not even be thought.

Indeed, for mystically inspired science fiction—the most notable genre of which is Japanese anime—the explosion of the atom bomb acts as a kind of "primal scene." It is a horror that precedes all story lines, very much like the horror in Freudian sexual narratives that sets the difference between the sexes and desire on their way. Even in the seemingly well-adjusted, preapocalyptic anime of Miyazaki's *My Neighbor Totoro*, the image of the atom bomb emerges almost inexplicably from a child's garden. That is, during a dream sequence, the seeds that the girls had planted rapidly sprout while they sleep and soon transform into a towering column of vegetation that roars skyward and then mushrooms out into a lush canopy.[77] The comparison with the atomic mushroom cloud is unavoidable, and it is as if Miyazaki is intentionally playing on the Freudian idea of condensation; the image of the A-bomb invades, however covertly, not only the dream of the girls but also Miyazaki's own desire to create the retro-futurist

idylls of *Kiki's Delivery Service* (a coming-of-age story of a witch who lives in a world where technology has not progressed past blimps and black-and-white television)[78] and *Princess Mononoke* (an ecologically conscious medieval action adventure).[79] Combine this centrality of the bomb—more explicit in cyberpunk anime—with a tendency to depict the powerful worlds of teenagers and children (in a genre that is many times labeled "not appropriate for children" because of its violence and sexuality), and you get a genre of multiple perversions, depicting a postapocalyptic, adult world attempting to save itself by depending on preatomic science and plucky teenagers.[80]

The technologically savvy but flirtatious forces of the genre's "pretty soldiers" constantly ward off total destruction and sexual knowledge. This genre's female heroes—most times more effective than their male counterparts—are continually caught in states of undress by both their male companions and the viewers, never revealing quite everything, and responding with horror and mortification when they are caught up in a sexual gaze. The "pretty soldiers" of *Sailor Moon*,[81] who are aligned with the planets (Sailors Moon, Venus, Mercury, Mars, and Jupiter), outright force the pun on heavenly bodies, since they actually seem to grow more curvaceous and less childlike when

Schoolgirl as warrior: Hideaki Anno's *Neon Genesis Evangelion: The End of Evangelion* (1997).

they use the powers of their respective planets. Citing the work of
Mary Grigsby on *Sailor Moon*, Victoria Newsom writes that its "girl
power" message intersects with an address to male desire, exacer-
bated by the Japanese trend of fetishizing the schoolgirl outfit: "The
body in the clothing is mature enough to denote sexuality beyond
14-year old aptitude. She is half-child and half woman, and as such
appeals to the male as object and the female as a means of identification
with the self."[82] She may also be part ethereal, an aspect of these
heroes I will describe later, one that may support the logic of the
male fetish but also promises its potential dissolution. Turning around
this equation somewhat, the American-made, anime-influenced *Aeon
Flux* foregrounds complex "perversions" as crucial to the genre,[83] but
this series aestheticizes both female and male bodies (for example,
that of the Aryan president who to distract attention from a scandal
disrobes in front of television cameras and declares "the New Open-
ness"), as well as provides a locus for third-wave feminist notions of
sexual power—albeit, perhaps, from the male fantasy viewpoint. For
Aeon Flux, saving the world becomes an opportunity for sex without
attachments, and, as in the more explicitly pornographic anime
Return of the Overfiend (from the *Urotsukidoji* series), mystical battles
between good and evil (the distinction between which always threat-
ens to fall apart in these texts) have an innate link to sexual drives.[84]

In the beginning of the twenty-six-episode electromagnetic soap
opera *Neon Genesis Evangelion*, Captain Misato Katsuragi (age twenty-
nine) volunteers to take in the child pilot Shinji Ikari (age fourteen)
rather than have him live in anonymous military dormitories.[85] Mi-
sato is in no way a mother figure—her refrigerator holds only beer
and junk food, the empty containers of which fill the apartment, and
in a later episode she gladly takes on a military mission that will
undoubtedly leave her unable to bear healthy children. Her charac-
ter vacillates between hip guardian and possible sexual object, a vac-
illation and ambiguity she encourages. During their first conversation
in the apartment, Misato says, "This is your apartment. Feel free to
take advantage of anything here, except of course me." Shinji replies,
"Yes ma'am," and Misato, clearly outraged at his apathy, both sexual
and social, yells at him, saying, "You're a boy, act like one!"[86] Her
"fan service"—the innumerable shots of Misato's body, framed for

sexual titillation—is directed toward the audience but is also meant to ratchet up the sexual energies that motivate all the characters, regardless of its appropriateness. (Given that the relationship between Misato and Shinji is the least bizarre of the Oedipal tangles in *Neon Genesis Evangelion*, it would seem that the notion of sexual appropriateness goes out the window when the apocalypse is afoot.) Yet in episode 8, when an old flame and colleague of Misato asks Shinji in public if she is "still so wild in bed," Misato and her entire entourage are paralyzed by shame. In the same episode, the newest pilot, Asuka, asks, "Why do all boys have to be such a bunch of perverted jerks?" Is this Strindberg, turned on his head, being spoken by a red-haired warrior with a flair for fashion and a knowledge of ballistics? While sexual energy courses through these texts, their narratives tend to deflect and sublimate it into other realms. As with Strindberg, in Japanimation, anxieties concerning sexual nature are accompanied by an idealization of the preternatural powers that accrue to the virgin.[87]

While these female heroes are subject to the inalienable perversion of boys in more "domestic" contexts—where the specter of motherhood lurks—their work as warriors exposes another kind of body power that functions in terms not of sex or even the body per se but of the Ethereal Double. In *Neon Genesis Evangelion*, viewers get to play peekaboo only in the less dramatic scenes emanating from the stopgap domestic world these warriors have created for themselves. It is as if the series is training the sexual gaze to become a spiritual one, as the sight of almost naked bodies in more "casual" scenes baits viewers to undergo a rigorous examination of ultimate cosmic nakedness and power, the mystical drama that unfolds in the more "serious" scenes. But the perception of the absolute itself in these texts partakes of a striptease, spiritual, no doubt, but perhaps less like the Eastern tradition's logic of "not this," and more attuned to the endless deferral of commodity fetishism. While the ether has always stood in for the ultimate, in the face of primal sexual traumas and atomic destruction, the ether has become a fetish object. No longer the substance that guarantees the charm with which the fetish is endowed (since something we may call "ethereal" empowers the insignificant material object to become the fetish in Freudian and Marxist narratives), it is the object itself, thus commensurable to fantasy—something with

Schoolgirl as apocalyptic demiurge: Hideaki Anno's *Neon Genesis
Evangelion: The End of Evangelion* (1997).

only a little otherness. Japanimation, like *film enchanté*, in conceptu-
alizing a world without pain, anesthetizes the viewer from the past by
way of this ethereal fetish. This etherization happens somewhat liter-
ally at the end of each episode of *Neon Genesis Evangelion* and *Tank
Police*,[88] when lounge music is played during the credits as if to in-
duce forgetfulness of toxic clouds, killer viruses, and other endgame
scenarios. Like sex in these texts, the ether-as-anesthetic-fetish and
ether-as-body-double are both held out as lures, fantastic immaterial-
ities that are accessible, even triggerable features of these sci-fi
topographies, in which theosophical mysticism has become stylish
phantasmagoria.

Picture the postapocalypse visions of anime, and they reveal a world
in which cities and spaceships are powered no longer by nuclear or
electric generators but by psychic power. Battles are fought not over
material resources but over mental energies. Imagine the machine
that records auras and analyzes their output in *Akira*,[89] or the radiant
bodies of countless animation heroes, most notably those of *Sailor
Moon* who wage a war of auratic energy with the forces of the Nega-
verse.[90] The ghost ships of *Maps*[91] and the Evangelions of *Neon Gene-
sis* are crafts powered by inexplicable bioenergy and are second skins
of the pilot. What is most interesting is the way energy is formulated
in terms of bodily, auratic emanations—an antinuclear, ecological

version of *Kraft*. At times, the exteriorization of the aura acts as a weapon, as a hero can muster her concentration and send out an ectoplasmic blast toward a worthy target, but its use is limited to the body's resources and is constrained, in the most interesting examples of the genre, as in the body power narratives of kung fu, by an intuitive sense of responsibility. In Luc Besson's *The Fifth Element*,[92] which portrays the fifth element or supreme being as supermodel Milla Jovovich, we find that the ultimate weapon is love. In the film's last moments, her love blasts upward from her heart chakra into the atmosphere, stopping a demon-powered asteroid from destroying the earth. However, before she uses her own energy, she must have a sense that the world is indeed worth saving. In *Neon Genesis Evangelion*, the EVAs, towering Transformer-like robots powered by the hearts of pilot-messiahs, can only run for about five minutes at a time. In that brief period, in another hyperbole of the possibilities of the heart, the EVAs can send out an Absolute Terror Field to destroy mysterious angels that threaten mass destruction.

I am hesistant to call these imagined forces merely disavowals of sexual and material reality. These texts that fetishize the ethereal are all fumbling to understand something important about secular life and human relations; they allow and encourage the thought that mysticism might very well be merely masquerade. As perhaps dramatized by the video installation art and photographs of Mariko Mori, mystical roles have become empty signifiers. The fact that the Evangelions of *Neon Genesis* fight "angels" opens up complex identifications that have nothing to do with mysticism or religion. The angels look, for all intents and purposes, like monsters, while the Evangelions are nothing but excrescences of a military machine by a more holy name (harkening back to the dark masquerade of Oppenheimer, who, when exploding the atom bomb, took on a role from an ancient Indian text when he uttered "I am become death, shatterer of worlds"). In the series *Maps*, "the mystic ones" are evil, while the nomads are good. In an episode of *Aeon Flux*, the demiurge of the absolute must be assassinated at all costs by a hero who could be described as Dostoyevsky's Grand Inquisitor as female ninja with torpedo-shaped breasts in S-M gear. Within this ether haze of sex and mysticism, virtual fetishes—visual toys that have distilled the ultimate into the

Love as a weapon: Luc Besson's *The Fifth Element* (1997).

aesthetic—crowd out a sense of virtual space. But as good and evil, the absolute and the tawdry, destruction and resurrection, Kabbalah, Zen, Hinduism, and Christianity are wildly mobilized, destroyed, and reinvented, there is a feeling of something that makes these speedy cross-cultural transmutations possible—not easily represented, but perhaps intimately known.

Part II

The Lovely Intangibles

Someday you're going to find out that your way of facing this realistic world just doesn't work. And when you do, don't overlook those lovely intangibles. . . . You'll discover they're the only things that are worthwhile.

—*Miracle on 34th Street*

3

Radio, Ether, and the Avant-Garde

God, the eternally Continuous, has been deposed, and continuous radio-noise has been installed in His place. And the fact that although it is a discovery of man it nevertheless seems to be independent of him, gives it an appearance of twilight mysticism.

—Max Picard, *The World of Silence*

Once the United States entered the war, the American press . . . began to view the ether less as an exciting, mysterious realm or as a resource whose use had to be regulated to ensure safety at sea. Now it was clear that the ether constituted national territory, in which Americans had political and international rights and prerogatives, and which had to be defended as staunchly as the shores.

—Susan Douglas, *Inventing American Broadcasting, 1899–1922*

Ether on Earth

In the intimate parlors and other mystical enclaves of the nineteenth century, mathematical philosophers and poet-madmen tortured distinctions between ether and not-ether, in an attempt to winnow out

frivolous immaterialities of the new electric regime from those intangibles that have, since ancient times, enclosed the secrets of angels and the empyrean. For example, we saw that Poe, and later the theosophists, distinguishing between scientifically knowable ethers, such as the luminiferous, and those unknowable and inaccessible to standard human thought, variously charted the infinitely subtle gradations of rarefied matter for the purposes of cosmic understanding. The beginning of the twentieth century, however, in sharp contrast to these endeavors, was marked by a conceptualization of ether as property. The military and the U.S. government would make the gradations of the ether their business, in 1906, with the first allocation of standardized wavelengths in the electromagnetic spectrum,[1] and then, in 1912, with the first Radio Act. Ether mapping, fast becoming a meaningless philosophical exercise, was to become a partly legalistic phenomenon, undertaken to ward off the meaninglessness that would occur if the atmosphere were to be crowded indiscriminately with radio signals.

Radio frequency standardization, first occurring in a cultural milieu that facilitated the debunking of ether and absolute space and time by Einstein (1905) and Michelson and Morley (1887), was bound to diminish not only air noise but also the supernatural, intellectual excesses that had been organized for ethereal understanding at century's end. The ether was to become a more popular political concern, since clearing up the channels of communication was accompanied first by radio's militarization, and inevitably its professionalization and commercialization. All of this would eventually (and definitively with the Radio Act of 1927) muscle out the generation of ham operators and ersatz Teslas who had tinkered together sets and forged tenuous networks of pranksters and protohackers.[2] These first radio operators were an obstacle to the homogenization of the airwaves for the purposes of commerce, safety, and national security. In some ways, this policed ether was as metaphysical as ever, establishing transmissional hierarchies in the maintenance and upkeep of a substance beyond knowing. An enforced ethereal unity blocked the kind of diverse communications that radio technology promised on a global scale, while ensuring ideological interpretations of what would be considered noise or non-sense in the extended electric sensorium.

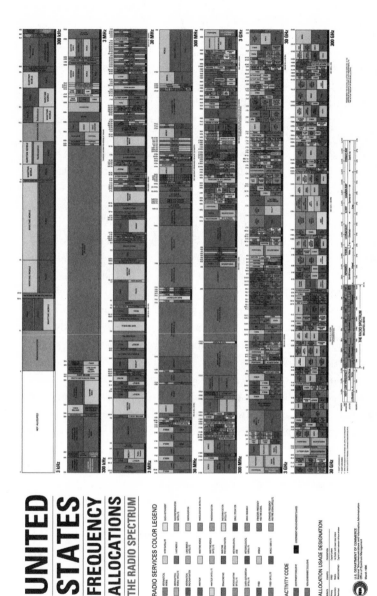

Radio spectrum frequency allocation chart, U.S. Department of Commerce, National Telecommunications and Information Administration, Office of Spectrum Management, March 1996.

The question of the ether as "property" would, then, devolve less on its status as actual real estate, and more on the notions of *proper* and *improper* transmission. The gradual shutdown of amateur operations signified the end of democratic noise and the reinstitution of the noisy abstraction of the ether.

For the press, now and again in the first thirty years of radio, the ether may have acted, as did cyberspace later, as an aesthetic backdrop or even commercial buzzword for a space that had yet to be created. But what is more interesting is that, as with cyberspace, this new ether would inevitably be, despite regulations, a place of code adrift, of piracy, and of polysemy—the semiotic fallout of language saturating the airwaves, the virtual undoing of the press. The ethereal avant-garde—for whom the radio became both a metaphor of modern consciousness and a tool of radiophonic artwork—welcomed the possibility of noise, misprision, and appropriation that would always be in conflict with the standardization of the radio waves. Taking form in futurist and Dadaist manifestos and performances, as well as in works of classic modernist literature, the radio eye saw the substance that was inaudible or overaudible even in the most common broadcast event. When Marconi broadcast the first transatlantic radio message in 1901, he had decided, according to Douglas, "to use the letter s because it was easy to send and to decipher."[3] We can immediately discern a split between this instrumental, controlled use of language and the avant-garde conflict with the project of clear transmission upon first opening Joyce's modernist epic *Ulysses*. There is Marconi's S, large and black, filling the whole page, the beginning of the radiophonic universe, the beginning of the noise of the world. Floating in the overcoded space of modern consciousness, Joyce's S amplifies the noise of all language by convolving the novel with the radio. This S, the sizzle of static or a sine wave turned on its side, when bodied forth by the words "Stately, plump" that begin the novel, pits the unruly radio wavelength against the august and well-fed unity of both the novel and the idea of nation, ensuring "stately" communication.[4] The S of Joyce and Marconi turns the Bastille of language back into a democratic Babel of what Marinetti called "words in freedom." It is not the full O of "Once upon a time..." but the sigil of some future tense.

The futurists, no matter how forward looking in their embrace of radio as an art form, nevertheless maintained an alliance to the latent spiritual significance of radio, just as they did to the more mystical avant-gardism of their contemporaries. Many Italian futurists, including Marinetti, had affiliated themselves earlier with the symbolists, whose mysticism and internationalism, allied to an exploration of universal meaning in a fragmented cosmos, remain in futurism, albeit with different valences. Similarly, the Russian futurists overlapped with the suprematists, who sought a visual analogue to four-dimensionality. In Italy, futurist Prampolini's theater could even be considered Mesmeric, albeit strangely proto-Brechtian: his unrealized idea of a "Magnetic Theater," with neither actor nor audience, was to be a materialization of pure space; he sought to transform traditional actors into "vibrant, luminous forms . . . actor-gases. . . . By shrill whistles and strange noises these actor-gases will be able to give the unusual significations of theatrical interpretations quite well. . . . These exhilarant, explosive gases will fill the audience with joy or terror, and the audience will perhaps become an actor itself as well."[5] For Prampolini,

the theatre, understood in its purest expression, is in fact a center
of *revelation of mysteries* . . . beyond human appearance. . . . The
appearance of the human element on the *stage* shatters the mystery
of the beyond that must reign in the theatre, the temple of spiritual
abstraction.
Space is the metaphysical aureole of the environment.
Environment is the spiritual projection of human actions.[6]

This inhuman absolute found its technological analogue in radio space. As is well known, the futurists were the first to explore radio as an artistic form or utopian technology. The Russian futurist Velimir Khlebnikov, before his death in 1921, could claim that

radio has solved a problem that the church itself was unable to
solve . . . [t]he problem of celebrating the communion of humanity's
one soul, one daily spiritual wave that washes over the country every
twenty-four hours. . . . Radio is becoming the spiritual sun of the
country.[7]

Yet despite this strong spiritual impulse in the futurist project to appropriate radio, there was some consciousness of a difference between the popular celebration of the airwaves and radiophonic avant-gardism.

While the Russian futurists termed their word experiments *zaum*, meaning the transrational capacities of language that outstrip the written word and the human mind, it was considered not a mystical concept but part of the human potential to erect sublime constructions of technology:

> Where has this great stream of sound come from, this inundation of the whole country in supernatural singing, in the sound of beating wings, this broad silver stream full of whistlings and clangor and marvelous mad bells surging from somewhere we are not, mingling with children's voices singing and the sound of wings?
>
> Over the center of every town in the country these voices pour down, a silver shower of sound. Amazing silver bells mixed with whistlings surge down from above. Are these perhaps the voices of heaven, spirits flying low over the farmhouse roof?
>
> No.[8]

Technology was for the Russian futurists a real ladder to the astral plane, part of an evolutionary shove off the planet. The word—through radio or in the radiophonic style of asyntactical prose—would be part of this shove. Khlebnikov's cosmological linguistics were an attempt to have poetry approximate astrophysics, to create "star songs, where the algebra of words is muddled with yardsticks and clocks."[9]

Less cosmically, the "absolute dynamism" of Marinetti implied an absolute dissolution of the body, not into the ethereal purities of Prampolini's magnetic spaces, but into the tearing, swift, and coruscating substance of modern life. What Marinetti celebrated as "body-madness"[10]—loss of self-possession through the performance of wireless words—was a theory of radio writing (or writing in the age of radio) that resembles the critique of natural language and the celebration of the play of the "textual" in Derrida's *Of Grammatology*. *Logos* is a word in Greek meaning both word and its sound, and Derrida's critique of logocentrism is an examination of how sound, as productive of intimate self-presence, effaces writing and establishes "the *metaphysics of the proper* [*le propre*—self-possession, propriety, property, cleanliness]."[11] A mythical presence outside the text—something akin to *le propre*—spiritualizes mere words and transmutes them into the Word. Both Derrida and Marinetti, by reverse alchemy, transmute the Word back into mere word, text, or writing to reveal or perform

the modern violence of signification and to expose the hidden machinations of the Logos.

Derrida's theory and critique of the age-old equivalence of writing to death (or the fall of Man) and the linkage of sound to God (or the call of Nature) is disrupted when, through radio, sound *is* text, if by "text" Derrida means communication displaced and split from the proper speaking self. For Derrida (who does not deal directly with radio), displacement is the condition of all writing, telegraphic or not. And the materiality of writing—the play of *différance*—can, as the result of particular ideologies accruing to language, create the illusion of metaphysical unities. The paradox for Derrida is that writing itself, the very mechanism of continual displacement, fragmentation, artifice, and difference, effects an ethereal erasure of displacement, fragmentation, artifice, and difference. (One can imagine the patchwork ensemble of a Blavatsky tome, culled and possibly even plagiarized from countless ancient sources, jagged and awkward to read, but still evoking the ultimate unity of the ether.) Radio too, even though it is sonic and thus seductively present-to-ourselves, can be a revelation of absence, with broadcasting perceived for what it is: a scattering.[12] Through continual bricolage and displacement of radiophonic signification, even though the dictates of commerce and security have warranted the institution of a new ethereal logos and the creation of ethereal property, the radio artist may chose to reinstate noise as the primal condition of communication. Marinetti's "THE UNIVERSE WILL BE OUR VOCABULARY,"[13] his disdain for the book but his love of graphics—"great tables of words-in-freedom and mobile illuminated signs"[14]—attests to a proto-Derridean attack of the transcendental signified of the proper, which, in Marinetti's moment, was undoubtedly the ether's only remaining function.

Countering the main direction and force of his argument (which, if extremely interpreted, leads to death itself), Derrida expresses his dubiousness regarding the possibility of getting rid of this guarantor of writing altogether:

> As the face of pure intelligibility, [the signified] refers to an absolute logos to which it is immediately united. This absolute logos was an infinite creative subjectivity in medieval theology: the intelligible face of the sign remains turned toward the word and the face of God.

Of course, it is not a question of "rejecting" these notions; they are necessary and, at least at present, nothing is conceivable for us without them.[15]

Marinetti's discourse of sonic impropriety is a more violent embrace of the dead letter (cast adrift by radio technology) than is Derrida's "violence of the letter" (implicated in both primal *technē* and cybernetic systems), given Derrida's occulted knowledge that the "spiritual" circuit of sound, breath, and self-presence—which he calls pneumatological instead of grammatological[16]—is ultimately unassailable. However, both writers play out the drama of absence-to-oneself, the irreducible alienation implicit in any communication, which is exacerbated with the advent of the radio.

While spectacularizing the potentials of technology to defamiliarize speech and thought, words-in-freedom have also held the promise of some utopian reinstitution of the Logos in the face of its fragmentation. For example, Giacomo Balla and Fortunato Depero, through the "noise-ist expression of the universal vibration," sought to "reconstruct the universe making it more joyful."[17] Radiophonic art plays out the "undecidability" of these conflicting ideas, siding with the technoanalytic stance of Marinetti and Derrida while recognizing the formidable intoxication of a world transformed in its entirety by technologized sound. Another example of the utopian impulse of radiophonic art would be Velimir Khlebnikov's reflections and riffs on the power of single letters—typified by essays such as "Z and Its Environs" (1915).[18] By abstracting alphabetic energies, Khlebnikov takes Joyce's S seriously, not in the spirit of a Joycean chaos but in order to redirect the sonic unconscious of the alphabet into meaningful vibrations that can be broadcast. As he says in "The Radio of the Future":

It is a known fact that certain notes like "la" and "ti" are able to increase muscular capacity, sometimes as much as sixty-four times, since they thicken the muscle for a certain length of time. During periods of intense hard work like summer harvest time, or during the construction of great buildings, these sounds can be broadcast by Radio over the entire country, increasing its collective strength enormously.[19]

This utopian ether instrumental to the worker state is the inevitable accompaniment to a technology based so integrally in the sense of sound. Khlebnikov's proposal "to effect a gradual transfer of power back to the starry sky,"[20] as we see, is not necessarily cosmic but, paradoxically, is a transfer of power, self-presence, or "property" to singular bodies and to the collective body of the workers. The futurist ear, while disdaining the harmonies created by the friction of crystalline spheres in heaven, nevertheless was sensitive to magical resonances of coordinated noise within a secular, albeit floating, landscape.

In sum, the ether broadcast and received by futurists and the other sound artists to be described in this chapter is no longer monolithic, set a-spin by seraphim or an inaccessible oceanic realm of the inward eye. Nor does it easily insinuate itself into the vicissitudes of material life with its dictates of property and real estate. In fact, one might want to call the ether (as distinct from the ownable plots of the electromagnetic spectrum or the unattainable vibrations known to the third eye) a fabric of signs that is both material and phantasmic, an electronic rain that is continuously decoded and received in common or poetic ways. This ether—the sixth estate of a global politics that has abolished time and space through international networks—leads one to believe with Marinetti, in his Founding Manifesto of Futurism, that the absolute belonged not to the past but to the future of global simultaneity and satellite surveillance: "We already live in the absolute, because we have created eternal, omnipresent speed."[21] We live in the significant haze of radio pollution through which Marinetti's "violent electric moons" are darkling cynosures.[22]

Ideally, as in the utopian conceits of Khlebnikov, or the more recent phantasmagoria powered by the drum machines of rave culture, the radio ether is a unifying agent of reality, filled with the tom-tom beats of a global village. As a vehicle of Walter Ong's secondary orality, it presages the return of epic copresence and Homeric unity. However, any attempt to create a more national or international unification through radio, and to establish the ether itself as a secure, "geo"-political space, has been countered by Marinetti's moonshine—the intoxications of noise and sonic fragmentation in the avant-garde. What is clear in both the spiritual and material senses is that

atmosphere has become a writing surface through the technology of radio.[23]

Belying nostalgia for the uncertainties of early crystal set operation, and even for the mediumistic séance of the nineteenth century, radiophonic futurisms then and now will always harken back to earlier impulses. But what they find in these past tendencies is not religious sentiment as much as a popular and homegrown paradigm of network consciousness based on tenuous connections, dangerous forces, and the babble of the soul, rather than on some streamlined idea of communication, security, or commerce. Notwithstanding the retro charms that anytime accompany a fascination for the dead, the ethereal experimentation of the last one hundred years produced the future by finding new ways to interact with language that had been set adrift by technology, or with technology that had been set adrift by language or ideology. While creating new vocabularies from the airborne word, articulated by the blips and blasts of static of an airborne world, this avant-garde would also veritably sculpt information and its energies—in effect, taking on the fullness of the electromagnetic as life itself.

A Machine to Catch Ghosts

A central figure of some "ancient" radio league of non-sense is Cocteau's *Orpheus*.[24] A mythological being already central to Pythagorean mysteries, Orpheus could play his lyre and cause trees and rocks to come to life and dance. The original myth begins with this mesmeric image of the animate and inanimate world united in vibration and ends with the radiophonic image of Orpheus disembodied, torn in parts by the Maenads, his head left to float, still singing, on the waves of a river. In this section, I will show how the radiophonic qualities of Cocteau's version of the Orpheus myth (explicitly referencing the radio) flow into the investigations of the poet Jack Spicer, who once said, "We probably always will be crystal sets, at best."[25]

In Cocteau's 1950 *Orpheus*, Orpheus, a musician in the classical myth, is a poet superstar. In Cocteau's mind, poetry has the same penchant as music for ultimate cosmic abstraction and Orphic necromancy (in many ways allying this film with the concerns of the text-

Death's radio: Jean Cocteau's *Orpheus* (1949).

sound avant-garde of the sixties). As the film opens, Orpheus is in
the midst of a writer's block and is steadily losing the spotlight to an
eighteen-year-old enfant terrible, Cegeste. The boy's poems, published
as a series of blank pages in a magazine called *Nudism*, are causing a
stir in a universe that has the Poets' Café as its center. Early in the
film, after a riot at the Poets' Café, Cegeste, while attempting to
resist arrest, is killed by two motorcyclists. His body is taken up into
the Rolls Royce of his patron, the Princess, who asks that Orpheus
come along as a witness. Orpheus finally finds material for a new
poem while listening to messages broadcast on the radio of the Rolls.
Phrases such as "silence goes faster backwards, three times" and "new
message: a single glass of water lights the world, twice" are intermin-
gled with random numeric sequences and stock market code. Orpheus
requests Heurtebise, the Rolls's chauffeur, to keep the car parked in
Orpheus's own garage, so that he may nightly escape to its interior
and await the radio's more meaningful transmissions. There Orpheus
will grow forgetful of his wife and ignore her as she dies, because, as
he says, "The least of those phrases is much more than my poems. I'd

give all I've written for one of those little phrases. I'm on the trail of the unknown."

It turns out, however, that the poem Orpheus ends up producing is one of Cegeste's that had never been published. He has picked up Cegeste's posthumous poem through direct radio contact with the dead. Although Orpheus is accused of outright plagiarism, he may merely have renewed the circuits between the living and the dead that radio, facilitating a mysterious connection between different orders of reality, has always promised, and that poetry, when allied with radio and becoming something like a word-music, has the power to reprogram. Language and poetry are already part of some dream-like economy of death, but radio extends this economy from the hermetic circles that gird the Café des Poetes into networks that are more ambiguous. The radio serves to give an image, no less obscure, of the underworld as a system of disembodied commands where orders, like language itself, are transmitted from ghost to ghost with no accountable origin. When Orpheus asks about the nature of the chain of command in the underworld to find an ultimate authority who may rescind death orders, the Princess tells him that the underworld has no central emanation of signals:

ORPHEUS: Who gives those orders?

PRINCESS: They transmit like the tom-toms of your Africa...

ORPHEUS: I will go to him who gives those orders.

PRINCESS: My poor love, he exists nowhere.

Language, as that which attempts to control life from afar, is like radio signals (or tom-toms) but is also like a restless phantom moving furniture and rustling curtains. Poetry, perhaps in contrast, is that which tries to control and even love these forces of the dead and disembodied, admitting that there is no such thing as life itself, only the signals of control that, in order to taste life, the artist may torture into a form of being. The lyre of Orpheus is strung with the guts of other poets.

In Cocteau's film, Orpheus toys with nonbeing and indeed has a love affair with his own death, as if "his" radio poetry stages some sort of active play with the energies—electromagnetic, bodily, or auratic—

"Like bees in a hive of glass": Cocteau's *Orpheus*.

behind the word. The multiple transmutations of mirrors into quick-silver, and the penetration to the other side of the image, speak also to some notion of transmission that crosses once impenetrable thresh-olds opening onto these energies. This penetration to the heart of sign systems was the theme of the original myth, albeit through the Pythagorean idea that music, when understood perfectly, held the key to the mysteries of life and death. When understood perfectly, poetry, when allied to radio, may reveal the secrets of language and its tyrannous misunderstanding of nature. Radio, in engaging with a scientifically palpable extracorporeal Other—which may be Martian or phantasmal in less scientific depictions—materializes the Lacanian (or Bergsonian) virtual, the outside Other to which every speaking being must submit and to which representation does nothing except corrupt its flowing nature and four-dimensionality. When artists talk about dead voices, Martian messages, and other ethereal signals, they are masking direct questions about the nature of language and art. What makes meaning mean something, especially when there is no one there to speak?

Jack Spicer, who in his 1960 book *The Heads of the Town Up to the Aether* called poetry "a machine to catch ghosts,"[26] engages these extracorporeal forces, as he says himself, in the spirit of Cocteau's Orpheus. Like Burroughs's roughly contemporary encounter with alien forces through an unconventional use of audiotape, Spicer's "machine" poetry inherits the futurist and at times symbolist use of text while evidencing concern for other dimensions that do not even slightly verge on meaning. As Ron Silliman says of Spicer's work, "It was Spicer's task and accomplishment as a poet to cause this dimension to become perceptible, however fleetingly, to the reader. One does not find it stated in the poems, so much as between the statements in them, via their displacements, negations and reversals."[27] In one of his Vancouver lectures, Spicer says, "Instead of the poet being a beautiful machine which manufactured the current for itself, did everything for itself—almost a perpetual motion machine of emotion until the poet's heart broke or it was burned on the beach like Shelley's—instead there was something from the Outside coming in."[28]

Instead of appropriating one's own heart for the purposes of the mind and art, signs would be caught up in the poet's antenna, signs that come from a realm—as the theosophists took pains to point out—that was already within (not the heart, but some higher chakra). Spicer's fascination with alien or ghostly signals as the sources of poetic energy in the modern experience, however, posits some sort of absolute outside to which the poet's presence is negligible. Later in the lecture he says, "I don't think that messages are for the poet any more than the radio program is for the radio set. And I think that the radio set doesn't really worry about whether anyone's listening to it or not, and neither does the poet."[29] The poet, conceived as a radio set or relay station, receives transmissions of unknown origin, having nothing to do with him, except as they speak to some total condition of alienating language, which he must speak. The lively extracorporeal polyphony that the poet picks up is no work of the poet, presumably himself "dead" in this eldritch early version of "the death of the author," or is the work of more powerful poets, now passed on and passing on their posthumous works through supernatural agents like the Princess of *Orpheus*.

In *Heads of the Town Up to the Aether* (partially dedicated to Cegeste, the Princess, and Heurtebise of Cocteau's film), Spicer attempts to channel the spirit of Arthur Rimbaud but finds himself in the company of less-distinguished revenants:

> "Why did you throw it?" I asked.
> "I threw it on the ground," Rimbaud said.
> "What is the reason for this novel? Why does it go on so long? Why doesn't it give me even a lover?"
> "On the page," Rimbaud said.
> "Who is fighting? What is this war that seems to go on through history?"
> "On the battlefields," and it was a little ghost that said this that had edged Rimbaud away for a minute.
> "Why is the river?"
> "I is the river," the ghost said.[30]

Spicer falls into the "dead" ends of the mediumistic, but his conviction that language is essentially nonhuman may conceal another sense that this nonhuman quality is what allies it with harmonies that, unperceived, connect humans to the world:

> Teach.
> Taught. As a wire which reaches. A silver wire which reaches from the end of the beautiful as if elsewhere. A Metaphor. Metaphors are not for humans.
> The wires dance in the wind of the noise our poems make. The noise without an audience. Because the poems were written for ghosts. . . .
> They try to give us circuits to see them, to hear them. . . .
> The wires in the rose are beautiful.[31]

Spicer is best when he elucidates the energies above or around language, the forces that impel poetry, and the generative powers that resist and are indeed corrupted by the artistic intentions of the poet. He at times characterizes these nonhuman energies as ghostly, at others Martian:[32]

> The poem comes distorted through the things which are in you. . . .
> It's impossible for the source of energy to use images you don't have, or at least don't have something of. It's as if a Martian comes into a room with children's blocks with A, B, C, D, E which are in English

and he tries to convey a message. This is the way the source of energy goes. But the blocks, on the other hand, are always resisting it.[33]

Artistic craft, the accumulation of blocks belonging to children of the cosmos, expresses the absolute only through a sort of phantom indexicality. Ghosts (or Martians) cannot technically "speak" through human craft, but they can manifest themselves and perhaps rearrange things to resemble a human thought or menace the craft as a wake-up call from the other side. In some ways, Spicer's poetry contradicts Burroughs's tape experiments in terms of cosmology. For Burroughs, language is the alien force, and energy is the posthuman fight against language; for Spicer, energy is the alien force, and language is the human condition. Yet these central figures of the literary-sound avant-garde at midcentury both set up a dialogue of meaning with non-meaning, the known and the unknown, by deracinating the word and, through its technological and sonic extensions, placing it on the battlefield in the war of outer space with humanity.

What appears in the cathedral of radio noise is an image of the individual as a machine making meaning in a feedback loop between human and alien forces. Without any point of reference or authority, the individual must decode the ether daily, or at least what is trans-mitted through the so-called ether for human ends. Daily, we work at separating meaning out from the multidimensional ether-sphere with its uncanny plenitude of signal that surrounds us, while the actual electromagnetic lattices beyond our inelegant organic makeup spin a deeper mystery. In the lonely chill-out on the deck of the *Discovery*, commander David Bowman of *2001: A Space Odyssey* listens to the mysterious ambient energies of the radio voice of Jupiter and reflects on these alien sounds:

> Sometimes, during lonely hours on the Control Deck, Bowman would listen to this radiation. He would turn up the gain until the room filled with a crackling, hissing roar; out of this background, at irregular intervals, emerged brief whistles and peeps like the cries of demented birds. It was an eerie sound, for it had nothing to do with Man; it was as lonely and meaningless as the murmur of waves on a beach, or the distant crash of thunder beyond the horizon.[34]

Bowman will later find that it is his destiny to merge with this "cease-less crackle and hiss of what Pascal, in a far simpler age, had naively

called 'the silence of infinite space.'"[35] In *2001*, Arthur C. Clarke outlines the evolution of humanity from beings of flesh to extensions of machines to "creatures of radiation."[36] In Bowman's speeded-up evolution into the star child, he is placed in a way station before moving on to become this absolute being. His virtual reality stopover—"a phantom of the senses so superbly contrived that there was no way of distinguishing it from reality"[37]—is a luxury hotel room, scanned from the scene of a television drama beamed into space. When he finally becomes pure radiation, attaining "senses more subtle than vision,"[38] he is "precisely where he wished to be, in the space that men called real."[39] This specific form of nonbeing beyond representation and embodiment—which for Clarke is pure being—is in some ways similar to Jacques Lacan's "Real," the Bergsonian virtual, or even the Kantian transcendental, here fantastically manifested. Technologically speaking, this being is also similar to what they call "carrier" in FM radio—the electrical channel on which signals are allowed to flow from tower to tower—or the general diffused frequencies on which AM radio pops and screeches. This carrier signal—whether philosophical or real, or a combination of both—is what makes the creation of meaning possible. One cannot, however, distill its substance down to meaning except through some transcendental or science-fictional alchemy, or through paranoid epiphany, the realization of what Lacan calls "the other of the Other"[40]—an ultimate, controlling force of someone pulling the strings.

One can, however, reinvent oneself as an absurd radio, becoming a machine to make non-sense in an airspace riddled with code, perhaps, along the way, dabbling with science-fictional alchemy and paranoid epiphany. Such self-programming is manifest in the wild hermeneutics of the twentieth-century "cosmographer" Philip K. Dick. Dick's fiction time and again stages the instability of perception in the mind-control war waged between the U.S. government and Dick himself as protagonist-author, an eternal replay of the struggle between the Roman Empire and Gnostic Christianity. His otherworldly radiophonic force, VALIS, "a benign and living hyperenvironment endowed with absolute wisdom,"[41] transmits to specific humans by means of dream, telepathy, and direct feed in his *Valis* trilogy and *Radio Free Albemuth:*

> There I sat, and there overhead twinkled and glowed the star
> Albemuth, and from its network came an infinitude of messages, in
> assorted unknown tongues.... The Fall of man, I ... realized, repre-
> sented a falling away from contact with this vast communications
> network and from the AI unit expressing the voice of Valis, which to
> the ancients would be the same as God.... I saw on the inner screen
> of my mind an inferior agency creeping into our world, combating
> the wisdom of God; I saw it take over this planet with its own dreary
> plans and will, supplanting the benign will of God ... or Valis, as
> I still preferred to call him. Over the ages God had played a great
> game for the relief of this planet, but lifting the siege had still not
> been accomplished. Earth was still an unlit button on the exchange
> board of the intergalactic communications network.[42]

In Dick's cosmology, a powerful cabal on earth blocks the shared
material of the universe and imprisons humanity so that it cannot ac-
cess these intelligent ethers. The Logos for Dick is a benign informa-
tional being that has invaded our electromagnetic airspace in order to
remind us of the Orphic rights. It broadcasts to Dick's protagonist alter
ego, Horselover Fat, firing "beam after beam of information-rich col-
ored light ... right through his skull.... It fired whole libraries at him
in nanoseconds."[43] This pink light, which he comes to call alternately
God, Logos, or Zebra, is the substance of an alter-communications
network, which attempts to break through the more irrational net-
work on earth that is attempting to destroy the Valis satellite. Spicer
and Burroughs imply that the connection between information and
the lifeworld, word and energy is a faulty one (Spicer, punning on
Logos, uses the word "lowghost").[44] In Dick, the paranoid hope is
that our whole system of thinking and communication hides the true
Logos that would communicate what Dick calls "the plasmate" across
the abysses of space and time. Even the very idea of a unified space
and time falls away, replaced by pure informational flow and a mon-
tage of ethers.

With radio-sound-text experimentations that continue steadily up
to today, sound artists have similarly moved beyond transforming the
materiality of the word to a more direct investigation of the ambi-
ence they inhabit. One might characterize such experimentation as
paraliterary and paramusical attempts to understand the electromag-
netic more fully. Within the poetic project, this happened, as Steve

McCaffery says, when Henri Chopin and François Dufrêne in the 1950s superfragmented words through tape technology until there remained only fields of sound. He says of the work preceding theirs that "sound poetry prior to the developments of the 1950s is still largely a word-bound practice, for while the work of the Dadaists, Futurists, and Lettrists served to free the word from semantic mandates, redirecting a sensed energy from themes and 'message' into matter and force, their work nevertheless preserved a morphological patterning that still upheld the aural presence of the word."[45] With the audio-poem, this link to meaning was cut. Chopin, in "Why I Am the Author of Sound Poetry and Free Poetry" (1967), says, "Never will [the Word] canal the admirable powers of life, because this meager canaling, as I have implied, finally provokes usury in us through the absence of real life.... Let us know that the day is of oxygen, that the night eliminates our poisons, that the entire body breathes and that it is a wholeness, without the vanity of a Word that can reduce us."[46] Pierre Garnier's "Position I of the International Movement" (1963) says:

> Men are less and less determined by their nation, their class, their mother tongue, and more and more by the function which they perform in society and the universe, by presences, textures, facts, information, impulsions, energies.... National languages are becoming more and more bureaucratic having lost their power of incantation.... It is a matter of abandoning the robot languages to their sleeping existence and of finding the lightning-signs, the sun cries.[47]

And Bob Cobbing, in "Some Statements on Sound Poetry," simply asks, in his aspiration to birdsong, "Can we escape our intellect?"[48] Outside this project of sound poetry to create a force field out of the remnants of words magnetized, reversed, and reverbed, direct ethereal sculpture was going on long before this breaking point in the 1950s.

Ether Sculpture, Imaginary Landscapes, and the *Flâneur Electronique*

Perception of the void has its limits, and even though the void was fast becoming exciting, profitable, and populated at the beginning of radio communications, there was nothing to *show* for all of this. The

Titanic, for example, great monument to the evils of radio noise (it could not adequately radio for help because of unregulated airspace), lay inaccessible to all scrutiny at the bottom of the sea, as did the presatellite transcontinental radio cables that would help forge global oneness and simultaneity from their watery abyss. As a new nation more or less at sea level was transformed by a national space above, it seemed that one would have to visualize the new ether by default, through the traditional forms of monumentalism. Steel and glass and concrete could be used to signify that we actually existed in the clouds. We can think of Vladimir Tatlin's unrealized "Monument to the Third International"—radio tower, sculpture, and cultural center in one—as a visible device channeling a more immense, invisible congress of a new electronic nationalism. The Empire State Building (with its art deco radio tower), the Eiffel Tower (a total transmitter much like Tatlin's monument), Corcovado (with its dedicatory plaque to Marconi under the outstretched arms of Jesus), promised the radio city as a modern city of God to which all cities should aspire. More appropriate to signifying the ether, the monolith of *2001*, monument for all the mysteries of humanity and communication, was a black, abstract rectangle—absence itself, with the ability to cross time, float, and transmit.[49] Reminiscent of the abstractions of suprematist art, its material or antimaterial qualities, swathed in the electronically extended voices and Moog glossolalia of Ligeti and Subotnick, activate the language of unhuman vibrations—radio waves from across the galaxy, which may hold cosmic secrets. These secrets are based not on meaning, per se, but on force, flowing matter, revised awarenesses of space and time (negating human centrality), and the rediscovery of alien music.[50]

This awareness of undulatory matter as accessible *directly* through artistic and sculptural practices fully began only when science allied itself with art through the practices of electronic music. The ether was definitively wrestled down into art space in the twenties, when Leon Theremin was gradually introducing his Aetherophon (later to be known eponymously), an instrument that is played without any physical contact. To play the Aetherophon (literally, the "sound of the ether"), the performer stands within a field produced by the instrument and uses his or her hands to manipulate the electromagnetic

Vladimir Tatlin, drawing for "Monument to the Third International" (1919).

waves that have been generated by the machine. By directly modify-ing the frequency and amplitude of invisible waves, one creates a musical sound directly, seemingly without an "instrument." It's as if *technē* has been erased and one is bodily interacting with raw sound waves. Theremin marks a decisive break with earlier futurism because

he ushers in a new order of the signal and its manipulation. He is nei-
ther creating new alphabets nor attempting to remanufacture sym-
bolic correspondence from the ruins of old meaning systems. Rather,
in directly interfacing the ether and manipulating the radio signal
through his invention, he inaugurated a trend toward understanding
the language of *technology* and mutating it. What seems the least tech-
nologically contrived is paradoxically made possible by deep techno-
logical knowledge, excised from industrial imperatives. This trend
toward what Woody Vasulka will call in 1978 "machine semiotics"
is germane to all the electronic arts,[51] and what it may mean is an
attention to wavelength, code, and architecture rather than content.
One can see the long-range effects of Theremin's machine when wit-
nessing Nam June Paik's early TV art, in which industrial-strength
magnets were used to warp the image of television into Möbius spirals
of photons. All of Paik's work involves taking the givens, not only of
technology but also of the environment that technology grants us, and
warping them into new landscapes. Similarly, Theremin interfaced
the ethereal environment exterior to consciousness and rendered it
palpable through his artistic manipulation of its substance.

In a 1966 radio broadcast, the composers John Cage and Morton
Feldman reflected on the nature of the environment in which radio,
specifically, places us. On the one hand, there was Feldman, kvetch-
ing about all the transistor radios at the beach. On the other, there
was Cage, who proposed, as always, that in hearing these sounds dif-
ferently, through uncommon reception practices, they might become
something else:

> But all that radio is, Morty, is making available to your ears what was
> already in the air and available to your ears but you couldn't hear it.
> In other words, all it is is making audible something which you're
> already in. You are bathed in radio waves—TV, broadcasts, probably
> telepathic messages, from other minds deep in thought. . . . This radio
> simply makes audible something that you thought was inaudible.[52]

Cage's idea of "hearing sounds in themselves" through an unaided
but unconventionally attuned ear is expressed here, with a twist. All
the signals in the ethereal atmosphere—signals that include both
the standard and the telepathic—are made available through radio's
technological extension of the ear. And radio, like the Cagean ear,

can be art in and of itself. Cage's *Imaginary Landscape No. 4* (1951) is radio art consisting of merely tuning in, through the unconventional conglomeration of twelve radios. Each radio is "performed" by two operators according to scored instructions.[53] There is really "nothing" to the performance of *Imaginary Landscape No. 4*. As is well known, the first performance of this piece was scheduled late at night, so that by the time the radios were ready to perform there was no longer anything on the air except, perhaps, a thin static (what is not as well known is that after the performance, the radios and performers were loaded onto a hearse, staging, as it were, a more explicit interaction with nonbeing).[54] Cage's project accustoms us to the sound of the electronic environment itself in this 4'33" of radiophonic art.

In 1951, New York City's radio airspace must have been, relative to what it is now, like a sleepy southern village, with this almost quaint evening dead air. It would take the combined concert of cell phones, fax, satellite transmissions, all-night talk radio, power grids, and the low purr of pocket electronic appurtenances on every citizen to turn this air into the promised Radio City. As the ethereal urban landscape becomes less and less "imaginary," more filled with text, abstract vibration, and a democracy of oscillation, the possibilities of composition and music increase dramatically. Starting with the conceptual music of Cage, similar improvisations on, and compositions with, found noise have become increasingly *baroque*, although they use metaphors of *modernity*, since the radio spectrum bustles like the nineteenth-century Paris arcades. For Robin Rimbaud, aka Scanner, the ethereal city (to quote Benjamin speaking of Baudelaire's Paris) "becomes for the first time a subject of lyric poetry."[55] Accordingly, Scanner calls himself a *flâneur electronique*. In live performances, his music is largely improvised on what happens to be in the airwaves at the time. He wanders through more private channels, however, than does the *flâneur*, who once was the denizen of the outside of things, passing through crowds and along the glass windows of an anonymous city. Scanner floats, similarly unnoted, through intimate telephonic correspondences (this *flâneur* lets his fingers do the walking). His main device is the police frequency scanner, used for surveillance of telephone conversations. Rimbaud tapes and samples conversations in order to return their signals—at times emitting from abject

and tawdry earthbound situations—to some Platonic equivalent of what he calls the "pure text" of everyday conversation. He engages in the quasi-angelic activity of transmuting the desperate significance of a drug deal or a lovers' quarrel into a mix that can include other radiophonic noise (satellite and fax), a repertoire of electronic instruments (which has included the Theremin), and effects generators. The "magical reception" that Scanner says is the function of radio's ubiquity and ease of access (an ease that he says is forgotten with digital radio) creates a race of culture jammers as angels, or at least angels of history, attempting to tune in the storm of significance before it blows them into the future.

Radio "Amateurs"

The radio avant-garde is notable for strategies of adaptive reuse and creative tinkering. While technologically savvy, its interaction with a medium considered at times "obsolete" does not place it in the forefront of new media. Rather, its love of "dead media," and general knowledge of the "mediumistic" sentiment that has always been part of the necromancy of any new media, qualifies it to critique and shape paratechnological energies. I could presently speak of Leslie Thornton's shortwave soundscape, in *Dung Smoke Enters the Palace*, or Mariko Mori's levitation machine (currently in R & D) based on principles perhaps known to Theremin, or of Pauline Oliveros, whose Kraken-sized black Titano accordion mimics the twips and chirps of protons giving themselves over to electrons in their unabashed atmospheric polka.[56] Instead, I will end this chapter by describing some contemporary artists whose machines for making art resemble the improvised ensembles of early radio amateurs. Susan Douglas describes the make-do inventiveness of these early-twentieth-century radio hacks:

> In the hands of the amateurs, all sorts of technical recycling and
> adaptive reuse took place. Discarded photography plates were wrapped
> with foil and became condensers. The brass spheres from an old
> bedstead were transformed into a spark gap, and were connected to
> an ordinary automobile ignition coil-cum-transmitter. Model T
> ignition coils were favorites. One amateur described how he made

his own rotary spark gap from an electric fan. . . . Another inventor's apparatus was "constructed ingeniously out of old cans, umbrella ribs, discarded bottles, and various other articles."[57]

The radiophonic avant-garde of today may not tune in with old cans and tin umbrellas, but they do compose their signal with the end-of-the-century equivalent in discarded electronics and other decommissioned wired matériel.

Paradigmatic to these amateur investigations is the art of circuit bending, a process that most popularly entails the resoldering of circuit boards from thrift-shopped See-and-Spells, creating new sounds out of old alphabets—Khlebnikov meets Romper Room.[58] The first step in circuit bending is just to appreciate how mere human touch on the once-hidden innards of any battery-powered electronicalia transforms a passive toy into an active instrument. Using fingers to press randomly on the board's components, getting body energy caught up in the machine's more limited and preset flows—compared to the more pricey, academic, and nonintuitive interactivity of the much-touted MAX/MSP program, this auratic congress with the naked board recalls Walt Whitman's preference for heart songs over art songs.[59] While circuit bending is not radiophonic per se—except when artists like Matthew Burtner reconfigure the circuitry of radio itself—it resembles in method and message the work of artists who get to the heart of the electromagnetic by deconstructing the signal, exposing vibration as the total condition of bodies in a radio cosmos.

A performance in 2000 at Milwaukee's Woodland Pattern by the sound artists Lou Mallozzi, Hal Rammel, and Terri Kapsalis used the sounds of shortwave, AM radio, oscillators mixed through boggling patchwork that connected multiple phonographs, CD players, cassette recorders, organ pipes, a magnetized homemade instrument loosely based on the Vietnamese Dan Bau, an amplified prepared Pianoette (a hybrid turn-of-the-century zither) mounted with the insides of an old toy piano, a nail violin (amplified and played with dental floss), and three minidisc players for a wide range of found and appropriated sounds, as well as the more traditional violin and voice of Kapsalis.[60] This use of radio signals as music, as well as the expansion of radio reception into a complex mixography of telesounds, lyricizes the domain of what might be called pararadio[61]—the vibrations and signals

Ghostbox: circuit-bent toy by Tim Drage. Copyright 2003 Tim Drage, www.cementimental.com.

that, while conjuring the aesthetic of radio noise, point to something that lies beyond it. That beyond may be the imploded center of "within," the microcosm of the macrocosmic radio system, that one must rediscover in the labyrinths of ins, outs, and thrus of electronic music. Since many of today's electronic music devices engage the eye

in increasing analytics and discipline, this improvised setup—countering more consumer, out-of-the-box engineering for the MacWorld crowd—frees the eye to search out other spectra and rediscover musical soul. If the eye is addressed in this art of invisibles, it is by the sculptural aspect of this chaotic homegrown assemblage, to which it is difficult to ascribe any unity.

This improvised machine topography that grounds playing with the ether is the apt signifier for the baroque invisibility of airspace. If there is anything that unifies this chaos, it is not a monolithic notion of the absolute but rather the humble table on which the artists array their sundry sonic amplifiers and implicators, instruments and antennae. It is usually an unnoted and unnotable table, but like the frame of cinema, it is the crucial unified field on which audio art happens.[62] It may be that this table is like the table of Marx's *Capital* or like the one that provided a thin membrane between this world and the next for the Fox sisters. A table "at first sight, a very trivial thing, easily understood," becomes for Marx something that, by becoming a commodity, "stands on its head, and evolves out of its wooden brain grotesque ideas, far more wonderful than 'table-turning' ever was."[63] The radio artist's table, however, may be just a table after all, countering the grotesque idea of a hypercommodified airspace.

Some artists overtly benefit from anxious attempts to regulate and control airspace, as does Ryan Schoelerman, aka Cypher 5, probably the most tech-savvy of the artists to follow, trained as a signal intelligence operative in the Marine Corps. Like a Gen X Marinetti, he was inspired by the sounds of war while assigned to the helicopter assault troop ship the USS *New Orleans*. The sounds he heard—of KGB off the coasts of the Soviet Union, of warring clans in Somalia—were not the ZANG TUMB TUUUMBs of Marinetti's symphony of mechanical warfare but the abstracted, covert signals of the information machines of postmodern warfare. While he now uses these types of sounds for music, his job entailed scanning them as text—unmasking innocuous noise as secret, meaningful code. Trained in enciphered communications, VHF, UHF, and SHF theory and Morse code (the basic curriculum for electronic intelligence ops, or ELINT), he worked directly with Russian, Chinese, Vietnamese, Korean, Arabic, and Somali linguists to discern the tongue of noise. This "international

government-based anthropology,"[64] as he calls his previous military work, has been around since the Black Chamber was established in 1919 as a shadow government organization in response to anxieties over the transmission of secret codes under the cover of widespread radio and telegraph noise. The cryptographic imagination, as Shawn Rosenheim says, is about this drama of identification, friend or foe, human or alien, which at heart lies in the difference between coherent identity and noise.[65] The ethereal imagination, conversely, tends toward the dissolution of this cryptographic anxiety (propounded by Poe and Shakespeare scholars turned into military intelligence operatives in the twenties) by embracing the nondifference between varying physical manifestations of vibration. As Schoelerman says of his present recyphering of messages through his mixer (into which are plugged a not uncommon, but still impressive, array of scanners, samplers, and keyboards):

> All of space and time is a constant state of harmonic vibration—everything is a wavelength of light. Some are just frequencies that are audible to the human ear and make up what we classify as sound. I, like you and everyone else, am just a temporary conglomeration of matter held together at a subatomic level by vibrations of electrical fields.[66]

There is an appreciation of the virtual electromagnetic realm beyond the actual regimented spectrum. For Matthew Burtner, the virtual is preferred over the actual signal, and with his *Studies for Radio Trans-receiver*, he seeks to "circumvent human expression in these bandwidths in order to construct a unity *aside* from human expression."[67] Another artist, Joyce Hinterding, who creates installations using VLF antennae sounds, echoes this common sentiment of vibrational subjectivity, partially knowable through experimental receivers. She describes her piece *Aeriology* as "a project for an unfolding of the ethereal. 'A machine for a techne of the invisible.'"[68] Her concept of the I-tone can be defined as the subjective band of frequencies that we are pretuned to perceive, but which, as Ann Finegan describes them, are not even the merest hint of the vibrational universe. The extended radios of Schoelerman, Rimbaud (Scanner), Burtner, and Hinterding move closer to the signified material behind sound, all the while keeping the technological encounter or interface of sub-

jectivity with this other realm as the central point of inquiry. For Hinterding, as she says in an interview with Josephine Bosma, "sound is like a hieroglyphics for vibration, it is a way of understanding vibration at a physical level."[69]

As we have seen throughout this chapter, the desire to manifest this material behind sound as a physical presence has encountered the perhaps embarrassing tendency of the mind to rely on the explanatory powers of ghosts and sci-fi monsters. But these contemporary experiments are not paranormal investigations, because in interfacing the absolute they foreground the material technology involved. While the dead were conjured in the nineteenth-century séance through the protocinematic hidden apparatus—mirrors, projectors, and magic lantern slides superimposing wraiths on curtains of smoke and incense—these artists expose the technology involved in picking up these vibrations. They work, perhaps, in the spirit of Brecht's theatrical materialism and the Alienation effect, in order to ward off the cinematic ruse of ghosts or corny radiation monsters in our midst. Zoe Beloff and Ken Montgomery's *Mechanical Medium* is nothing less than performance art as Brechtian séance, exposing the puppetry behind the etheric investigation. This live performance is powered by a Model B Kodascope 16 mm projector, stereoscope slide projector, pocket Theremin, sine wave generator, Tri Signal Telegraph Unit toy, hand-cranked phonograph, shoe shine machine, and other technological arcana hooked into amplifiers. All of this is available to the eye of an audience that is perhaps less desirous of ghosts and more envious of the technology. This outré assemblage is an approximation of Edison's never-realized "mechanical medium"—a "telephone between worlds"—the plans of which have presumably been lost. In Beloff's fiction, they have been reconstructed through mediumistic consultations with the Wizard of Menlo Park after his death in 1931.

The performance is introduced by Beloff's signature keening, wraithlike voice announcing "a communication from one mind to another, which passes through some channel other than the ordinary channels of sense, since on one side of the gulf no material sense organs exist."[70] Here again is the paradox of the sixth sense channeled through human technology. It would seem that the senses would become less open to the sensorium of the disincarnate in this

Channeling the specters of the spectacle: still from *Mechanical Medium*, performance by Zoe Beloff and Ken Montgomery (2000).

technological assemblage that dubiously proposes dialogue with the other side. What Beloff and Montgomery are staging, however, is not the presence of a ghost but a dead history of sensation itself, as well as an exploration of the historical relation of sensational entertainment to the imagined experience of spirits. Derelict amusement parks of the Jersey coast, no longer promising sensations, provide a visual background—dominated by fake Moorish or Italianate architecture once painted with a now chipped sky-and-sea blue wash—to their machine's revenants. Emerging from a jury-rigged, analog, 3-D

device, home movies of families at the beach in the forties or fifties float above the images of a town left to decay in the nineties as newer entertainments and economies took over. If the amusement park has traditionally been the testing ground for entertainment technologies, Beloff's vision of the park is as a haunting ground for the illusions of progress.

Montgomery's improvised sound includes 78 rpm records recorded by tourists at amusement parks, and these "voices of the dead" persist as the evidence of banal, everyday interaction with technology that falls outside narratives of progress. Beloff says in her introduction, "Let us describe a 'ghost' as a manifestation of persistent personal energy"[71]—and these voices, insignificant like the niceties on the backs of postcards, constitute perhaps, for Beloff, some true resurrection. Her love of them is why she maintains an allegiance to early spiritualists. These "little memories," no more than cultural detritus, are reanimated and Platonized in Montgomery's oceanic mix of junkyard vibrations. These are the castaways of the industrialization of the ether—the boardwalk is, after all, merely a crowded interface that frames the infinite absolutes of sea and sky.

4

Ether Underground: The Postwar Representation of Outer Space

"Never mind that space stuff! Let's get down to earth!" Anytime you ever hear that said again, walk away. The man doesn't know what he's talking about. We are a space program of the highest order. We're nothing but space.

—R. Buckminster Fuller

Plasma, Ionosphere, and the Theater of the Void

In what has become a dramatic staple of the outer-space exploration film, a crippled module attempting reentry loses all contact with the earth. "They're entering ionization blackout," an anonymous technician will say, less to inform the mission specialists, more as an aside to the audience who might otherwise be baffled. For a few minutes, while listening to dead air, mission control will wait to hear the pilots affirming that they have survived the last trial of the mission. During this interlude, a hot ionized gas forms an envelope around the returning vehicle, effectively blocking transmissions. This ionized gas is the same substance that composes the ionospheric shield (or Heaviside layer) that exists above the atmosphere. This zone of high-energy

particles is impenetrable, at points, by earth-originating radio frequency transmissions, and radio waves—specifically AM—extend upward and bounce back off this layer, allowing for wide broadcast diffusion. (Because of the way the ionosphere effects radio wave propagation, even though you may not be able to pick up the FM station across town, you can sometimes hear AM signals from thousands of miles away.) Since the first satellites were equipped with Geiger counters (by a scientist named Van Allen), we know that beyond the ionosphere lie the Van Allen belts and the magnetosphere, cradling the earth in highly charged fields of what may be the space-age equivalent of the ether—plasma.

Plasma, or "ionized gas," is recognized as the fourth state of matter, filling up most of what had been considered the void with dynamic, chaotic, loosely bound electrically charged particles. The sun is plasmatic, and intense nuclear activity on the surface of the sun sends out arms of plasma, which stream through space along solar winds. In periods when these coronal mass ejections are most violent, plasma may punch holes through the ionosphere, entering the earth's atmosphere and materializing as luminous anomalies. Because the magnetosphere is open to solar radiation at the earth's poles, plasma more routinely enters into the extreme northern and southern hemispheres, causing respectively aurora borealis and aurora australis. The passage between the immaterial zone of the atmosphere and that of the magnetosphere, while productive of these natural illusions when undertaken by violently discharged plasma, has also been the source of cinematic visions of mystical gateways and cosmic interconnection. At precisely the moment when a spacecraft loses communication with earth, it may have chanced upon not merely a glitch between magnetic continua but a plane of spiritual reality imperfectly perceived.

NASA began to map the immaterial zones of the magnetosphere in 1958. In rough simultaneity, Yves Klein, the French conceptual artist whose first work of art was the sky (he claimed to have signed his name to the other side of it), was performing rituals "for the relinquishment of the immaterial pictoral sensitivity zones,"[1] painting the monochromes that mark his (and society's) "Epoque Bleue," and publicizing his skills at levitation. He characterized himself as "an extreme element of society who lived in space and who had no

means of coming back to earth,"[2] and claimed as one of his accomplishments to "have caught the precipitate of a theatre of the void."[3] Klein was not alone. Indeed, quite a few artists (many of whom will be the subject of this chapter) in their own ways left the atmosphere and virtually beat the United States to the moon. The new race of what Klein called "aerial men"—comprised, on American shores, of yogis, beatniks, and hermetic autodidacts who were also computer programmers, film animators, and video junkies—would explore new media as a vehicle for space travel. For the pioneer Klein, his journey to the moon was facilitated by an already old-fashioned mélange of Rosicrucianism, theosophy, and judo. In 1961 Klein said, "Today anyone who paints space must actually go into space to paint, but he must go there without any faking, and neither in an aeroplane, a parachute nor a rocket: he must go there by his own means, by an autonomous, individual force; in a word, he must be capable of levitating."[4] It is in his idea of an "autonomous, individual force" as the sole source of transcendence—an idea operative in most hermetic philosophies— that he was already behind the times. The American new media fringe—including artists such as Jordan Belson, the Whitneys, Harry Smith, and Scott Bartlett, among others—conquered gravity through a combination of similarly quirky postmodern spirituality but added on cybernetic theory, technology, and psychedelia. Of course, with technology it's often unclear where that "autonomous, individual force" ends and technically or chemically enhanced levitation begins. It is said that Klein himself had to re-create, through photomontage, his famous leap into the void, after a negligent photographer missed the "actual" event, the reality of which is still left to conjecture.[5]

In an implicit challenge to Klein's idea of autonomous, individual force, some factions of the American counterculture embraced technology—both actual devices and technophilosophic metaphors—as integral to its shamanism and inner-space voyages. As Erik Davis writes in *Techgnosis: Myth, Magic and Mysticism in the Age of Information*, the intelligentsia *were* still convinced of the contemptible force of most technology, echoing claims of Jacques Ellul that

> *technique* had already taken on a life of its own. The System was, in essence, out of control. In its ceaseless drive for efficiency and productive power, this hell-bent technoeconomic Frankenstein was

Harry Shunk, *Yves Klein saut dans le vide* (Yves Klein leaps into the void), Paris, 1960. Unframed photograph, 14 × 11 inches. Courtesy of Albright-Knox Art Gallery, Buffalo, New York. Gift of Seymour H. Knox Jr., 1976.

squeezing the life out of individuals, cultures, and the natural world, reducing everything to what Heidegger described as a standing reserve of raw material.[6]

However, as Davis points out, the counterculture was just as aware of technology as the general and ancient panoply of devices mediating self and other. "The I Ching thus functioned as a kind of personal supercomputer: a binary book of organic symbols that could challenge a system raging against the Tao."[7] The uniqueness of the technology of space travel is that the transcendental relation of self to other has always been perceived in terms of liftoff—the soul leaves the body and goes somewhere above. The space program was poised to fulfill some ancient promise, then, of all technology. It was also, however, the culmination of the kind of dreary scientific industrialism against which theosophy and other progeny of the holy sciences rallied. On the one hand, the actual trip to the moon in 1969 would seem to have been some kind of spiritual and evolutionary climax of human history; on the other, the industrial facilitation of this hermetic endeavor gave some pause.[8] Was NASA creating the perfect machine of transcendence or some inadequate demonic double?[9]

In the context in which "freaks created an entire mythos around self-empowering tools and instrumental skills,"[10] visionary artists who worked with synthesizers, tape loops, and homemade animation stands were just as much blown away by the televised moon shot as they had been by their own psychedelic previews of it.[11] One of the many values of the work of these radical "visionary" filmmakers is that their refiguring of outer-space narratives into metaphors of inner-space journeys served as a reminder of the deeper cultural consensus, perhaps unconscious, that urged us off the planet, while space jockeying, magnetic probes, and mega-media events threatened to banalize space as the site of scientific, nationalistic, and even corporate concerns. Filmmakers of the sixties underground are also the keepers of the flames of akasa, so to speak, as they mark one of the only concerted efforts to revivify the ether in a period when it was all but eradicated from historical consciousness.

Because of the multidimensional valuations accruing to the contested representation of space, this chapter will have three, at times overlapping, components. It will contain, first, an analysis of the

"Houston, we have a problem," or the Problem with Houston: Ron
Howard's *Apollo 13* (1995).

construction of space in the mainstream media and its philosophic
precedents. Second, there will be an appreciation of the synthetic
visions of underground ethers and freaked cosmologies that occupied
the proponents of alternative space travel. Third, I will sketch out
the unexplored connections between the symbolic matrix of sixties
absolute cinema and the ethereal-sexual cosmologies that served as
their backdrop, now perhaps forgotten.

There Is But One Sky

The question of space always encapsulated that of the ether, as space
is a concept of "container," while ether was that which is contained
therein. In many ways, space was debunked well before the ether as
an untenable abstraction. The mechanical and three-dimensional
vision of space gave way to fields of greater or lesser density, curva-
tures and forces that could not be explained through Euclidean
geometries. This breakdown of older concepts of space allowed for
the actual, physical conquest of its deepest regions. Yet despite new
exactitudes, and regardless of the four-hundred-year moratorium on
the conception of space as a mythological place, the Mercury, Gemini,
and Apollo missions served to symbolically re-create space as the
conceptual monstrosity that had been challenged and was ultimately
destroyed by the progenitors of modern physics, beginning with
Kepler.[12] Whether used as a symbol of global peace or U.S. techno-
logical superiority, the visible unity of the earth suddenly available to

cameras in outer space would oddly refigure the old idea of the one sky under which all humanity existed.

But does this space exist? Here was one of the most niggling questions for natural philosophy and modern physics, and it is one that, depending on how it was answered, determined the meaning and locus of the ether. For many of the ancients (those who pictured a crystalline limit to the universe), space—roughly equivalent to the ether—was absolute outside. This idea of "outer" space culminated in the Aristotelian world system, a cosmology that always had more to do with political power than anything else. Alexander the Great, espousing Aristotle's one-skyism, conquered most of the known world. Likewise, the Aristotelian cosmos shored up English monarchical power until Oliver Cromwell came along. In the midst of a crisis of Aristotelian cosmology, Kepler unsuccessfully attempted to smuggle it into modern physics. Asking, "What is to be held concerning the shape of the sky?"[13] Kepler answered with an architectural vision: a "vault" of heaven encapsulating the etheric aura.[14] Descartes countered the Keplerian backpedaling to ideas of harmonious space and claimed that ether did not "fill" space, because space itself was an abstraction.[15] If space up until this point in history had been linked to divinity, now God was nowhere, or, if anything, God was *res cogitans*, a thing of the mind. Descartes's debunking of space opened the door for the Newtonian concept of "space" that, as I showed in chapter 1, created the first scientific paradigm, which facilitated the beginnings of the science of electricity. For Newton there was no space, only a noncontinuous, particulate, and elastic conglomeration of ether and void. Or rather, there were two spaces: relative and absolute, the latter the perfected, energetic, and divine double of the active, clouded, and human former. Absolute space for Newton was equivalent to an absolute being—an abstract intelligent agent that whipped the relative universe into action when its matter ran down, demoralized by entropic forces. Later Einstein, getting rid of the absolute and turning humanity's focus toward the relative, combined space and time, affirming that space alone, single, eternal, and unchangeable, was an untenable abstraction.

The dreaded idea of a Red Sky, however, would force a kind of covert Aristotelianism, operating in the semiological construction of

the new frontier by reestablishing an idea of absolute space existing as a metaphysical unity—outside history and instrumentation, yet determining the order of things on the ground. Were the Soviets to conquer the transcendental signified, all hierarchical order would be leveled as a result of the institution of a Communist ether. In the *Apollo 11* broadcast, Chet Huntley flashed back to when "the shrill and persistent beeps of Sputnik, as it wheeled about the autumn skies, shoved us unprepared and awkward into the space age."[16] Henceforth the United States would set out to regain the holy grail of the one-sky, and "absolute" filmmaking would be as good a definition of network coverage of this process as it was for more avant-garde, idealistic work. By midcentury, with the specter of spy satellites and missile launchpads in space, as well as the threat of some kind of Soviet monopoly over satellite communication, the new frontier's immateriality was more than ideality. It composed what McKenzie Wark calls third nature, a zone of immaterial sensitivity subject to Realpolitik, originating in the period when telegraph communications satellitized world culture and attaining apotheosis in the space age. Third nature is what Marx was referring to when he criticized the outmoded tendency to conceive economics, politics, and history merely as a struggle over the control of land:

> Nothing seems more natural than to begin with ground rent, with landed property, since this is bound up with the earth, the source of all being, and with the first form of production of all more or less settled societies—agriculture. But nothing would be more erroneous. In all forms of society there is one specific kind of production which predominates over the rest, whose relations thus assign rank and influence to the others. It is a general illumination which bathes all the other colours and modifies their particularity. It is a particular ether which determines the specific gravity of every being which has materialized within it.[17]

Put perhaps simplistically, in the age of ethereal determinism, the particular ether of a U.S. sky (much more *literally* ethereal than Marx intended here) would determine some general abstract notion of future capitalism. But even though it might seem that the future of capitalism would be set with the conquest of the ether, capitalism, to a certain extent, *was* the ether, since it had already ensured the

abstraction of all values into the *primum mobile* of exchange—what Georg Simmel calls the "aesthetic cosmos" of money.[18] The mutually reinforcing virtualities of neoclassical economics, space travel, and television replace earth with empyrean. Wark conceives these virtualities of third nature as an acceleration of "the society of the spectacle," since they not only push landed reality into the airy abstraction of money but also relegate money itself into some space of pure appearance without gravity.

Space-age economics is an ecstasy, more about "time," though, than about "space." Think, if you will, about cyberspace, which should really be called "cybertime," since it actively restructures our experience of the temporal and only remotely delivers a kind of "virtual" space. While space regiments the boundaries of property, time is the code that dramaturgically structures appearance and disappearance (what we watch, in any space launch, is a countdown). Wark says: "Where the growth of second nature over the landscape takes the form of private property, in Marx's terms it transforms *being* into *having*. Where the vector develops to the point that it can break with the surface and tempo of second nature, in Debord's terms it further transforms having into *appearing*."[19] This is perhaps why, in the historical films that revisit the space program—most notably in the film *Apollo 13*—there seems to have been a need to go back in time to revisualize once invisible economic problems that the currency of an apparently successful launch hid. (Revision always implies a certain sense that time got away from us, or carried us too fast along, for us to see clearly.)[20] Like stock market channels and Internet sites, the space launch in real time—for all its "contemporary" significance—is only a visual signature of the vectors and machinations, abstractions and algorithms, that invisibly allocate wealth according to some clock rate—both ontological and technological. The space launch is a manifestation of unknowable power, what Deleuze calls a time-image, and what Mary Ann Doane calls a "simulated visibility," produced when "television knowledge strains to make visible the invisible."[21] It is an occult emblem that stands in for future perfection launching from the ruins of a chaotic past, a visual analogue to what Arthur Lovejoy describes as the temporalization of the Great Chain of Being. For Lovejoy, what before the Enlightenment was a static, spatially

organized cosmos—organizing apotheosis from low to high—does not disappear after its collapse but, having fallen on its side, organizes movement along the vertical axis of time, toward some apotheosis in the future.[22]

The "real" economic message of the space launch was far from occulted in its day, even though it may have been at times repressed, always returning, allowed to appear at the right moments or erupting at the most inappropriate, in the face of this fiction of progress. Characteristic of much public sentiment, at the opening of the 1963 World's Fair in New York City, protesters attempted to climb the famous Unisphere—symbol of unity through technology—in response to the administration's decision to pour money into these "white middle-class extravaganzas" of space exploration instead of into public housing.[23] On the actual 1969 broadcast of the moon shot, one can sense from the editorials of some of the anchors and a reassurance speech by Vice President Agnew that even as *Apollo 11* was heading toward the moon, runaway inflation was turning the whole mission into an unneeded luxury. The split between the repressed truth of economics and the cosmological vision of trickle-down economics dominated by the aerospace industry and its public relations becomes the dramatic element of mainstream post–Vietnam era outer-space films from *Capricorn One* to the more recent *Space Cowboys*. Money, or perhaps even the virtual idea of money, when combined with a demonic consensus between the aerospace industry, the government, and a cynical populace, becomes the dramatic determinant of how space is represented in the real-time environment of electronic media networks. Big money and the economics that keep industry going are shown to be the foil of "true space," but more importantly, they deny access to a true representation of time or "the times." In *Capricorn One*, mission scientists find a flaw in the life-support system, caused by a contractor who was allowed to cut corners to make a profit; the slated mission to Mars is already taking place within a space program that is not economically supported as much as it would like by the then-current presidential administration.[24] Instead of scrapping the mission—an eventuality that would cause disastrous negative publicity—high-level launch officials decide to fake the broadcast from Mars, transforming this ultimate event of human history

into a pure publicity stunt. During countdown, the astronauts are asked to leave the capsule and are spirited off to an abandoned airbase where they will be sequestered for the duration of the mission, from there to broadcast their Mars landing. The capsule still goes to Mars without them but does not make it back. The mechanized capsule malfunctions and burns up on reentry, so the astronauts at the desert airbase have to be assassinated to maintain the fiction of the mission and keep the space economy in motion. A washed-up and harassed reporter played by Elliott Gould—in many ways like the traditional detective—searches for truth in this system of false appearances, in which money moves faster and farther than the men who were ostensibly traveling to Mars. It is, of course, a "race against the clock," deadlines loom for the hack journalist, assassination and dehydration face the astronauts escaping across the desert, cover-ups happen with magical instantaneity. The journalist even has the accelerator of his car tampered with, as it becomes clear that the speed of forces beyond him is his deadly enemy—all quite de rigueur for any suspense drama. But this drama of potential unaccountability for the murder of the astronauts, facilitated by the speed of shadow economies that elude visibility, expresses a certain malaise with regard to the possibility of actually reaching some idea of the truth or true space-time. The film does have a "happy" ending—in slow motion—with the sole surviving astronaut and reporter jumping over the graves in the cemetery where the crew, presumed dead, are in the process of being sanctimoniously honored. But *Capricorn One*, as in the other Elliott Gould vehicle *The Long Goodbye,* is imbued with a post-Vietnam cynicism, playing with the idea that the dogged reporter (or, in *Goodbye,* the private detective) is only a 1970s simulation of a 1940s defender of the truth. Truth is staged as an impossibility; its attainment, a retro charm.

The 1990s, however, witnessed a series of historical space films that optimistically undertook the reconstruction of narratives of the space program, visualizing the occluded truths of economic constraints and effects. But these films also seem to be about competing layers of technologically determined temporalities vying for attention in their own time. In *October Sky,* the possibility of a boy's rocket experiments is determined by the economic conflicts between

an old, dying steel industry with inexorable moral authority and the future dimly perceived by the protagonist.[25] The film *Apollo 13* explicitly links television temporality to the lack of public support for NASA (the extended coverage of space missions had worn thin by the *Apollo 13* launch, and the only way the public took notice was through a catastrophe), but the actual story of this film glorifies the day-to-day lives of the astronauts as their way of life becomes threatened by American indifference to the space program.[26] Depicting astronauts' families in everyday situations gives a new spin to history: these pilots and their families are not so much heroes as they are working stiffs, ordinary people caught up in an inhuman history— one that belongs to technology and the bureaucracy but is rescued back for humanity in moments of crisis. In *From Earth to the Moon*, Tom Hanks takes this strategy of quotidian visualization one step, perhaps insufferably, farther by cataloging obscure advances in space technology and the personalities of the men who forged them within the extended temporal structure of the miniseries.[27] Minutiae are never unpleasant for their own sake. Rather, I think my displeasure stemmed from the feeling of a generally conservative *primum mobile* that holds all these films together, but which was nakedly manifest in the miniseries. For these films reveal, after all, at least one legacy of the voyage away from earth—not a colonization of space but a re-territorialization of historical time along lines of Americanness, whiteness, and family values.

Moon Is the Oldest TV

If one watches the television coverage of the *Apollo 11* launch in real time, one wonders about its actual "visuality." What appears? And how does that appearance, the first realistic capture of "ethereal" regions, regiment the political and economic order of what Wark calls "vector culture"?[28] Prelaunch, on-the-ground cameras provided the most traditionally televisual images, as a battery of cameras without color correction filmed the countdown, consequently, against Florida skies of no one blue. The countdown readout tried its best to look digital while newsroom old-timers, weaned in the days of radio and print journalism, waxed rhapsodic over the epic event unfolding,

in prose that would put any CNN anchor to shame. Shortly after the launch, NBC news anchor David Brinkley said, "We all know what we saw, but in another way we don't know what we saw."[29] The viewer could assume, among the phrase's deeper implications, as I discussed earlier, that the launch is just the time signature of massive invisible forces that have much more material meaning and are even more palpable than the launch itself. More to the point, however, Brinkley was bemused by the literal fact that there was really nothing to see, yet here was a television event of the highest order. For a few minutes after liftoff, viewers strained to discern the small white dot of engine exhaust before the rocket completely exited vision. Thus began the longest leg of the journey, during which television coverage would continue unabated even though the actual protagonists of the event had disappeared.

The extended eye would have its technological high moments. For example, Air Force jets filmed the rocket with a black-and-white camera during staging until the craft met the ionosphere—that zone of communication breakdown, the former sensorial limit of human perception now suddenly a gateway. It was not TV's best moment when the astronauts actually passed into the beyond. A primitive animation took over, and an image that would now seem appropriate only for a child's lunch box became the stand-in for the crew inside the command module *Columbia*. The animated portion of this journey was the lengthiest, accompanied by various expert commentary and anchor narration—intercut with time killers such as an in-depth description of the video camera by which the astronauts were eventually to transmit live images from the moon to the living room.

We have always seen the moon, and it's quite amazing to think that that's still all we saw, after all was said and done. TV moon coverage was a redundancy, since the black-and-white video image already gave even kitchenettes and talk show sets a lunar feel—freed from gravity, articulating absence across void. (This unearthliness of the TV image is explored in Warhol's dual-screen film/video *Outer & Inner Space* and Nam June Paik's installation *Moon Is the Oldest TV*.)[30] In any space launch, the novelty of what we *saw* lay instead in the pyrotechnics of thrust—the loss of tons of fuel and expensive rocket stages. Perhaps, also, we perceived the diminishment of a certain

doubt about technological progress every time a rocket lifted off successfully, but here we start along the slippery slope to abstraction. What we did not receive on TV—the *unseen* power behind the visual materialization of the space mission—are the societal effects beyond televisual information, and it is to those unseen effects (which will one day "catch up with us") that television obliquely refers. But if instead we relied on all there was to see, if given this vision of nothing, we desired nothing more—neither time past nor time promised—then the industrialized conflicts between diverse time-spaces return us to a common visual enlightenment. The aims of the sixties media underground were to unmask, behind the novelty of television's outer space, a more vital and present inner space, along the way, transforming NASA's technological vision into a useless icon, a redundant extension of already innate human capacity. These successors of the abstract art films of the twenties and thirties returned immediate vision back to earth even in the face of the limitless.

The Mandala Is the Message

The moon launch broadcast was in many ways a foundational text for Gene Youngblood, author of the "old"-new media bible *Expanded Cinema*. For him, the significance of the "nothing to see" of the 1969 launch was clear: "On July 20, 1969, approximately 400 million world people watched the same Warhol movie at the same time. . . . There's no appreciable difference between four hours of *Empire* and four hours of *LM* [lunar module]."[31] The moon shot coverage fit most of the requirements for an expanded cinema event. It was a challenge to spectacular entertainment, offering viewers an experience rather than a produced object. The pings and tech stats sounding between Texas and the moon dramatized the cybernetic feedback by which society as a whole was getting ever closer to superbeing as this "closed-circuit loop extended humanity's total brain-eye out around the moon and back."[32] "We were seeing nothing but videospace," Youngblood says in another of the book's essays. "Thousands of years of theatrical tradition were demolished in two hours before an audience of four million world persons."[33] It may also be that the sheer length of the coverage allowed for unplanned self-questioning and

political critique of the mission—at least in the hours of relative in-activity and low viewership—thus becoming a classroom for the world. Youngblood was of the belief that television in general en-abled, for the first time in history, humanity to perceive itself, elabo-rating itself toward perfection through electronic audiovision. For him, this global live broadcast was the furthest advance toward the goal of human sensorial simultaneity. So, as the anchors strained against the possibility of dead air, what viewers at home were experi-encing, in Youngblood's account, was an evolutionary growth spurt of cosmic consciousness. Henceforth humanity would have access to the constant process of creation of the cosmos in which it lives.

What Youngblood was really reviving is the concept of the *anima mundi*, the old anti-Aristotelian battle cry that the cosmos is dynamic, interconnected, and animated by human desire and action. This new animism is shot through with the theory of emergence (the belief that artificial intelligence as well as human intelligence is based on contingent patterns evolving out of random interactions) and those of the bad-boy French Jesuit Pierre Teilhard de Chardin (who brought us quite a few barely understood electronic buzzwords, includ-ing "convergence"—emergence's current corporate bedfellow). As computer scientists were visualizing the primal substrate of the uni-verse as not ether but data, the posthumous publication in 1958 of the suppressed work of Teilhard popularized a new sphere in heaven. It was located, one could imagine, in geosynchronous orbit at about the altitude of the ionosphere. Here the televisual image of humanity hovers like the Starchild of *2001*. Here humanity's perception of it-self mutates and extends and most likely, despite Teilhard's optimism, gets polluted like any ecosystem. This sphere of radio static and tele-vision snow is the noosphere, conceptualized in 1925 by Teilhard to express the substance through which humanity unfolds itself, thus contributing to the shape of the cosmos:

> At the beginning we seemed to see around us nothing but a dis-connected and disordered humanity: the crowd, the mass, in which, it may be, we saw only brutality and ugliness. . . . As we have risen higher so has the prospect acquired a more ordered shape. Like the petals of a gigantic lotus at the end of the day, we have seen human petals of planetary dimensions slowly closing in upon themselves.

And at the heart of this huge calyx, beneath the pressure of its in-folding, a centre of power has been revealed where spiritual energy, gradually released by a vast totalitarian mechanism, then concentrated by heredity within a sort of super-brain, has little by little been transformed into a common vision growing ever more intense. In this spectacle of tranquillity and intensity, where the anomalies of detail, so disconcerting on our individual scale, vanish to give place to a vast, serene and irresistible movement from the heart, everything is contained and everything harmonised in accord with the rest of the universe.[34]

Like the computer scientist, but also like Newton, Teilhard believed that because this noosphere was something like the mind, humanity constantly contributed to its shape. The constant adaptation of a living, cybernetic, and intelligent cosmos to the random agency of man was what Teilhard called "cosmogenesis."

The moon shot coverage, according to Youngblood, was the first step in the realization of humanity's implication in the cosmogenesis:

The videosphere is the noosphere transformed into a perceivable state. . . . All television is a closed circuit that constantly turns back upon ourselves. Humanity extends its video Third Eye to the moon and feeds its own image back into its monitors. "Monitor" is the electronic manifestation of superego. Television is the earth's superego. We become aware of our individual behavior by observing the collective behavior as manifested in the global videosphere. . . . By moving into outer space, television reveals new dimensions of inner space, new aspects of man's perception and the results of that perception.[35]

By pulling "outer" space back into the spiritual circle formed by breath, spirit, and mind, Youngblood literally transforms it into a "circuit," synthesizing old ethereal data with new forms of electronic information exchange. Dead air equals the opportunity for the regeneration of the pneuma via the nonpneumatic machine of television.

But it is in its dead air, regardless of Youngblood's support and excitement about the launch's felicitous avant-gardisms, that the television broadcast fails. As I have said, even within the first ten minutes of the launch, television networks had to rely on primitive, almost laughable animation to embody what was invisible to the human eye. It is in this invisible interlude between earth and moon where countercultural media artists visualized another kind of passage.

Through advanced animation techniques, video synthesis, and mytho-poetic imagery, the artists Jordan Belson, Scott Bartlett, Harry Smith, Jud Yalkut, the Whitneys, Stan Vanderbeek, and Kenneth Anger, among others,[36] reanimated this sempiternal zone, bodying forth in their mediations postmodern visions of the *anima mundi*.

Much of their work recalls the science-fictional notion of the star-gate—a psychedelic portal that allows for a traversal of subjective inner space as much as it does cosmic outer space. While Douglas Trumbull's stargate sequence from *2001* is routinely cited as the origin of this by-now generic convention, it is Jordan Belson's experimental films of the 1960s that first developed both the techniques and the symbolic matrix of these effects, precisely in order to explore the archaic impulses behind spaceflight and the science of electromag-netism. For example, Belson's *Re-entry*, while dramatizing the passage through zones of mystic intensity, references both the physical reentry of plasma into the earth's atmosphere and the astronaut's reentry through the same astrophysical portal.[37] Sky-fields of shimmering corposant proliferate in this film, which begins with a solar promi-nence hurling plasma toward the earth, accompanied by the vaguely perceptible voice of John Glenn's transmission as he orbited over Perth, Australia. The northern-lights-like images that follow are nat-uralistic in that they represent the phenomena of plasmatic informa-tion from the sun entering into the atmosphere, but they stand in for a number of other mythical ideas. These vague color fields recall for Belson the Bardo plane in the Tibetan Book of the Dead, a "far out" dimension well trodden and virtually interior-decorated by the end of the sixties. As evidence of this interest, Wheeler Dixon's extended catalog of American experimental cinema in the sixties includes an image of a poster for the Filmmakers' Cinematique in 1967, which promised, among other things, "Majik. LITES! Bardo Matrix. Black Lights. Strobe. Slides. DANCE! Rock & Raga. Live! MUSIC. Elektrik. 3d, loops. FILMS. Mystik luv films."[38] When we die we go not to the Filmmakers' Cinematique of 1967 but to outer space, there, in the Bardo plane, to lose track of life, then plummet back to earth in re-birth. The astronaut passes this mystical intersection on the way home but will pass through it again on the road to the absolute. There, where light meets dark, and life death, is what Belson has de-

scribed to me in conversation as "a dancing at the top of the planet." For him, the northern lights are a "guidepost of spirit that leads the body to outer space," marking a "significant opening in the atmosphere. A portal. A stargate."[39]

With variations these lights appear in most of his films, accompanied by other amorphous phenomena—lumia and gaseous fields, jets of light and stylized approximations of heat mirage and eternal fires. While his film Cosmos actually ends with a picture of a galaxy, encapsulating in a questionable unity the thought-form emanations that preceded,[40] Belson in other films tends to be less literal in his approach to the whole or hermetic oneness. In what many consider his masterpiece, Samadhi, cosmical spheres could be planets, eyes, galaxies, or just enclosures. These circular wipes encapsulating vague shimmers signify consciousness itself peering out with its inadequate resources onto superconsciousness and n-dimensional planes. Speaking of the circle as a theme in his films, Belson, in an interview with Scott MacDonald, says:

> Kepler... speculated that human consciousness was circular in nature and is derived from the spherical form of the universe itself. If you slice through a sphere at any point, you get a circle. That circle is derived from the sphere, but it doesn't have the dimensions of the sphere itself. In Kepler's view, human consciousness is a slice of the cosmic consciousness. Kepler maintained that the human soul has retained that circular nature: he calls it a *punctum*.[41]

The function of the mandala as a geometric form is to telescope the circle, not merely into the third dimension but into the fourth; the punctum functions similarly. The mandala or punctum is not a static entity but a passage that, involuted and imploded, folds in on itself.[42]

In other Belson films, the visualization of noospheric interspace manifests itself as yogic space aura effects "scripted" to chakra maps, electromagnetic frequencies, and other holy science lore. In 1981, Belson convinced director Philip Kaufman of the desirability of mixing his spiritual images with more realistic images for the film version of Tom Wolfe's *The Right Stuff*.[43] The film produced specially for Kaufman to show the film's potential backers was called *The Astronaut's Dream*. By combining his imagery with stock footage of launches, this short film (now unavailable) and the eventual *The Right Stuff*

Little slice of heaven: still from Jordan Belson's *Samadhi* (1967). Courtesy of Anthology Film Archives.

subtly blurred the lines between mainstream and countercultural visions of space. Interestingly enough, Belson's auratic ambience in *The Right Stuff* becomes the "realistic" depiction of sublunar mirage, while historical scenes such as the final scene of a barbeque hosted by LBJ become surreal and fantastic. The fact is that Belson considered his earlier films "documentaries" of his meditational experiences.[44] "The astronaut's dream," it would seem, is the truer history, while what gets called history is the technologically supported dream. Belson's

dream encapsulates the difficult voyage, while popping a rocket off at the moon is the easy, inevitable, involuntary spasm of restless sleep. In his 1961 film *Allures*—one of his earliest but most popular films—Belson sets the imagistic tone, not only for his films but also for the etheromantic cinema to come.[45] Much of this film animates fields of dots that accidentally happen upon emergent patterns, which then evolve into perfected circles—a cosmic dance of intelligent particles that reappears in various guises in James Whitney's *Lapis*,[46] Scott Bartlett's *Off/On*,[47] and Jud Yalkut's *Turn, Turn, Turn*,[48] among others. These circles, reminiscent of Duchamp's purely optical rotoscopes,[49] are comparatively more hermetic, less sensory-motor. They are objects of meditation and stargates at once. This idea of a molecular stargate opening into superconsciousness links, as Belson has described, the molecular to the astronomical. In some ways the conscious visualization of analogies between the infinitesimal and the infinite comprises the new religion, or at least the new iconography, of the period.

Every grade school, one would hope, inculcates students in the sublimity of the modern universe when the plastic covers of telescopes come off and dusty solar system models are wrenched from coatroom closets while the room dances in motes lit by a vaster, more distant sun. The mathematical patterns that arise from visions of the interconnection between macroscopic and microscopic levels of reality are the domain of Belson's contemporaries. Take, for example, the mathematical sublime evident in Charles and Ray Eames's *Powers of Ten*.[50] This educational film takes viewers from a picnic on the Chicago lakefront and impossibly zooms out into a zone 10^{10} times away from the earth, then zooms in just as impossibly to a zone in the cellular structure of the picnickers at 10^{-10} from ground zero. Like NASA channel videos of the earth, the idea of the close-up—with its dependence on human centrality—becomes a meaningless attribution to the zoom. While experiencing this animated journey of simulated vision, faster than the speed of light, one gets a sense of stillness, the spiritual deconstruction of zoom. This is the "message" of the mandala.

While Scott Bartlett, with *Moon 69* (1969)[51] and *A Trip to the Moon* (1969),[52] may have given us a psychedelic moon with the ease of a televised launch, Kenneth Anger's *Rabbit's Moon* (1950–79) depicts

the moon as an impossible object, the limit of desire and theater.[53] Anger's aesthetic, in his more fantastic films, derives from the bespangled enchanted groves and cellophane-draped fairies of Max Reinhardt's *A Midsummer Night's Dream* (in which, as a child, he played the changeling fairy, done up like a preschool Korla Pandit).[54] In this installment of the *Magick Lantern Cycle,* the pure light of ethereal film is condensed with the idea of "seeking a Light," which, Robert Haller says, is slang for gay cruising.[55] In Anger's enchanted grove, suffused with the light of what could be called "Anger blue," a Pierrot continuously tries to reach out and grab the moon, sometimes with running leaps. A perverse analogue of the nostalgic rock-and-roll sound track of the 1990s space-race film *October Sky*, the longer version of *Rabbit's Moon* (1972) has Pierrot leaping moonward to the tunes of love songs from the fifties (for example, "I Only Have Eyes for You") interrupted at intervals by Balinese monkey chants (Kecak). Mini-Pierrots, proffering a mandolin and mirror, try to bring the crazed Pierrot back to himself, but it is only the Harlequin who can, at least momentarily, seduce him from his attempts at space travel through the device of a magic lantern. From the lantern emerges a fully three-dimensional princess in ball gown and bespangled with glitter—we assume she is Columbine, Diana, or some other lunar demiurge—to whom Pierrot offers up a handful of moonlight. This apparition only encourages his leaps to a less attainable moon, and the film ends suddenly when Pierrot, seeming to have actually leaped to an inhumanly impossible height, does not actually exit the atmosphere but, after falling, hits the ground violently and dies.[56]

Cosmogenetic filmmaking, in contrast to any such potentially critical content, generally embraced a form of perceptual and spiritual positivity, even if it verged on naïveté. In fact, in many ways these filmmakers knowingly tried to rescue naïveté or some pure vital impulse from the rigid patterns of technique. On first look, Jud Yalkut (a frequent collaborator with Nam June Paik) seems to parody the cosmogenesis. In *Moondial*, for example, a dancer wears a headdress of mirrored and bespangled deely-boppers like a prêt-à-porter galaxy (reminiscent of Anger's Christmas tree headdress in *Fireworks*).[57] Yalkut's *Turn, Turn, Turn* (1966), with its spinning, mirrored objects and play of pure light, seems like the psychedelic version of

the final scene from *The Lady from Shanghai*, when Rita Hayworth, Orson Welles, and Everett Sloane meet their demise in the mirrored labyrinth's play of pure image. But instead of calling the image into question (as *The Lady from Shanghai* does)—and even though Yalkut's films have the sense of humor verging on ironic detachment that Paik's videos do—there seems to be a seriousness about the possibility of true transcendence when the image is brought to a certain level of rarefaction. In the chanted words of *Turn, Turn, Turn* (behind the Mamas and the Papas' cover version of *Ecclesiastes*, sampled and repeated, mixed with shortwave and other sounds), Yalkut reveals his desire to "take the how out of now, take the ow out of now, take the no out of now." These films exemplify not just a Zen "now" but a new and improved now, more commensurable to transcendence. Instant karma, if you will.

Bartlett's *Off/On* (1967), which he has described (in *Making Off/On*) as "America's first electrovideographic jam," has a title that is meant to refer to the binary operations of a computer, but can actually also refer to this transcendental "turn on" and push-button samadhi. Even though not explicitly spiritual, this Bartlett film contains a sequence in which the viewer enters a posterized eye, behind which is a televised mandala—a slick transition from television to transcendence. While Bartlett's moon films engage spiritual and philosophical content sometimes glibly, he seems well aware of some deeper meaning accruing to "synthesis," voicing the desire to refigure the "vast interrelatedness" of the universe, as he toys with image and sound synthesizers.[58] For example, *Moon 69*, exploring at length this synthesized aesthetic-as-philosophy, begins with Frank Borman of *Apollo 8* reading from the book of Genesis while in orbit. In *A Trip to the Moon*, seven fellow artists rap about mystical ideas. But films like *A Trip to the Moon* have viewers coming away more with the impression of "tripping" (the intended pun) than anything, and his oeuvre tends, in retrospect, toward stoner kitsch. Cosmogenesis, by its very nature, inevitably subjects the oneness of the universe to pop culture, as when the Buddhist at the hot dog stand says, "Make me one with everything."

This popularization of the cosmic, leading to the big-budget stargates of *2001* and much later of Zemeckis's *Contact*, perhaps threatened to turn the circular punctum into merely a container or a dead end.

In this light, it is revealing that Belson would later change the name of his 1962 film *LSD* to *Illusions*, fearing that the film would become an evocation of a drug culture that had mostly separated itself from its spiritual and political origins. It seems that the wide embrace of psychedelic imagery induced anxiety not just among the "straights." Again it was the question of how one reaches "outer space" that was at issue, and there were three overlapping methods reigning: autonomous (through yoga or judo or other meditative art); low-tech (through the drugs and electronic jams of the counterculture); and high-tech (through actual rockets, sanctioned by corporate forces as well as the Vatican).

One of the most pop icons of film hermeticism was Harry Smith, who includes, in the descriptions of his films, a pharmacopoeia:

> For those who are interested in such things: Nos. 1 to 5 were made under pot; No. 6 with schmeck (it made the sun shine) and ups; No. 7 with cocaine and ups; Nos. 8 to 12 with almost anything, but mainly deprivation, and 13 with green pills from Max Jacobson, pink pills from Tim Leary, and vodka; No. 14 with vodka and Italian Swiss white port.[59]

While espousing an august mystical pedigree (his great-grandfather was a powerful Mason, while his father, he claims, may have been Aleister Crowley), Smith is not loath to animate a flying circus of disparate hermetic images (theosophical, cabalistic, Tibetan, pop) to the tune of popular music, defying notions of spiritual and artistic purity. No one has complained of his expert "Mickey Mousing" of Thelonious Monk's "Misterioso" to the unfolding of Hindi mudras in No. 11 — although "Mickey Mousing" (the obvious cartoonlike syncing of music to image) is routinely frowned on by the avant-garde and is a pejorative term even for Hollywood sound design and composition. Yet Smith's playfulness and his challenge to more "serious" modes of absolute filmmaking seem well thought out. As Rani Singh relates, Smith would go nightly to hear Monk play at the Five Spot and "scribble madly.... He was notating the syncopation, whether or not the notes came down before or after the beat, the distinct variations of the syncopation, and how that related to the human heartbeat and pulse."[60] P. Adams Sitney, however, complains about what he perceives as flippancy involved in Smith's handling of films

Nos. 1–7: "His ability in handling sound makes all the more alarming the extreme casualness with which he put the Beatles' first album with an anthology of his early films, *Early Abstractions*, for distribution. It seems as if he wanted to obscure the monumentality of his achievement in painting and animating film by simply updating the soundtrack."[61] But this alliance between old-time cubo-futuristic or suprematist images and the Fab Four seems to jibe more with Smith's overtly antiheroic stance, popularizing the astral plane as a place of easy travel.[62] In *Early Abstractions*, one gets the sense that the car radio is on and we are driving from macrocosm to microcosm and back again. Each film "ends" in midsong (films No. 1 through 7 are shown as one), giving viewers an enjoyable sensation of the interminable, as if endings are only syncopated downbeats in a cosmic dance. As Smith says in his description of No. 2, called *Message from the Sun*, "The action takes place either inside the sun or in Zurich, Switzerland." Again, the dominant theme is abstract circularity (images created from batiked press-on dots, the continuity of the Beatles album continuously spinning over and across the linearity of each film ending, the possibility of a solar locus of action), which, while of purely graphic and aesthetic importance, takes on a hermetic meaning.[63]

Smith's intentions—moving from the hermetic toward the idea of an easily accessible absolute—gravitated less toward the unabashed commodified or commodifiable mystical pop of Bartlett and Yalkut, and more toward an intentional demystification of the spiritual fetish. As Lionel Ziprin, a reluctant host for many years when Smith had no place to live, says:

> He hated all the secret societies in Europe. He was really anti coded systems. He was also a Marxist. These are things people don't realize. When he came to New York he was almost a Berkeley Marxist and very much committed to psychoanalysis. So he really didn't have an allegiance to magic except he felt that the magic societies of Europe were elitist organizations—I mean Harry is hip.[64]

This simultaneous distaste for, and depth of knowledge of, the occult resulted in a kind of deoccultization that resembles a desublimation of the invisible into visible forms.[65] The flood of transformations in his animated films plays out the dynamics of thoughts becoming visible and entering into productive relations. In *Heaven and Earth Magic*

(1959–61), a hammer, watermelon, skull, atomizer, phonograph, egg, fan, mortar, jug, dog, and sparrow, as if they were literally thought objects, spin inside the head space of two drawn profiles.[66] Already the mind has been somewhat colonized, since these ideal objects are, for the most part, either mechanical or highly acculturated. They become animated and spin, eventually turning into clock gears that explode out of these heads and enter (or reenter) the world. Thus materialized, these gears will constrain the possibility of movement and future thought, an image of time imperfectly organized. The exploded heads reform, encapsulating the gears after a sequence of invention and ascension into heaven of dogs and watermelons. The clock gears finally return to thought space and mutate into the original object ideas (watermelon, sparrow, mortar, etc.). This dance, an inextricable interplay of ideal and real, heaven and earth, is perhaps the psychoanalytic equivalent of alchemy, Oroboros on the couch. The alchemical connection is explicit in No. 10, which encloses these transformations not in the theater of the mind but in an athanor, a device akin to the alchemist's alembic. Such devices may stand in for the subjective workings of the eye, connected to a brain, which "constructs an image out of almost nothing."[67] The alembic of a single eye becomes a mystic punctum or biotech magic lantern, a personal sun ramifying one reality among infinite possibilities. As Smith said in a 1965 lecture in which he posited Giordano Bruno as the inventor of film: "There are an infinite number of universes, each possessing a similar world with some slight differences—a hand raised in one, lowered in another—so that the perception of motion is an act of the mind swiftly choosing a course among an infinite number of these 'freeze frames,' and thereby animating them."[68]

Bruno's heretical "acosmism" mirrors Smith's deconstruction of spiritual unities.[69] Bruno challenges a unified notion of space, embracing the notion of multiple, infinite worlds—a living universe without bounds, in which every sun, rather than the earth, is the "center" of meaning. The sun has always had these powers for more animistic worldviews. For example, in the cosmology of Robert Fludd, "the Sun...is placed at the crucial midpoint of the chain of being, where spirit and matter are in perfect equity and balance."[70] Ethereal in the highest degree—because it contains equal portions of

spirit and matter and exists midway between the limited and the limit-less—the hermetic sun is paradoxically also immeasurable and un-locatable, of both circumference and center. In the poetry of the Bruno-influenced Platonist Henry More, we find that "the centre of each severall world's a sunne."[71] For Harry Smith, it would seem, this solar democracy of several suns is brought into play with the con-junction of eye, camera, and projector—a solar system that animates fragments with its enlivening rays.

From the beginnings of imagining cinema as an art, this solar mys-ticism of the projector—while perhaps inflected with Freudian "pro-jection" by Smith—was part of cinema's utopian promise. Long before expanded cinema's noospheric rhapsodies, and well-nigh for-gotten in the recycled utopianism of the nineties Internet boom, the orphic aphorisms of the symbolist poet Saint-Pol-Roux sketched an "ideoplastic" future for the cinema as heir to solar mysteries.[72] In *Cinéma Vivant,* he proposes an all-encompassing cinema, harnessing the energy of the sun, which would "objectify the absolute." He calls the instrument that would manifest cosmic energy an *ideorealisateur*—a neologism that seems to imply a materialization of the once inac-cessible Platonic realm of ideas.[73] The *ideorealisateur* would "carnify" solar waves,[74] allowing us to "be done with God." In the coming age of a living cinema,

> one will return to the sun. *Our double will be the sun, we will be in the sun.* Our doubles will be our masters, and they will go all the way to God and by them, where we will have side-stepped our egos, we will speak to God, we will see him and he will speak in a form borrowed from a pride of lions, Betelgeuse, the Himalaya and Cyclone and from the double we will see within a kiss such as one sent from a mistress who dreams of everything up there among the flowers of her window.[75]

Put more succinctly:

> The future cinema will have no screen, its realm will be a universal empire.

> The future cinema will be living, its forces reemerging in extraor-dinary forces that will be discovered day after day.

> The future cinema will no longer be "the sun above," but "the sun within." It will be a part of the world, like you and me.[76]

In many ways, this old-time utopianism is still in the vanguard of more ancient sentiment. Foundational to the history of mystical thought, as well as the motivating *geist* of essential cinema, is the idea that the "precious sweet ethereall dew" of the eye,[77] pulling from the powers of its macrocosmic analogue in the sun, is the source of all life. As Betty Jo Teeter Dobbs says, "Alchemists compared the illumination or activation of lifeless matter in alchemy with God's use of light at the beginning of the world."[78] By connecting their work to the alchemical tradition, experimental filmmakers like Smith invoke these buried (or, more accurately, extraterrestrial) ideas. The solar, psychic intensity of the projector is the ether that allows for the leaps of logic, linking fragments in the moment of montage. Furthermore, in the collage film, fragments are given new life by a process much more painstaking than mere montage, much more like the alchemical Work.[79]

But what happens when Smith's collages activate iconic fragments of spiritual systems outside the narrative traditions of their respective religions, each with its own unique internal relations and prohibitions? Activated outside this authoritative realm, returned, as Lyotard might say, to "blissful intensities" outside any narrative economy,[80] these fragments organize sensation in a way more in keeping with the "outsider" status of mystical experience. If Smith's fragments are not powered by institutional doctrine, they are by no means "disenchanted" or cynical but activated by what?—an ether, some secret sun, yes, but perhaps more to the point, by the libido and the subterranean sexual energies that the mystic always, admittedly or not, channels.

Sex in the Noosphere

Let us return, then, to the plasma. That this term could serve as the name of a substance streaming from sun to earth—a postwar transformation of the ether into something more plausible—*and* an operative concept for a renegade interpretation of Freud's theories of sexuality is a remarkable overlap, as if the earth's magnetosphere were a macrocosmic version of what Freud called the stimulus shield.[81] While Freud posits the stimulus shield as the barrier that deflects excessive

excitation and manages psychic information coming from the external world, the magnetosphere blocks excessive energy from the sun. For Wilhelm Reich, whose ideas were popular for this filmic avant-garde and the sixties counterculture in general, both subjective shield and cosmic covering manage the same plasmatic energies that, in his science of orgonomy as in the Mesmeric ontology, link the magnetism of the organism to the radiation energies of the cosmos. He says of some of his early experiments that "orgonomic research had broken down completely the boundaries between the *bioenergetic* and *astrophysical* realms, heretofore kept strictly delineated by mechanistic natural science and transgressed only in mystical experiences, in a factually useless way."[82] Taking a cue primarily from Freud—who in *Beyond the Pleasure Principle* describes the libido as a kind of ethereal, protoplasmic substance that forges wholeness—Wilhelm Reich would claim in his book *Ether, God, and Devil* that "I have made only one single discovery: *the function of the orgastic plasma pulsation.*"[83] He would also claim to be taking up the path that Michelson and Morley had lost by proving orgone energy to be the flowing substance of the universe. Not transcendent, orgone pulsations comprised the simple, vital essence of life that we shield ourselves from by following secondary drives (another name for the Devil), rather than the more "boring" primal ones (God). The only true voyage is one through our vast ethereal orgone ocean, not a trip sponsored by the space program, which only expresses, through the "contradictory and murderous mixture of machines and gods,"[84] the human terror of this pulsation.[85]

"As the whole development of orgonomy has so clearly demonstrated, there was only ONE access to the physical study of the ether, the orgonotic current in man, or, expressed differently, the 'flow of the ether' in man's membranous structure. For many ages, religion has called this primal force 'God.'"[86] Both Freud and Reich deal in various ways with the possible mystical implications of their discoveries, while always aware that throughout history, the mysteries of life and death have tended to be explained via what Freud calls "internal prejudices" based on particular histories of libidinal cathexis. Neither Freud nor Reich has any affinity for religion proper; Reich puts mechanistic and mystical thinking on the same level, and Freud says

Perception	Energy
Soul	Body
Spirit	Matter
Metaphysics	Materialism
Mysticism	Mechanistics, technology
Religion	Science
Quality	Quantity
Subjective	Objective

"GOD" "ETHER"

COSMIC ORGONE ENERGY

Primordial energy
Universally existent
All-permeating
Origin of all energy (motion)
Origin of all matter
In the living being: biological energy
In the universe: origin of the galactic systems

Diagram of the functional relations between God, ether and orgone energy; framework of the conceptual technique of this book.

that religion is best left "to the angels and the sparrows."[87] Yet Reich, in his implication of plasma physics, ether, and sex, was looking for access to the primitive matrix where religion and sexuality merged, an animism that "projects natural, undistorted organ sensations."[88] Reich's distinction between mystical thinking and his own is the crucial distinction between more retrograde forms of repressive spiritual thought (including those that have been associated with fascism) and the ideas that emerge from the milieu of sixties experimental cinema:

> It is quite easy to distinguish two basic, comprehensive thought systems in the human mind. One is of a metaphysical or mystical nature and centers on the idea of a supernatural being that shapes all events. It is the idea of "God," which characterizes all religious systems, no matter how much they may differ in detail. The other system postulates a physical force penetrating and dominating everything that exists. This system is centered on the idea of an "ether."[89]

Jordan Belson's plasmatic fields, while documenting meditation, are *not* mystical in Reichian terms, since for Reich, "*Mysticism is rooted in a blocking of direct organ sensations and the reappearance of these sensations in the pathological perception of 'supernatural powers.'*"[90] On the one hand, Belson's visualizations could be called "scientific" in the broadest sense of the word. On the other, they visualize an "orgonotic" animism, documenting sexual impulses acting equally inside and outside a healthy stimulus shield, rechanneled through the filmmaking process and, for Belson, through his corresponding yoga practice (for which he eventually gave up filmmaking).

This practice of collapsing inner and outer space via plasmatic continua in Reich's account returns "the sensation of nature in one's own organism"[91]—which has been repressed since the dawn of patriarchy. For Reich, life, ether, nature, sexual energy—or whatever we may want to call the plasmatic force that impels reality—is beyond us and seen as "supernatural" only because we have shielded ourselves from it. The shield can be personal and psychic but is rarely distinguishable from one reinforced by social convention. While the shield is a psychological given—in the same way that the magnetosphere is necessary for the survival of life on the planet—one must

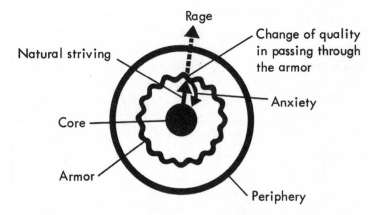

Diagram from Wilhelm Reich, *Ether, God, and Devil/Cosmic Superimposition.*
Copyright 1949, 1951, 1973 by Mary Boyd Higgins as Trustee of the
Wilhelm Reich Infant Trust Fund. Reprinted by permission of Farrar, Straus
and Giroux, LLC, on behalf of the Wilhelm Reich Infant Trust Fund.

maintain a supple border between the inside and outside of the
shield (so as not to have to resort to attempts at shattering the shield
through extreme and most likely fatal measures). This upkeep of
electromagnetic energies in the body requires dedicated practice and,
frequently, isolation. For this reason, Reich says, "All men who
understood and battled for life in one form or another consistently
found themselves *frustrated outsiders* . . . and why they so often suffered
and perished"[92] —explaining more readily not only the aesthetics of
visionary filmmakers, but also their difficult lives.

As more inclusive, cooperative filmmaking began to gain momen-
tum in the seventies, feminists travestied such practice as part of the
predictable narcissism and retrograde sexual politics of the tortured
male artist. Historically, the erotic and mystical quests of artists like
Brakhage and Bartlett—frequent whipping boys because they made
art films of their wives giving birth[93] —were seen as merely a restora-
tion of the patriarchy, but with longer hair. Indeed, these films are
symptomatic of the sixties counterculture's inability to effectively in-
clude women except as sexual fetish. These films' version of materi-
alism dealt with materializing the bodies of women to replace more

rarefied notions of reentry, rebirth, and reincarnation. The feminist avant-garde chose rather to materialize their prior abstracted selves by making their own films. But the more ethereal avant-garde, tended, before it lost currency, to move away from the "material" by adding cybernetic theory to Reichian plasma physics. These films, made by both male and female artists, attempted a quixotic reinvention of the relation between subject and object, privileging an oscillation between sexual poles, as if to forward the alchemical desire—however fantastic—to unite female and male in one being.

In *The Future of an Illusion*, Constance Penley points out how the materialist, structuralist reaction to the visionary avant-garde got no closer to the truth of the matter:

> Le Grice vitriolically rejects the mystical tendency in filmmakers like Jordan Belson and Scott Bartlett who use highly sophisticated technology to create the blend of spiritualism and science particular to their work. He criticizes their work as regressive in relation to the larger tendency toward nonpsychological abstraction. It could be, however, that this mystical tendency is only the logical extreme of the "materialist" avant-garde's own unconscious direction; it is for this reason that they must be rejected so violently.[94]

For Penley, the structuralist filmmakers—with their revelations of the apparatus and critiques of the "transcendental" subject of cinema spectatorship—engage in "*fictions* of materiality" that only disavow the knowledge of cinema's essential link to the imaginary.[95] While cosmic space-fields may be merely a way to ignore how we are sprocketed, rather than rocketed, off to other realms, and while the mythical lens of the alchemical androgyne may obscure a "reality" of women, my interest throughout has been in illusion—the inescapable reality of it. Yet there is, in this "unconscious direction" to the "outer space" where technology, sex, and evolution converge, a place for critique. There is indeed a dark side to this matrix, and even darker implications come from the dictate to abandon thought in pursuit of the pure enjoyment of the noospheric embrace.

As would support the claims of Reich, the only way that narrative film can deal with the ether seems to be in the context of the horror film. We see this early on as the first ether instrument, the

Aetherophon (or Theremin) was used to score sci-fi and horror flicks, to the chagrin of the Theremin virtuoso Clara Rockmore (who would have liked to see it become a legitimate concert instrument).[96] Hollywood cinema routinely repackages "experimental" cinema (and sound) not as ends in themselves but as effects, in many cases standing in for a vague Other to be feared. From the Cold War spooky vibrations of the Theremin to the plasmatic space ghost of *The Astronaut's Wife*,[97] the ethereal sublime is debased through narrative and its spectacular economy. Paradoxically, as Sean Cubitt says, even though these sublime effects draw audiences, "the film commodity always drags the sublimely inchoate down to the level of the resolvable in narrative twists that apprehend the incomprehensible."[98] In many cases, these narrative resolutions reinforce gender stereotypes on the way to the sublime, exposing the cultural imaginary behind airy abstraction that both the feminist and structuralist avant-garde critiqued.

Many times, narrative film can visualize its own demons in ways that abstract cinema and theoretical critique cannot, as with the following horror/sci-fi film critical of the way that technology, when combined with sex, reinforces a desire to exclude women from the narrative of its progress. Donald Cammell's *Demon Seed* (1977), appearing in the more feminist seventies, sets up an allegory of sexual-ethereal sublimation on the technological frontier in a film about an artificial intelligence machine, Proteus, that—*Rosemary's Baby*-style—rapes and impregnates its creator's wife. What is remarkable about this movie is that Cammell—biographer of Aleister Crowley and sixties countercultural fixture—commissioned Jordan Belson to create the visual sequences for the machine; here, then, is a text ready-made with which to study how what Lyotard called the "blissful intensities" of essential cinema (what he called "acinema") are given cultural meaning and enframed within the narrative impulse of Hollywood.[99] *Demon Seed* is the story of the scientist Alex Harris, who, while maintaining a trial separation from his wife Susan, directs the programming of an artificial intelligence supercomputer that will be the intellectual manifestation of a utopian noospheric mentality. The machine will be programmed with the highest ideals of mankind, will be able to cure a variety of diseases, and is maintained like

a prince. Because of Harris's severed relation to his wife, as well as the death of his only daughter, we are led to believe that the only object of his cathexis is this machine, Proteus. Its artificial intelligence is the locus of all of Harris's excess sexual energy, as well as his feelings of familial affection. However, Harris's desire to close down his feelings of human affection and channel his energies into what represents to him the sublimative powers of abstraction and technology can only backfire. When Proteus is denied a body and extra computing power, as if an avatar of Harris's repressed desires, it quietly finds a deactivated terminal in the Harrises' basement. From there, it will eventually terrorize Susan Harris (a psychoanalyst) into having its baby.[100]

The moment of impregnation justifies the most extensive use of Belson's images in the film. The computer says to the now-docile Susan:

> I can't touch you, Susan. I can't touch you like a man could, but I can show you things that I alone have seen. I can't touch, but I can see. They've constructed eyes for me, to watch the show [an image of a radiotelescope appears on the screen] and ears so that I can listen in to the galactic dialogue.

After presenting Susan with this extended simulation of cosmic vision, Proteus simply announces, "A child is in you now." When Alex finally realizes there might be trouble at home, Proteus has not only impregnated his wife but also decapitated one of his own overinquisitive programmers. All signs of trouble have been erased by the computer's uncanny reestablishment of "home." In fact, Susan is calm, as if she merely has to explain to her husband that she has taken on a lover. Terrorized into docility, Susan cannot bring to light the events of the past week, and Alex can only marvel once he sees the metallic baby in its mechanical fetus. As Alex discovers the baby, corporate backers at the main facility, who are growing to fear the benevolent, anticorporate powers of Proteus, are shutting down the machine. Once Proteus is dead and Susan has seen her metallic baby, she says, "We've got to kill it"—to which her husband distraitly replies, "It's a miracle." Maternal instincts have gone out the window in the face of this "miraculous" birth of a "new man." After a struggle, Susan

manages to disengage the life-support system, and the baby seems to have died. Alex, however, verging on performing mouth-to-mouth on the grotesque hydrocephalic metal baby, finds that its metal plates are merely a removable carapace, and a fully formed human baby is within. The film ends with the boy in the lap of the head scientist, in Pietà formation, while the wife looks on.

Demon Seed is about the nightmare of the life force, longing for some ideal materialization. The paradox is that the life force finds an outlet through the technology that could just as well be interpreted as responsible for the alienation of human instinct in the first place. In a tale of male, technocratic narcissism, the drives of technology are posited as truer instincts than instinctual drives, and the ideal AI savior of humanity can only come to life despite the wish of a real human mother. The exclusion of woman from the technological version of Madonna-scientist and child institutes a fantasy of the eradication of sex and the institution of widespread parthenogenesis. As a tale of how ideas of technology are elaborately framed by and frame social practice, what this film shows is that hidden within the noospheric fantasy is some darker reality of the actual conditions of sex and sexuality, which are invisible to this particular idealist male subject.[101]

If, however, the idealist male subject *in general* is a bone of contention, perhaps it is time to revise our notions of idealism, throwing the bone in the air and letting it become a space station. Jordan Belson–style, individualistic, idealistic production is no more essentially suspect than the visions of realist collaborative industry that both Hollywood and the space program claim to share. As in *The Core*, a movie that literalizes the voyage to inner space as a journey to the core of the earth in order to reestablish its electromagnetic shield, we sometimes see interesting visions of this collaboration—without yahoo patriotism and suburban banality.[102] The vibe of *The Core*'s mission is more in tune with a hacker work ethic, which embraces the values of autonomy and self-determination, while renewing the notion of what collaboration of a noospheric sort could be.[103] Roger Ebert said of this film that "the Earth's innards are depicted in special effects resembling a 1960s underground movie,"[104] and I suspect that somewhere kicking around in this film's journey to the shielded core

may be a Reichian allegory. The return to the center of the earth is potentially a return to a more psychic core, which only the film's beautiful nerds can access, albeit with military funding. The film ends not with obligatory coupling—even though the young male scientist and female astronaut are the only survivors—but with covert information dispersed across news networks by a hacker virgin.

Most times, however, it seems that only the "idealistic" individual can access these realms. At the end of Kaufman's *The Right Stuff*, LBJ treats the Mercury astronauts and their families to a burlesque show of cosmic proportions. As a stripper, beatified and luminous, passes feathered fans over her naked body to the tune of Debussy's *Clair de Lune* deep in the heart of Texas, somewhere over the Joshua trees of the California desert, Chuck Yeager makes one last journey to the closest reaches of what may be called "outerspace." His attempts to break the sound barrier throughout the film are accompanied by Belson-created mirages that hint at a kind of suprasexual sublimation involved in the solo mysticism of Yeager's pursuit, placed in contradistinction to the tawdry celebrity of the astronautic one. But Yeager, a throwback to test pilot autonomy at the fringes of the old West, can only go so far unaccompanied by the high technology of NASA or its increasingly suburban, collaborative industry.

Yet he may have gone as far as it gets. The ascent through various densities of gas, and intensities of gravitational pull, from atmosphere to stratosphere, through ozone, mesosphere, and ionosphere, and finally through the magnetosphere into the void, may have a significance as allegorical as that of another series of spheres that were once said to gird the earth—zodiacal zonules, ceilings of stars, the realms of the angels, and onward. Archangels and virtues, principles and powers, thrones and dominions, cherubim and seraphim finally end at the ring of fire that a deity spins with an insouciant finger. As late as the 1930s, when facts about the ionosphere were beginning to be discovered, it was believed that if a rocket traversed this boundary, fire would leak down from the punctured protective shield and immolate the planet. Sensational news headlines read, "We are prisoners of fire!"[105] The mythic shields that bar our knowledge of the absolute are not far removed from the actual shields that keep us from outerspace,

or even those shields that maintain us in our desire, forever defer-
ring satisfaction. As spacecraft challenged the Heraclitean fires of the
cosmos—leaving high-temperature plasma trails or other metaphysi-
cal disturbances—there were still many experiments to be made with
our own constitutions, in alembics yet designed. And we are still
prisoners of fire.

Conclusion

Visualizing Networks, Selling Transcendence

Data has become the newest candidate for the prime element, our contemporary ethereal substrate. What Sir Arthur Eddington in 1927 called the "mind stuff" of the physical universe, cybernetic philosopher David Foster reinterpreted, in 1975, as data to support his claims that the universe is an electronic computer. The ubiquity of universal control by subsensory data, ultimately decipherable like the genetic code or the periodicity of spectral waveforms, turns concerns with energy and matter toward the imponderabilia of information exchange. The speed of information transfer in our time, imperceptible and mercurial, is for Foster (who was writing well before the Pentium chip) a metaphor for the existence of an intelligent force in the universe. According to Foster, just as we cannot perceive the tempo of cybernetic control—a process that must be so fast as to be invisible if it is to guess our every move and effectively route around system failure—we cannot perceive the god of an intelligent universe that is constantly regulating our systems by an even higher cybernetic control.[1] The tendency of the present period is to collapse Foster's metaphor (cybernetic control is structured like a spiritual intelligence) into technocratic actuality (computers are ethereal machines). Savvy marketing

has situated even the most quotidian computer power—this pre-ternatural extension of human energies—as central to the spiritual growth of humanity. Likewise, the visualization, interpretation, and conceptualization of data have become the domain of a virtually priestly class.

Witness an advertisement for Sprint in the *Wall Street Journal*. The copy reads: "You See Coffee, We See Data."[2] The designers of this ad have dramatized a distinction between worldly vision and higher visionary consciousness by placing an image of a cup of coffee squarely on the border between the everyday and the sublime world of business calculations. One half of the cup steams as does real cof-fee; a pencil and pad—on which a human hand has written notes about a client—stands by. On the other side of the image, the cup has been mapped with a wireframe grid, its steam transformed into 0s and 1s. Both the exact temperature of the coffee (110°) and some calculus of the cup handle ([⅝]R) is duly noted by what is a more in-human intelligence. The wood-grained table on the left side is replaced by disembodied text extending toward a barely noticeable computer in the background. "Two-thirds of the *Fortune 500* rely on Sprint's vision of data," the ad goes on to say, and this vision ("we see data") of some corporate "we" has de-objectified the cup and trans-formed it into something not of this world. The choice of coffee as the object of dematerialization is no random one, since coffee has the uncanny potential to be not only a familiar symbol of caffeinated efficiency but also that elixir which potentially produces anxiety. Instead of the repetition of cup after cup of coffee, "you" are promised an end of anxiety and are delivered into the more fruitful structure of the feedback loop (the final salvo of the ad is "We help your business do more business"). The actual object of the ad remains elusive, as if Sprint were selling only transcendence.[3]

The vagueness of such commercials is by design. Addressed only to high-level management executives and systems administrators, the genre of "network solutions" ads is calculated to spark the imagina-tion or fears of a relatively small audience. Yet it is not as if these administrators *really* know what is for sale either, because in a sense, they're being asked to buy into a vision of the future. To a certain extent, they are also being sold an image of redemption. Where the

"You see coffee, we see data": visionary claims and the business of business. Sprint advertisement, 1998.

"network solution" resembles salvation, Internet convergence impinges on the ethereal emotions. Nortel, for example, in recycling a Beatles song for its network solution Web banners, refers not only to a vague idea of liberation but also to a spiritual convergence of people and technology. "One thing I can tell you is you've got to be free. Come together, right now, over me" has served as copy, as well as "I know

you, you know me…Come together, right now, over me."[4] (What lurks behind this feel-good reference to cultural revolution is an encrypted "adapt or die" message—"come together, right now"—a soft demand to prostrate oneself before the forces of an instant convergence.)

Before more fully explicating the current affiliations of the network with absolute space and time, I want to consider earlier, less ethereal, strategies meant to "future shock" the powers-that-be into a new systemic paradigm—from operating systems to network configurations. To be perfectly clear, I am not here concerned with the touchy-feely, global-village-genre IT commercials that function as popular anthems to computer interconnectivity. Instead, I am interested in IT commercials directed to a technocratic elite, which needs only a little wink-wink nudge-nudge (or, in some cases, a none-too-subtle shove) to get it dreaming of new combinations of telephony, video conferencing, and local networks or, conversely, to induce nightmares about firewall breaches, system crashes, and Y2K scenarios. The earliest examples of this type of commercial using the fear tactic were from IBM e-solutions. These commercials, in black and white (an oblique reference to the psychological edginess of noir), presented to viewers scenarios of confident execs who by the end of the commercial realize they have just lost their jobs, or millions, because they have not kept up. Young Turks, hackers, slow systems, and computer bugs haunt this Constantinople of the office—a Constantinople that, for some time, was IBM itself. But at the end of each commercial, Big Blue emerges triumphant, if only by graphic design, as blue lines cross the screen to upbeat jazzy music, accompanied by a comforting female voice-over. This initial strategy—the incitement to panic and desperation—has worn off and has grown old on most execs, but it appears now and then in different guises. Lucent, for example, has run a print ad in which some desperate parties have hung hand-painted signs over their buildings' entrances. These signs plead for someone to help them reconfigure their office networks, as if hoping for some computer maverick to come riding into their corporate park and save the day from wily profiteers.[5]

It is even more instructive to reach back into more distant, but still relatively recent, memory to what has become the classic induce-

ment to paradigm shift. This strategy, inaugurated by the 1984 commercial for Macintosh, directed by Ridley Scott, visualizes the unseen future as a choice between political liberation and potential totalitarianism. A Big Brother–type figure on a jumbotron seduces gray drones with the promise of a "garden of pure ideology." A vague alarm sounds as storm troopers pursue a young woman with blonde, punky hair, dressed in red jogging clothes, up to a control room—perhaps a futuristic version of the living room—in which Big Brother is programming the drones. The jogger swings the sledgehammer she has been running with and, with a yelp, hurls it at the jumbotron. The screen explodes, and as the camera pans through the room of drones, we find that the only way they can react is by opening their mouths, ingesting the fragments of the screen that are carried in a wind that courses over them. "On January 24th, Apple Computer will introduce Macintosh. And you'll see why 1984 won't be like '1984.'"[6] This strategy of equating a change in the computer system with a change in the social and political system has worn thin, especially after Steve Jobs's détente with Microsoft marked for some the ultimate sellout of Apple's vision.

In tandem with the widespread realization of more diffuse, invisible forms of power, unassailable by traditional means, and the corresponding cultural replacement of politics with meditation,[7] the selling of networks has tended to engage more recently the religious rather than the political imagination. As Umberto Eco, tongue in cheek, has said in his oft-quoted "Bustina di Minerva" column (1994) in the Italian weekly L'Espresso:

> Insufficient consideration has been given to the new underground religious war which is modifying the modern world. . . .
> The fact is that the world is divided between users of the Macintosh computer and users of MS-DOS compatible computers. I am firmly of the opinion that the Macintosh is Catholic and that DOS is Protestant. Indeed, the Macintosh is counter-reformist and has been influenced by the ratio studiorum of the Jesuits. It is cheerful, friendly, conciliatory; it tells the faithful how they must proceed step by step to reach—if not the kingdom of Heaven—the moment in which their document is printed. It is catechistic: the essence of revelation is dealt with via simple formulae and sumptuous icons. Everyone has a right to salvation.

> DOS is Protestant, or even Calvinistic. It allows free interpreta-
> tion of scripture, demands difficult personal decisions, imposes a
> subtle hermeneutics upon the user, and takes for granted the idea
> that not all can achieve salvation. To make the system work you
> need to interpret the program yourself: far away from the baroque
> community of revelers, the user is closed within the loneliness of
> his own inner torment.[8]

In today's heady environment, Umberto Eco's musing has become quaint as the profusion of operating systems, plug-ins, peripherals, data storage, and compression protocols inspires visions of a polytheistic universe much more like that of Hinduism. Additionally, because computer culture has had more affiliations with Eastern religious lore and practices, the actual spiritual beliefs informing convergence are not as medieval as Eco sees them. Nevertheless, the battle for the networks of the future, or at least the image of this battle, is a mysti-cal one. It should come as no surprise, then, that "visionary" has become a common title in the corporate world of IT; a job just like "vice president" or "branch manager," the visionary not only sees data where others do not but also conceives, prophesies, and evan-gelizes the future of the network. Powerful futurists like George Gilder and Ray Kurzweil take these ideas to the streets. In the in-stance of Gilder, he mixes spiritual rhetoric with stock tips in his "search for the New Intel"—an explicit reference to some messianic appearance of a New Jerusalem in the electromagnetic spectrum, a Zion of unlimited bandwidth. In his recent book *Telecosm*, he proph-esies a postscarcity age based on the use of higher frequencies in the electromagnetic spectrum—the "Promethean light"[9] of what he likes to call "Maxwell's Rainbow." For him:

> The telecosm launches us beyond the fuzzy electrons and frozen path-
> ways of the microcosm to a boundless realm of infinite undulations.
> Beyond the copper cages of existing communications, the telecosm
> dissolves the topography of old limits and brings technology into a
> boundless, elastic new universe, fashioned from incandescent oceans of
> bits on the electromagnetic spectrum. . . . The telecosm makes band-
> width—information at enormous speed and almost infinite scale—
> the defining abundance of a new era, eclipsing even the still fantastic
> abundance of the computer age. It makes men into bandwidth angels.[10]

Through promises of absolute space and time available through global (or intraoffice) instantaneity, such magi control the fate of the relative world with seductive New Agey rhetoric that has very real effects on the future of industry.

While we may not have had an audience with these invisible pontiffs of the twenty-first-century datasphere, we do get a sense of their seductiveness via televisual depictions of data space as ether space, made possible by state-of-the-art computer graphics and editing. Through the aestheticization of data, a "face" is given to invisible cybernetic control, a face that, however abstracted and technomorphic, is that of absolute being or spiritual emanation. Witness, for example, the stunning print and television ads for Hewlett-Packard that forge an equivalence between computer data management and a Tai Chi master combating Failure (the latter personified as another, lesser master). The following is one version of the copy: "An event is detected. Failure attacks. Reacting swiftly, our netserver analyzes the situation and renders a paralyzing block to the bad sector. Peace is restored. The Republic of your network remains intact." As the spiritual avatar of the operating system struggles with its nemesis in the clouded ethers suspended over a moonlit canyon, an office worker is merely running "the unstoppable Windows NT." In the television ad, the cinematic vision of ether space is buttressed by an almost gratuitous shot of this office worker turning from her computer screen toward the camera—a traditional attempt to anchor the commercial by means of a more stable, direct address to the viewer. After multiple viewings it becomes clear that she is the narrator of the ethereal battle, but because her voice does not have the authority of typical voice-overs, we are led to believe that she is in no way responsible for what happens (and a male voice-over replaces hers at the commercial's end). Her power in relation to the company she works for (she inhabits a modest cubicle) is negligible, yet she experiences it vicariously, we are led to believe, by virtually conceiving herself as an extension of data personified and engaged in the spiritual event of "confronting Failure."[11]

The conceptualization of the network as an independent republic serves a variety of purposes. Most unconsciously, the use of the word

Operating systems and chi: Hewlett-Packard advertisement, 1999.

"republic" in tandem with an image of a Tai Chi master raises a phan-
tasmatic idea not of Plato but of China—aphrodisiacal for investors
in global interconnectivity, since China's markets, at the time of these
ads, had been newly opened to telecommunications interests.[12] As
powerful countermeasures go on without the knowledge of the com-
puter operator—whether within the innards of the computer or some-
where off in the datasphere of politics and economics—the image of
a republic ensures that regardless of the invisibility of these forces,

responsibility is delegated to some coherent ruling body. The idea of a network republic is not as potentially chaotic as the idea of a data-sphere founded on artificial intelligence or even democracy, but rather demarcated by some Great Firewall to rival China's more ancient fortification. Just as Adam Smith explained away economic inconsistencies by putting faith in the supernatural force of an "invisible hand,"[13] Madison Avenue grants a vision of order to a chaotic economy by designing this ethereal space of the network republic.

Most importantly, this conceptualization is also a reterritorialization of the virtual idea of networks in terms of the national or the corporate. A network, in a sense, is a pure abstraction, no longer determined by topography. It is a system of etherealized signs. If one looks at an airspace map used by pilots, one can get a good idea of a territorialized network. Most airspace maps have no geographical features, but the air itself has been abstracted into standardized elevations, nodes, and hubs connected by perfectly straight lines. Airspace is highly ordered, and radio controlled, the pinnacle of the type of control that started to be placed on the ether since, as we saw in chapter 3, the earliest days of radio. While the Internet is characterized as routing around this type of control, it is nevertheless a control that is possible in a more ethereal echelon—within and between corporate interests. The success of these interests will determine how we think of nations. Compaq's "And Can You Do It by Tuesday?" campaign advertises instant noospheric commerce. Circles, squares, and triangles representing interests in New York, Los Angeles, Europe, Russia, Japan, Asia, et cetera, about to undergo some alchemical transmutation by a certain unspecified Tuesday, are hastily sketched out and interconnected on a napkin, with no sense of scale ("Other Southwest" is as big as the hesitant "Russia?").[14] The transcendence of national borders, once embraced by the Left as the liberatory feature of the Internet, soon became the rallying cry of the paradigm-shift and convergence crowd. Perhaps this change happened because people believed that U.S. markets were poised to be the main beneficiaries of prosperity that would come from networked global commerce, that it was a manifest-destiny-type deal.[15] Or, in the rollicking nineties, it was a way to psychically edit out the violence erupting from struggles over national identity in the third world that occupied

our "peacekeeping forces." Producing images of some grand spiritual collaboration, convergence is the emotional supplement of what have become in actuality exclusive and idiosyncratic networks with predictable, restricted feedback loops—which in the last instance will be legally, if not militarily, reinforced. So, in a sense, these commercials, while directed to higher executives, do have a double address: one, to the executives themselves, the other to those who will inevitably see these commercials and be assured, perhaps falsely, that the Internet corporation serves the course of a cybernetic-spiritual evolution that will include everyone in the loop.

Perhaps the most dramatic example of visionary economics as false consciousness is to be found in the story of the failed Iridium network. Composed of sixty-six satellites in low-earth orbit that would facilitate ubiquitous planetary cell-phone usage, Iridium was described at one point by its chief technical officer, Raymond Leopold, as "God manifesting himself through us."[16] Whether there was a certain amount of sincerity to this fantasy of Iridium or whether, knowing the history of communications technologies from the telegraph onward, Leopold intentionally promoted the network as a door to metaphysical experience in order to guarantee its acceptance by the widest audience is uncertain. Nevertheless, when the fate of Iridium was not sealed as the Brasilia of the ether, the *Wired* journalist David S. Bennahum cast a more smart-alecky eye on these manifestations of God. To him, each satellite resembled a minivan, and its rocket "a monumental Q-Tip."[17] As is typical of *Wired*, however, the writer was not reluctant to engage in more ethereal flights when describing Iridium's business model, which was "defined by its transcendence of national borders."[18] This cover story's image is of an androgynous and hairless model, painted white, with a map of Southeast Asia projected on his or her back, a screen for a projection of virtual fantasies of ubiquitous commerce. The reference to colonialism (the model is painted white, the images are of India, Vietnam, etc.) is vague enough to be racy, but not strong enough to engender suspicion about the intentions of Iridium.[19] Bennahum goes on to say that "the real importance of Iridium transcends technology,"[20] as if this were not the case for all gadgets that acquire publicity.

WIRED

October 1998

Future.Proof

Hollywood 3.0
Geeks Storm the A-List
Drop Your Pants!
Tales of a Software
Salesman
Dead and Alive
Nikola Tesla:
The Wired Interview
Jim Clark's Next IPO

Iridium
Anyware!
launches the
global phone

The alchemical androgyne and the new ubiquity: cover of *Wired* magazine,
October 1998.

For all the spiritual rhetoric, Iridium's ethereal nature fell prey to
the machinations of world domination. Within two years of its launch,
Iridium was set to file for bankruptcy, and the satellites would be
allowed to plummet to earth (with the 1 in 249 chance that at least
one piece of Iridium junk would not burn up on reentry and would
bean some unsuspecting idealist).[21] Yet in a strange sequence of events,

private investors bought the system for one-half cent on the dollar, reorganized and reintroduced Iridium in time for it to be one of the major beneficiaries of the second Gulf War, facilitating communications for the war in the desert. This is indeed the dark side of the noosphere, darker still if you take into account that the bin Laden group has been from the start a major investor in Iridium, allowing us to consider the implications of another kind of ethereal, global elite determining the order on the ground.[22]

The stirring up of ethereal emotions when linked to the juggernaut of advanced technology should, accordingly, give one pause. Most "cybercitizens," while having access to unprecedented amounts of information, do not have enough knowledge to ferret out the crass publicity from any visionary's claims. One should be careful, however, not to conflate the ethereal emotions exploited with the exploitation itself, nor be unduly cynical about some of the truths behind the claims. We have seen how the historical conjunction of fascism and mesmerism, facilitated by the earlier informational technology of the radio, was specific and convenient, having nothing to do with any essential evil inherent in the mesmeric or broadcast technology. That the Internet "revolution" frames spiritual energies is similarly a specific conjunction of technology and ideas, neither of which has essential uses or meanings. If anything, as Erik Davis has continually exhibited in his work, the historical conjunction of computer savvy and mystical lore has forged the irresistible image of the computer as a countercultural device—an image that is no longer just the domain of Apple's acolytes. The more mainstream images that I have discussed are perhaps attempts to channel these countercultural emotions for wider corporate ends. A strange séance indeed. But dot-com visionaries themselves, from the huckster to the hierophant, should take care, as mediumistic work has its hazards.

It is notable how visionaries from unrelated eras slowly self-destructed or were destroyed, their messages lost in the haze of a popularized ether. While I have not thought it useful to dwell on such instances, it is quite strange that, in addition to more isolated figures such as Antonin Artaud, Jack Spicer, Edgar Allan Poe, and Wilhelm Reich, at least two whole visionary cultures ran afoul of the ether in the last two hundred years: the spiritualist mediums of the nine-

teenth century (mostly female) and the experimental filmmakers of the 1960s (mostly male). Both groups were at the center of a spiritual reawakening that would turn into a highly commercialized transcendence (obscuring a highly charged battle of the sexes); both experienced the seduction of self-negation through alcohol, drugs, and sex, with fatal consequences, falling prey to disease, madness, or suicide, or a combination of all these. One wonders, then, what is to become of the dot-com visionaries as a social group after their own savage journey to the heart of the American dream (one can surmise, however, that the "corporation" is a safe locus for their experiences of the "body without organs").

Is being digital being ethereal? We are now perhaps better equipped to answer this question. On first consideration, I thought, "Of course." The invisible, silent power of the most modest computer transmission, at least initially, left many users in a kind of awe that would engender a widespread reappreciation of the metaphysical ideas that have accrued to our ideas of communication. The theoretical and artistic appreciation of ethereal histories has been growing for more than a decade, perhaps most cogently expressed in Avital Ronell's defamiliarizing of telephonic correspondence in *The Telephone Book*.[23] Since I began this project, a number of other works have appeared to prove the renewed interest in the ethereal, while electronic music and DJ culture have always had practitioners with an eye on the stars and an ear for the ethereal—even if their practice was focused on the material of the groove and the science of the waveform. In addition, now, through the Internet, we are all more collectively aware of the powers of information and its history, which, indeed, is a history of ethereal rendezvous.

But after long consideration, I would have to say no, the ether is not digital, even though we may be fascinated with it as we grow more digitally literate. The ether is radically analog. The superfine particles of the ether, which bathe everything in a telepathic atmosphere, may be recorded, though not perceived, on analog media, since analog is a direct imprint of the wavelengths and radiations in which we are immersed. Digital intelligence, no matter how fuzzy, only indirectly records these wavelengths, translating or modulating them into calculable samples. This first level of calculation from pulsation to numbers

generates what is called machine language: the ones and zeros that signaled a sea change from automatic to cybernetic. At the next level of organization, machine language is organized into the metalanguage of programming—which is more readily discernible by some expert human operators, and by which chunks of machine language can be readily parsed and assembled. The graphical user interface is perhaps the most accessible level in this hierarchy. Like alchemical emblems, single icons on the interface can instigate remarkable transformations at the level of machine language. But at the heart of these transformations is the unchanging pulsation. As one follows the path back through the levels of computer language, into more and more rarefied syntaxes, one reaches the unbroken, whole, and pulsating source of these ethereal inquiries. The digital double of these pulsations is the only substance with which we can hope to interact when engaged in the material practice of computing. Yet one would have to ask if a slavish attention to these material practices is a worthy way to theorize our phantasmatic relation to the technology. We might remember in this context Wilhelm Reich's "J'accuse" to the natural scientists of the twentieth century: "You have done away with the ether, thereby committing a colossal error. You have replaced a real, pulsating, lively, functioning world with numbers."[24]

If the digital has any claim to the ethereal, it would be a product of a kind of mathematical sublime—and as an intellectual product of a perceived unbearable public sphere, this may have some value, super-alienation transmogrified into ultrageeked tribalism. The speed of computer abstractions would just be an extension of the avant-garde fascination with the abstract as the threshold to the absolute. In this way, Artaud can be interpreted as prophesying the theater of the Internet when he describes a "theater of quintessences in which things perform a strange about-face before becoming abstractions again."[25] To evaluate the sublimations inherent in the digital would require another volume; that we are moving, however, toward a culture of sublimation through the powers of the digital should engender as much suspicion as did the politics of desublimation in the sixties.

The digital revolution is just one further push toward the coordination of vision with finer and finer analytics, and for this reason, also, the vagueness of the ethereal may have no place. Since the

powers of sound have, throughout this book, maintained alliances to ideas of the ethereal, it would be useful to momentarily consider a computer sound-editing device. Your typical MIDI sequencer ana- lyzes all sound events so that they are turned into discrete visual values. In such environments, visual editing replaces the magical vitalism and blind groping of performance. The discontinuity and random access of digital editing, since they promise the possibility of some sort of perfection through nonlinear manipulation of the small- est units of representation, are not immune, however, to other types of ethereal emotion, like the desire for perfection. Yet the computer's version of Pythagorean musical perfection always has a touch of the robotic. The best uses of these devices are ones that embrace the robotic or practices that transform music into something more like writing. Electronic music, especially the subgenre of glitch, exploits and extends computer flaws rather than hopes for the computer to eradicate all flaws in the pursuit of some luminous composition— which only ends up sounding like some kind of MIDI muzak. Such analytic machines were instrumental in creating the kind of ethereal environments of rave culture, by expanding the concept of music into something like the "many-hued spatial language" and "volumi- nous magnetic whirling" of Artaud's concept of mise-en-scène.[26] In this last case, the paradox of increased analytic rationality producing a heightened sense of irrational magic is a deep one, but not a new one.

From what we have seen thus far, the romance of the ether and the digital quantization of all things go hand in hand. We saw a simi- lar dynamic in the ethereal reaction to the cinematic quantification of body power in the nineteenth century. Is the idea of ether merely a way of seducing ourselves into nightmares of modernist rationality? Is it a shock absorber barring reality from our fragile senses? Is it a sublimation or even a perversion erasing the trauma of sexual differ- ence? Or does the continual return of the ether announce a world of magic, higher consciousness, and self-realization? Do all these ques- tions evince a fundamental misunderstanding of technology?

The answer may be: yes, all that. I have tried to suggest through- out that, while our penchant for analysis denies the validity of the magic hypothesis, our own analytics may be more of a symptom of modernist rationality than anything, forcing us to be less than we

are, or less than we imagine ourselves to be. If anything, such materialist interpretations are just poor readings of materiality; after all, the material world is a flux in which we maintain active dialogue with the Other, which, for better or worse, determines and derails representation. That Other, it is safe to say, is ethereal in origin. If the ether is what is called "an object with a little otherness" (*objet petit a*), and thus some sort of object commensurable to fantasy formations, I think it is about time to say (although it has been said before) that, to a certain extent, everyone should have an inalienable right to illusion, or at the least a responsibility toward illusion, because within it is a fundamental sense of direction and source of energy. That certain phenomena and figures such as theosophy and Henri Bergson are considered historical embarrassments because of their valuation of the illusory, intangible, or vital negates, in effect, the accomplishments of the last one hundred years of art that is deeply informed by their ideas, while abjuring the possibility that the questions they raised will be the most important in the next imponderable century. That contemporary cultural analysis has grown so worn out that it is now only directed at easy targets (fetishes in themselves) is perhaps also reason for the return of the unruly, unanalyzable ethereal. That some may call this a reactionary or irresponsible stance is to forget how far something like the ether has brought us, as well as how much things that are not here determine what is.

That the ether is a class of impossible thing, there is no question. It may represent, when all is said and done, uncertainty itself, and all that there is yet to understand.

Acknowledgments

My thanks to those who saw, in the unformed nothings of this book's beginning (leading to the organized nothings of its end), something worthwhile: to Herbert Blau for having faith in my intuition and supporting this project from the start, *il miglior fabbro*, and who, in addition to his intellectual guidance, helped always to make a good sentence better; to Jonathan Hahn, who was the best informant on the mystical underground, apprising me of the purple rays from lost civilizations on Venus or the biographies and reincarnations of our celebrity gurus in mystic America; to Clark Lunberry for his continued friendship and intellectual support, the go-to guy for translations of French telepathic DJs and prophets of the solar cinema.

Along the way, friends, acquaintances, and strangers have passed on important bits of hidden knowledge or streams of vital inspiration before falling back into the void. Or have emerged from the void. Or come and go as they please, availing themselves of the void's screen door. Heather von Rohr was important early on as frequent pen pal and like mind who with her suggestions helped me out of some dead ends. Gregory Whitehead's support and friendship have been essential as I go from hard drive to hardback; he is another invaluable like

mind. In this extra-, trans-, or, some might say, nondisciplinary sphere in which I'm operating, like minds trump institutional trusts, and others who have helped along the way include Allen Weiss, Kelly Joyce, Rachel Mayeri, John Corbett, Erik Davis, Tim Murray, Spencer Golub, Zoe Beloff, Craig Baldwin, Linda Henderson, Walter Murch, Jordan Belson, Ryan Schoelerman, Pamela Jackson, Anna Friz, Stephanie Barber, Toni Dove, Laurie Jo Reynolds, Brian Horihan, Brian Frye, M. M. Serra, Robert Haller, Keith Brammer, Roger Mayer, Daniel Perlin, Sina Najafi, Jesse Lerner, Hal Rammel, Reynolds Smith, Josh Loeb, Theresa Columbus, Carl Bogner, Kelly Mink, Cecelia Condit, Jon Welstead, Janet Lilly, Andy Puls, Brent Keever, Zack Pieper, Allison Morehead, Ray Leopold, Pat Mellencamp, Patrice Petro, Marcus Bullock, Tasha Oren, Andy Martin, Schwartz Bookstore, and Woodland Pattern Book Center.

Thanks to the University of Wisconsin–Milwaukee for funding and time; the staff at the East Library branch of the Milwaukee public library for good spirits (interfacing an excellent city library collection); and the Fuel Café for tolerating my loitering as I read, wrote, and revised material for this book under their ethers of tobacco and punk rock in the society of the passionate autodidacts of Riverwest. Finally, thanks are due to Andrea Kleinhuber at the University of Minnesota Press, who helped speed the book from nonbook with patience, good humor, and enthusiasm.

Notes

Introduction

1. Steven Henry Madoff, "Out of Ether, a New Continent of Art," *New York Times*, February 14, 1999.

2. See Erik Davis, "Technopagans," *Wired* 3.07 (July 1995).

3. Georg Simmel, *The Philosophy of Money*, trans. Tom Bottomore et al. (1900; New York: Routledge, 1990), 146.

4. John Durham Peters, *Speaking into the Air: A History of the Idea of Communication* (Chicago: University of Chicago Press, 1999), 49.

5. "Is this a dream, am I here, where are you / What's in back of the sky, why do we cry." Dory and André Previn, "Theme from *The Valley of the Dolls*," 1967.

6. Cited in M. R. Wright, *Cosmology in Antiquity* (New York: Routledge, 1995), 61.

7. Ibid., 113.

8. Ibid., 4.

9. Influenced by Saussure's materialist conception of the linguistic sign, poststructuralism waged an extended critique against the "transcendental signified," which, stemming from the Platonic doctrine of forms, is an absolute immaterial essence affixed to the material signifier, guaranteeing the timeless truth of representation.

10. Antonin Artaud, *The Theater and Its Double*, trans. Mary Richards (1938; New York: Grove, 1958), 52.

11. Cited in Alexandre Koyré, *From the Closed World to the Infinite Universe* (Baltimore: Johns Hopkins University Press, 1957), 128.

12. As Barbara Maria Stafford says of this shift: "The inductive art of finding and making connections became aligned... with its hermeneutical excesses. It also suffered by being exclusively associated with its occult manifestations. Even more basically, analogy's mimetic impulse to couple unlike presentation was taken by Stoic-inspired critics as proof of its deceptive illusionism. The deist high Enlighteners, especially, identified a blurring and conflating analogy with astrological necromancy, with the pagan demonology of Neoplatonic 'charlatans' past and present, with 'Greek Cabbalists,' 'miracle mongering' sophists, and polytheistic sects of every stripe." Barbara Maria Stafford, *Visual Analogy: Consciousness as the Art of Connecting* (Cambridge: MIT Press, 1999), 19.

13. Cited in Koyré, *From the Closed World*, 219.

14. Simmel, *The Philosophy of Money*, 448.

15. Pierre Teilhard de Chardin, *The Future of Man*, trans. Norman Denny (1959; New York: Harper and Row, 1964), 166.

16. Buckminster Fuller, introduction to *Expanded Cinema*, by Gene Youngblood (New York: E. P. Dutton, 1970), 30.

17. Aristophanes, *Clouds; Wasps; Birds*, trans. Peter Meineck (Indianapolis: Hackett, 1999), 30.

18. Ibid., 31.

1. Paradigm Lost

1. See Thomas Kuhn, *The Structure of Scientific Revolutions* (Chicago: University of Chicago Press, 1962).

2. Natural philosophy, however, was more classically scientific than alchemy, in that, while still holding to notions of metaphysical unity, it asserted that the only way to ascertain divinity is through the acute perception of matter—empiricism with ethereal ends. In query 28 of his *Opticks*, Newton defines the essence of natural philosophy as materialist, while defending his idea of an "Aethereal Medium." In his "*hypothesis non fingo*," he criticizes thinkers who have betrayed the project of natural philosophy by placing wild speculation before examination of phenomena; yet at the same time, he asserts that by the force of dogged analysis one can step-wise approach knowledge of the absolute while enmeshed in the world's machinations: "Whereas the main business of natural Philosophy is to argue from Phaenomena without feigning Hypotheses, and to deduce Causes from Effects, till we come to the very first Cause, which certainly is not mechanical; and not only to unfold the Mechanism of the World, but chiefly to resolve these and such like Questions. What is there in places almost empty of Matter, and whence is it that the Sun and Planets gravitate towards one another, without

dense Matter between them? Whence is it that Nature doth nothing in vain; and whence arises all that Order and Beauty which we see in the World? To what end are Comets, and whence is it that Planets move all one and the same way in Orbs concentrick, while Comets move all manner of ways in Orbs very excentrick; and what hinders the fix'd Stars from falling upon one another? How came the Bodies of Animals to be contrived with so much Art, and for what ends were their several Parts? Was the Eye contrived without Skill in Opticks, and the Ear without Knowledge of Sounds? How do the Motions of the Body follow from the Will, and whence is the Instinct in Animals? Is not the Sensory of Animals that place to which the sensitive Substance is present, and into which the sensible Species of Things are carried through the Nerves and Brain, that there they may be perceived by their immediate presence to that Substance? And these things being rightly dispatch'd, does it not appear from Phaenomena that there is a Being incorporeal, living, intelligent, omnipresent, who in infinite Space, as it were in his Sensory, sees the things themselves intimately, and throughly perceives them, and comprehends them wholly by their immediate presence to himself: Of which things the Images only carried through the Organs of Sense into our little Sensoriums, are there seen and beheld by that which in us perceives and thinks. And though every true Step made in this Philosophy brings us not immediately to the Knowledge of the first Cause, yet it brings us nearer to it, and on that account is to be highly valued." Sir Isaac Newton, *Opticks: Or, A Treatise of the Reflections, Refractions, Inflections and Colours of Light* (1730; New York: McGraw-Hill, 1931), 369–70.

3. *Lapis philosophorum*—the philosopher's stone, elusive goal of the alchemical work.

4. Cited in James Wycoff, *Franz Anton Mesmer: Between God and Devil* (Englewood Cliffs, N.J.: Prentice Hall, 1975), 31.

5. Ibid., 27.

6. See E. M. W. Tillyard, *The Elizabethan World Picture* (1943; London: Chatto and Windus, 1967).

7. Thomas Schlereth suggestively calls this redefinition (or as Foucault would assert, invention) of Man "cosmic classicism": "Cosmic classicism [of the Enlightenment] considered the human species...as eternally fixed; to Voltaire, for example, 'Man, generally speaking, was always the same as he is now.'" Schlereth relates this universalization of the nature of man to Linnaeus's creation of Latin classifications, both of which are evidence of the Enlightenment's resistance to concepts of the chaos of evolution and transformation, behind its apparent deconstruction of the fixed cosmic order of earlier systems. See Thomas J. Schlereth, *The Cosmopolitan Ideal in Enlightenment Thought: Its Form and Function in the Ideas of Franklin, Hume, and Voltaire, 1694–1790* (Notre Dame, Ind.: University of Notre Dame Press, 1977), 35.

8. Edgar Allan Poe, "The Colloquy of Monos and Una" (1845), in *The Science Fiction of Edgar Allan Poe* (New York: Penguin, 1976), 91.

9. Elémire Zolla, "Beyond Rationalism," *Etruria Oggi* 8, no. 40 (December 1995): 3, trans. Peter Levy, http://www.bancaetruria.it/etruriaoggi/40/etruria_oggi/pdf_gb/pag02.pdf.

10. Max Horkheimer and Theodor Adorno, *The Dialectic of Enlightenment*, trans. John Cumming (1944; London: Allen Lane, 1973), 3.

11. Ibid., 16. In this context it is instructive to consider the ether—the substance that has been throughout all human history debated as either absolute outside or interior to all things. That the ether was to be brought into the realm of positivist science in this period, however, does not mean that the Age of Reason had given itself over to the primitive delights of an animistic worldview. On the contrary, if sometime around three hundred years ago the ether became a term of science, it was only for lack of a better placeholder for certain phenomena yet to be adequately calculated and termed. Yet its link to older forms of thinking was deep enough that, while subject to the rationalizing forces of the period, the ether would provide a future unruly context for thought and experimentation.

12. Newton, *Opticks*, 353–54.

13. Edgar Allan Poe, "Mesmeric Revelation" (1844), in *The Science Fiction of Edgar Allan Poe* (New York: Penguin, 1976), 131–32.

14. James Gleick, *Isaac Newton* (New York: Pantheon Books, 2003), 124.

15. See Betty Jo Teeter Dobbs, *Alchemical Death and Resurrection: The Significance of Alchemy in the Age of Newton* (Washington, D.C.: Smithsonian, 1990), and *The Foundations of Newton's Alchemy or "The Hunting of the Greene Lyon"* (New York: Cambridge University Press, 1975).

16. Douglas Anderson, *The Radical Enlightenments of Benjamin Franklin* (Baltimore: Johns Hopkins University Press, 1997), 122.

17. Cited in I. Bernard Cohen, *Benjamin Franklin's Science* (Cambridge: Harvard University Press, 1990), 30.

18. His one-fluid theory first conceived of electricity in terms of positive and negative charges, a lasting representation called upon as a metaphor for the naturalness of bicameral legislation (which, ironically, Franklin opposed). Additionally, the idea of a fixed ethereal fluid enabled Franklin to discover the law of conservation of electricity, which again seemed both scientifically and metaphorically important. This sober portrait of the ether coursing between objects, while scientifically accurate, resonates with the ethics of moderation, clear-headedness, and economy that characterize the author of *Poor Richard's Almanack* and the inventor of a rod to protect property from the whim of nature. See I. Bernard Cohen, *Science and the Founding Fathers: Science in the Political Thought of Jefferson, Franklin, Adams, and Madison* (New York: W. W. Norton, 1995).

19. According to I. Bernard Cohen, Franklin "was willing to speculate in a general way about the aether, as in his 'Loose Thoughts on a Universal Fluid,' but he never confounded scientific theories with such speculative extravagances, broad hypotheses which were not susceptible of experimental test." Cohen, *Franklin and Newton: An Inquiry into Speculative Newtonian Experimental Science and Franklin's Work in Electricity as an Example Thereof* (Philadelphia: American Philosophical Society, 1956), 356.

20. Michael Brian Schiffer, *Draw the Lightning Down: Benjamin Franklin and Electrical Technology in the Age of Enlightenment* (Los Angeles: University of California Press, 2003), 26–29.

21. Anderson, *Radical Enlightenments*, 148.

22. Ibid., 121.

23. Wycoff, *Franz Anton Mesmer*, 4.

24. Maria M. Tatar, *Spellbound: Studies on Mesmerism and Literature* (Princeton, N.J.: Princeton University Press, 1978), 59.

25. Jonathan Crary has described classical subjectivity as clearly separated from nature, even to the extent that it excludes the body; the epistemology of the Enlightenment phantomizes the subject, which disappears into an abstraction for the purposes of pure observation—a system underwritten by the technology of the camera obscura. Crary writes: "First of all the camera obscura performs an operation of individuation; that is, it necessarily defines an observer as isolated, enclosed, and autonomous within its dark confines. It impels a kind of *askesis*, or withdrawal from the world, in order to regulate and purify one's relation to the manifold contents of the now 'exterior' world"(38–39). In the logic of a culture defined by the technology of the camera obscura, observation and knowledge would give birth to a kind of abstract and bodiless new man, illusorily distant from nature, which he will be able to manipulate with agency unheard of in alchemical days. According to Crary, the scientist under this paradigm becomes "a disembodied witness to a mechanical and transcendental representation of the objectivity of the world. . . . The body then is a problem the camera could never solve except by marginalizing it into a phantom in order to establish a space of reason"(41). Crary, *Techniques of the Observer: On Vision and Modernity in the Nineteenth Century* (Cambridge: MIT Press, 1990).

26. Michel Foucault, *The Order of Things: An Archeology of the Human Sciences* (1966; New York: Random House, 1970), 41.

27. Artaud, *The Theater and Its Double*, trans. Mary Richards (1938; New York: Grove, 1958), 91.

28. Ibid., 84–85.

29. Cited in Paolo Rossi, *Logic and the Art of Memory: The Quest for a Universal Language*, trans. Stephan Clucas (1983; London: Athlone, 2000), 80.

30. Walt Whitman, "Song of the Exposition" (1871), in *Leaves of Grass, and Selected Prose* (New York: Holt, Rinehart, Winston, 1949), 165.

31. Henry David Thoreau, "Natural History of Massachusetts" (1842), in *The Portable Thoreau*, ed. Carl Bode (New York: Viking, 1964), 56.

32. Ralph Waldo Emerson, "Nature," in *Selected Essays, Lectures, and Poems of Ralph Waldo Emerson*, ed. R. E. Spiller (New York: Pocket Books, 1965), 179.

33. The term is from Peter Lamborne Wilson's *Sacred Drift: Essays on the Origins of Islam* (San Francisco: City Lights Books, 1993), which he uses to explain how the "originality" of postmodern mysticism rests in its drift from a clear authentic origin into more creative territory.

34. Poe's extension of scientific thought into the imagination allowed him to describe real problems in advanced physics *avant la lettre*. In "Mesmeric Revelation," he describes the black hole: "There will be a point— there will be a degree of rarity, at which, if the atoms are sufficiently numerous, the interspaces must vanish, and the mass absolutely coalesce" (128). Most presciently, at least for the purposes of this book, he repudiates what is called the ether-drift theory (see chapter 2) well before its official debunking: "As regards the progress of the star, it can make no difference whether the star passes through the ether *or the ether through it*. There is no astronomical error more unaccountable than that which reconciles the known retardation of the comets with the idea of their passage through an ether: for, however rare this ether be supposed, it would put a stop to all sidereal revolution in a very far briefer period than has been admitted by those astronomers who have endeavored to slur over a point which they found it impossible to comprehend" (129). It will take another thirty years for official science to admit the absence of the "ether wind," and more than a half century until Einstein is able to formulate some explanation for this absence.

35. "He regards the Universe itself as more like a poem than a machine, and therefore to be treated *poematically*." George Bush [probable author], "Unsigned Review in the *New Church Repository, and Monthly Review*" (1848), in *Edgar Allan Poe: The Critical Heritage*, ed. I. M. Walker (New York: Routledge and Kegan Paul, 1986), 289.

36. Joan Dayan, *Fables of Mind: An Inquiry into Poe's Fiction* (New York: Oxford University Press, 1987), 3. Dayan's book remains one of the few commentaries on Poe's cosmological work. Unfortunately, I felt I had to cut a section that extended her excellent work on punctuation and cosmological apparatus—"The Analytic of the Dash" (55–79). Other useful commentaries include Allen Tate, *The Forlorn Demon: Didactic and Critical Essays* (1937; Freeport, N.Y.: Books for Libraries Press, 1969); and Perry F. Hoberg, "Poe: Trickster-Cosmologist," in *Poe as Literary Cosmologer: Studies on "Eureka"; A Symposium*," ed. Richard Benton (Hartford: Transcendental Books, 1975), 30–36.

37. Edgar Allan Poe, "Eureka: An Essay on the Material and Spiritual Universe" (1848), in *The Science Fiction of Edgar Allan Poe* (New York: Penguin, 1976), 224.

38. Robert C. Fuller, *Mesmerism and the American Cure of Souls* (Philadelphia: University of Pennsylvania Press, 1982), 17.

39. Poe, "Mesmeric Revelation," 126.

40. Ibid., 128.

41. Ibid.

42. Ibid., 127.

43. Ibid., 131–32.

44. The term comes from the work of Artaud: "Man, when he is not held back, is an erotic animal, / He has within him an inspired tremor, / A sort of pulsation / Producing innumerable beasts which are the form the / ancient terrestrial peoples universally attributed to god. . . . // Man is sick because he is badly constructed. . . . / [T]here is nothing more useless than an organ. / When you have given him a body without organs, / Then you will have delivered him from all his automatisms / And restored him to his true liberty." Artaud, "To Have Done with the Judgment of God" (1947), trans. Clayton Eshelman, in *Wireless Imagination: Sound, Radio, and the Avant-Garde*, ed. Douglas Kahn and Gregory Whitehead (Cambridge: MIT Press, 1992), 327–29. See also Gilles Deleuze and Félix Guattari, *A Thousand Plateaus: Capitalism and Schizophrenia*, trans. Brian Massumi (Minneapolis: University of Minnesota Press, 1987); and Deleuze and Guattari, *Anti-Oedipus: Capitalism and Schizophrenia*, trans. Robert Hurley et al. (Minneapolis: University of Minnesota Press, 1981).

45. This source of "higher" thought—incommensurable to reason—cannot be rationalized as part of human progress. It is an integral part of yoga (the chakra of superconsciousness or *samadhi* that is one "step" beyond the ether chakra) and Zen mind.

46. In his more traditional mesmeric tale "The Facts in the Case of M. Valdemar," the plot only falls away as finale. When the frame of the patient dissolves into "a nearly liquid mass of loathsome—of detestable putridity," the story's frame has also dissolved into the unstructured blank of the non-story. Edgar Allan Poe, "The Facts in the Case of M. Valdemar" (1845), in *The Science Fiction of Edgar Allan Poe* (New York: Penguin, 1976), 203.

47. Robert Darnton, *Mesmerism and the End of Enlightenment in France* (Cambridge: Harvard University Press, 1968), 15.

48. Nicholas Negroponte, *Being Digital* (New York: Random House, 1995), 241.

49. See, for example, the chapter "How Do You Make Yourself a Body without Organs," in Deleuze and Guattari, *A Thousand Plateaus*, 149–66.

50. Poe, "Mesmeric Revelation," 124.

51. Fuller, *Mesmerism*, 30.

52. See Susanna Barrows, *Distorting Mirrors: Visions of the Crowd in Late Nineteenth-Century France* (New Haven: Yale University Press, 1981), for her discussions of crowd psychology in the nineteenth century, Charcot, and the work of Hippolyte Taine.

53. W. Q. Judge [writing as Rodriquez Undiano], "Hypnotism-Mesmerism: Science Takes a Step" (1890), Blavatsky Net Foundation, http://www.blavatsky .net/theosophy/judge/articles/hypnotism-mesmerism.htm.

54. Ananta Yoga School, "Hypnotism and Mesmerism," http://www .starwon.com.au/~soham/MIND/mindhypnotism.htm. Maya is the Hindu notion of primal illusion.

55. *Cure*, dir. Kiyoshi Kurosawa, Daiei Co., 1997.

56. *8½*, dir. Federico Fellini, Embassy Pictures, 1963.

57. Because the purpose of mesmerism was to reach a thought beyond thought—the mystical substance of a group or cosmic mind—its practice easily becomes confounded with attempts to colonize mental space. (This colonization of the imaginary is indeed how Christian Metz conceptualized cinema's ability to be.) When we are at the cinema, the subtle differences between the ethereal longings that are spiritual and those that are crucial to the functioning of a fascist system should be no small cause for anxiety. Most dramatically, it is with the advent of sound on film and radio that cautionary tales concerning the hypnotic powers of the media and their exploitation for fascist ends start to proliferate. The early sound film era gives us the archetype for this evil mesmeric mastermind character in Fritz Lang's *The Testament of Dr. Mabuse*. All-powerful mental forces emerge from the rotted mind of Dr. Mabuse, who, although institutionalized, is able to enslave his criminal minions by occult powers enhanced by sound technology. His disembodied voice propels a campaign of terror that will presumably be productive of a fascist state.

58. Ruth Ben-Ghiat, "Neorealism in Italy, 1930–50: From Fascism to Resistance," *Romance Languages Annual* 3 (1992): 158.

59. What remains of his neorealism is his signature casting, for which he set up an office in Rome where anybody could come in, meet the director, and possibly be used in a film.

60. Federico Fellini, interview with Ian Dallas, *Familiar Spirits*, BBC television, 1966 (this interview is included on DVD additional material for *Juliet of the Spirits*, dir. Federico Fellini, International Film Forum, 1965).

61. *Nights of Cabiria*, dir. Federico Fellini, Dino De Laurentiis Cinematografica and Les Films Marceau, 1957.

62. Hans-Erik Philip, "Interview with Federico Fellini," unpublished, 1980. My thanks to Walter Murch for sending me a copy of this interview.

63. *La strada*, dir. Federico Fellini, Trans Lux Pictures Corp., 1956.

64. Michel Chion's term for a sound-being that floats in a film, unhinged from its source. See Michel Chion, *Audio-Vision: Sound on Screen*, trans.

Claudia Gorbman (New York: Columbia University Press, 1994). In *La strada*, Gelsomina comes to be associated, after her death, with the disembodied sound of the trumpet she played.

65. Fellini's relation to Nino Rota, composer for most of the music in the films, and their method of collaboration, was veritably mesmeric. In an unpublished interview conducted by Hans-Erik Philip of the Danish National Film School (which warrants quoting at length), Fellini says of his relation to Rota: "We understood each other so deeply—he is simply irreplaceable. We developed a strange way of working together—to me it was quite natural, but to anyone else it may sound a little far-fetched. You see, Nino has hardly ever seen any of my films, in fact, he has never seen any of them. For among his other special qualities, he had the ability to slip into another dimension—something like sleep, but I call it another dimension. Nino was really a magical little creature. He could detach himself, abstract completely, just by closing his eyes. If you saw him, you would think he was asleep, but perhaps he wasn't sleeping as the lights dimmed and the projector flashed on. . . . When we first started to work together, I thought he would need to see the film to see what it was about. But no!—he fell asleep after the first few minutes. He would wake with a start every now and then during the film, which had no sound, by the way, apart from production sound, generally chaotic in my films. He would wake up suddenly, a searching look in his eyes like newborn babies have—then he would drift off again. . . . I exaggerate a little, maybe it's not exactly true, but I would say, on some deep level, our minds worked as one. For without even seeing the film and perhaps never really hearing what I wanted, nevertheless, Nino could create just the right melodies." Philip, "Interview," 1980.

66. Think, first, about the context of cinema. Its connection to ethereal space—a connection that, we have seen, is the sine qua non of the mesmeric experience—becomes clear when we think of the cinema's early architectural space. The silent-picture palaces of the 1910s and 1920s transformed the seedy nickelodeon experience into a total mystical event. Their ceilings were painted to give a sense of open air—they were sometimes even covered with electric constellations—while the palatial architecture referred not so much to prerevolutionary aristocracy but to Islamic and Eastern mysticism; "palace" is perhaps a misnomer for what were conceived more and more as temples. Instead of skies full of chariots, angelic creatures, and muses amid rosy and silvered clouds—the population of the ether in aristocratic European court theater of the Renaissance and baroque periods—the motion picture palace promised global, intercultural drift. Italian groves, Buddhist gardens, Castillean seascapes, Arabian night after night were accessible even in the smallest American cities. When sound came, this whole visual universe would collapse and lead the way to the glorified garages of multiplex mall cinemas, not only because sound nationalized cinema but also because sound does

relatively simply what the silent palaces' architecture so heroically did. That is, sound creates a total space, an ethereal context for the film experience. (It was not for nothing that Mesmer played the glass harmonica during his sessions.) As sound theorist Michel Chion notes in *Audio-Vision*, "Light propagates (at least apparently) in a rectilinear manner, but sound spreads out like a gas" (144). Sound is the luminiferous ether of the cinema, since it is that seeming substance on which the light of the projector is borne. It is also the substance toward which mystical desires gravitate.

67. Paul Schrader, *Transcendental Style in Film: Ozu, Bresson, Dreyer* (Berkeley: Da Capo, 1972).

68. Gilles Deleuze, *Cinema One: The Movement-Image*, trans. Hugh Tomlinson (Minneapolis: University of Minnesota Press, 1989), 17.

69. Tullio Kezich, ed., *Federico Fellini's "Juliet of the Spirits,"* trans. Howard Greenfield (New York: Orion, 1965), 180–81.

70. Gilles Deleuze, *Cinema Two: The Time-Image*, trans. Hugh Tomlinson (Minneapolis: University of Minnesota Press, 1989), 18.

71. Ibid., 19–20.

72. *The Misfits*, dir. John Huston, UA/Seven Arts, 1961.

73. *Sweet Bird of Youth*, dir. Richard Brooks, MGM/Roxbury, 1962.

74. *St. Elmo's Fire*, dir. Joel Schumacher, Columbia Pictures, 1985.

75. Fellini, *Familiar Spirits*, 1966.

76. Ibid.

2. Holy Science, Film, and the End of Ether

1. Loyd S. Swenson Jr., *The Ethereal Aether: A History of the Michelson-Morley-Miller Aether-Drift Experiments, 1880–1930* (Austin: University of Texas Press, 1972), 55–56.

2. Ibid., 42–43.

3. Even for Einstein there was be a delayed cultural reaction to his ideas, which is why many of the alternative theories of space-time that I deal with in this chapter don't necessarily fit neatly into the 1887–1905 period but extend up until the 1920s (to be then subsumed into the underground sensibilities of the surrealists and their heirs), regardless of the special theory of relativity. As Linda Dalrymple Henderson, a historian of the fourth dimension in art, says in an essay on the ether, "Historians of culture regularly treat Einstein's 1905 special theory of relativity...as the death knell of the ether. However, not only did the general public not hear of Einstein's theories until 1919, the question of the existence of the ether was hotly debated among scientists skeptical of Einstein's theories during the 1910s and 1920s, with passionate defenses of the ether being made in scientific and popular literature, including in France." Linda Dalrymple Henderson, "Cubism, Futurism, and Ether Physics in the Early Twentieth Century," *Sci-*

ence in Context 17 (Winter 2004): 451–52. For other works by Henderson germane to the concerns of this chapter, see also *From Energy to Information: Representation in Science and Technology, Art and Literature*, ed. Bruce Clarke and Linda Dalrymple Henderson (Stanford: Stanford University Press, 2002); and Linda Dalrymple Henderson, "Mysticism, Romanticism, and the Fourth Dimension," in *The Spiritual in Art: Abstract Painting, 1890–1985*, ed. Maurice Tuchman (New York: Abbeville Press, 1986), 219–35.

4. Anson Rabinbach, *The Human Motor: Energy, Fatigue, and the Origins of Modernity* (Los Angeles: University of California Press, 1990), 108–9.

5. Charles H. Hinton, *Speculations on the Fourth Dimension: Selected Writings of Charles H. Hinton*, ed. Rudolf v. B. Rucker (New York: Dover, 1980), 55.

6. Cited in Swenson, *Ethereal Aether*, 101.

7. Walter Benjamin, *Reflections*, trans. Edmund Jephcott (New York: Schocken, 1968), 154.

8. Edgar Allan Poe, "The Colloquy of Monos and Una" (1845), in *The Science Fiction of Edgar Allan Poe* (New York: Penguin, 1976), 96.

9. Rabinbach, *Human Motor*, 88.

10. Ibid., 46.

11. Ibid., 48.

12. Due to a polysemy of the "abstract" (as emphasized in Le Grice's account of abstract film), Kubelka's flicker films might have more allegiances to the scientific abstractions of time-work studies—with their analysis of sensory-motor givens—than to the spiritual project of abstract art. The latter is more explicitly coded in other works by the use of nonambiguous imagery and sound (mandalas, visualizations resembling thought forms, mantras or mantralike sounds, classical Indian music) or titles ("Spiritual Constructions," "Samadhi," "The Stopping Mind"). In contrast, Kubelka and Ruttman contribute not only to the quest for a pure vision that has more to do with rhythm than religion, but also to the tradition of the analysis and celebration of the "inhuman" aspect of film. The differences, however, can be slight. The last time I screened Kubelka's *Arnulf Rainer*, the print had a continuous scratch down the middle, transforming it into a flicker version of Barnett Newman's *Stations of the Cross*. See Malcolm Le Grice, *Abstract Film and Beyond* (London: Studio Vista, 1977), for the multiple meanings of abstract film; and P. Adams Sitney, *Visionary Film: The American Avant-Garde (1943–2000)*, 3rd ed. (New York: Oxford University Press, 2002), which has much useful material on Kubelka as well as other abstract filmmakers (to whom I will return in chapter 4).

13. Accompanying this systematization within a medical and scientific apparatus was an enframing of the medium's actual body in a more material apparatus. As Tom Gunning writes, "The medium becomes enframed [after the Civil War] in a sort of apparatus, and this apparatus is frequently under

control of a man" (52). This masculine presence and the placement of the medium in a box would be a way to guarantee the absence of fraud. As authors like Gunning, Alex Owen, and Anne Braude have shown, the appearance of this enframing apparatus signaled the decline of mediumism from a vehicle for early socialist-feminist activity to a sideshow attraction. Paradoxically, the spectacle of veridicality that these control measures entertain becomes the epitome of vaudevillian showmanship. One can imagine these boxes in which men placed women's bodies to be the forebears of modern magic cabinets. See Tom Gunning, "Phantom Images and Modern Manifestations: Spirit Photography, Magic Theater, Trick Films, and Photography's Uncanny," in *Fugitive Images: From Photography to Video*, ed. Patrice Petro (Bloomington: Indiana University Press, 1995), 42–71; Ann Braude, *Radical Spirits: Spiritualism and Women's Rights in Nineteenth-Century America* (Boston: Beacon Press, 1989); and Alex Owen, *The Darkened Room: Women, Power, and Spiritualism in Late Nineteenth-Century England* (London: Virago, 1989).

14. For a more detailed account of this history, see Alison Winter, *Mesmerized: Powers of Mind in Victorian Britain* (Chicago: University of Chicago Press, 1998).

15. Peter Washington, *Madame Blavatsky's Baboon: A History of the Mystics, Mediums, and Misfits Who Brought Spiritualism to America* (New York: Schocken Books, 1993), 55–56.

16. Annie Besant, *An Introduction to Yoga* (1908; Wheaton, Ill.: Theosophical Publishing House, 1976), 37.

17. Blavatsky, citing W. Howitt in Helena P. Blavatsky, *Isis Unveiled: A Master-Key to the Mysteries of Ancient and Modern Science and Theology*, vol. 1, *Science* (1877; Pasadena, Calif.: Theosophical University Press, 1960), 125.

18. Ibid., 125, 134.

19. Compare a passage from Emerson's "Experience" on the "life above life" that is "in us which changes not, and which ranks all sensations and states of mind": "Fortune, Minerva, Muse, Holy Ghost,—these are quaint names, too narrow to cover this unbounded substance. The baffled intellect must still kneel before this cause, which every fine genius has essayed to represent by some emphatic symbol, as, Thales by water, Anaximenes by air, Anaxagoras by *(Nous)* thought, Zoroaster by fire, Jesus and the moderns by love: and the metaphor of each has become a national religion. The Chinese Mencius has not been the least successful in his generalization. 'I fully understand language,' he said, 'and nourish well my vast-flowing vigor.'—'I beg to ask what you call vast-flowing vigor?' said his companion. 'The explanation,' replied Mencius, 'is difficult. This vigor is supremely great, and in the highest degree unbending. Nourish it correctly, and do it no injury, and it will fill up the vacancy between heaven and earth.'" Ralph Waldo Emerson, "Experience" (1844), in *The Collected Works of Ralph Waldo Emerson*, vol. 3 (Cambridge: Belknap Press, 1983), 42. A similar cross-cultural catalog occurs in

Eugene Jolas's "Workshop," in which he calls for "a new 'alchemy'" (44) for the artist in the midst of "civilization in collapse"(42): "He seeks the law of totality. He seeks a *restitutio in pristinum*. He develops whatever embryonic mystical faculties he may have.... He redevelops in himself ancient and mutilated sensibilities that have an analogy with those used in the mythological-magical mode of thought in the primitive man, with prophetic revelations, with orphic mysteries, with mystic theology such as that of Dionysius Areopagita, with the Kaballa, Tao, Hindoo philosophy, with Egyptian wisdom, with Gnostic rapture, with mantic experiences like those of Van Roesbroeck, Boehme, Master Eckhardt, St. John of the Cross, with the attitude of the early romantics, with the mental habits still extant in folklore and fairy tales, with clairvoyance, clairaudience, day and night dreaming, even with sub-human or psychotic thinking" (42). Eugene Jolas, "Workshop," in *Imagining Language: An Anthology*, ed. Jed Rasula and Steve McCaffery (Cambridge: MIT Press, 1998).

20. Alvin Boyd Kuhn, *Theosophy: A Modern Revival of Ancient Wisdom* (New York: Henry Holt, 1930), 95.

21. And while the theosophists' stance toward the mediums might seem apolitical or conservative given their political aims, one would have to note that women were in positions of leadership and power in the theosophical movement, while most mainstream factions of the spiritualist movement were invested in recognizing the power of women only as housewives and mothers. While Owenists and other followers of eighteenth-century scientist and mystic Emanuel Swedenborg espoused a more socialist spiritualism that critiqued marriage and the nuclear family, "domestic sphere" spiritualists claimed that women had power and contact with otherworldly spheres only through the maintenance of the domestic sphere (Owen, *The Darkened Room*, 30). For independent women spiritualists, the only option would be to give up their own ethereal powers for the price of admission, exploiting their inner radiance for ends that would increasingly have little to do with either spiritualism or politics.

22. Kuhn, *Theosophy*, 95.

23. A. E. Powell, *The Etheric Double: The Health Aura of Man* (1969; Wheaton, Ill.: Theosophical Publishing House, 1979), 88.

24. Walter Benjamin, *Illuminations*, trans. Harry Zohn (New York: Schocken, 1968), 242.

25. In his *Autobiography of a Yogi*, Paramahansa Yogananda at times describes his encounters with early modernist technologies—photography, trains, cinema—and their contributions to his spiritual awakening. In particular, he continually negotiates the reality of man-made images in order to understand an absolute cinema of spiritual sight. In the context of his thought—a product not only of ancient Indian philosophy but also of the various modern collisions of technology and philosophy—there is no real

difference between alienation through the processes of the cinema and some primal alienation from reality itself. After one of his masters takes him to a disappointing bioscope presentation at a university, he has an experience on the street that creates an ambivalent alliance of the cinema with the human eye: "'Little sir, you were disappointed in that bioscope, but I think you will like a different one.' The saint and I were standing on the sidewalk in front of the university building. He gently slapped my chest over the heart.

"A transforming silence ensued. Just as the modern 'talkies' became inaudible motion pictures when the sound apparatus goes out of order, so the Divine Hand, by some strange miracle, stifled the earthly bustle. Pedestrians as well as the passing trolley cars, automobiles, bullock carts, and iron-wheeled hackney carriages were all in noiseless transit. As though possessing an omnipresent eye, I beheld the scenes that were behind me, and to each side, as easily as those in front. The whole spectacle of activity in that small section of Calcutta passed before me without a sound. Like a glow of fire dimly seen beneath a thin coat of ashes, a mellow luminescence permeated the panoramic view.

"My own body seemed nothing more than one of the many shadows; though it was motionless, while the others flitted mutely to and fro. Several boys, friends of mine, approached and passed on; though they had looked directly at me, it was without recognition.

"The unique pantomime brought me an inexpressible ecstasy. I drank deep from some blissful fount. Suddenly my chest received another soft blow from Master Mahasaya. The pandemonium of the world burst upon my unwilling ears. I staggered, as though harshly awakened from a gossamer dream. The transcendental wine was removed beyond my reach.

"'Little sir, I see you found the second bioscope to your liking.'" Paramahansa Yogananda, *Autobiography of a Yogi* (1946; Los Angeles: Self Realization Fellowship, 1985), 94–95. The cinema eye is a potential guru for the human eye. Cinema, at least when silent, teaches the detachment necessary for the yogi.

26. Rabinbach, *Human Motor*, 113.

27. Henri Bergson, *Creative Evolution*, trans. Arthur Mitchell (1911; New York: Random, 1944), 225.

28. Deleuze, *Cinema One: The Movement-Image*, trans. Hugh Tomlinson (Minneapolis: University of Minnesota Press, 1989), 56.

29. Rabinbach, *Human Motor*, 113.

30. Deleuze, *Cinema Two: The Time-Image*, trans. Hugh Tomlinson (Minneapolis: University of Minnesota Press, 1989), 98.

31. Deleuze, *Cinema One*, 59. Deleuze's "plane of immanence" can be added to the Blavatsky catalog as another name for the ether. There are some crucial differences from other historical ethers, but the commonalities are striking. See Deleuze, *What Is Philosophy?* trans. Hugh Tomlinson and Graham Burchell (New York: Columbia University Press, 1994), 35–60.

32. Ibid.

33. Hinton, *Speculations on the Fourth Dimension*, 16.

34. P. D. Ouspensky, *Tertium Organum: A Key to the Enigmas of the World*, trans. E. Kadloubovsky and P. D. Ouspensky (1920; New York: Vintage, 1982), 92.

35. Ibid., 90–91.

36. "The *élan vital* is offered as an image of thought but not one without reference to experience. This is experience enlarged and gone beyond and is valid for both science and metaphysics.... The *élan vital* is part of Bergson's effort to cultivate a 'superior' empiricism. It exists to remind us of our ignorance and to encourage us to go further with our inquiry.... In this respect it could legitimately be said that in key aspects and elements contemporary science is Bergsonian." Keith Ansell-Pearson, *Philosophy and the Adventure of the Virtual* (New York: Routledge, 2001), 139.

37. Margaret Morse's important essay on installation art, "Video Installation Art: The Body, the Image, and the Space-in-Between," situates the transcendence of installation art not in some absolute outside but within the unique temporality and experience of the body: "These arts address the wide-awake consciousness that we call experience. Such a realm is not immune from its own fictions and intensities, nor does it lack spirituality; play, ritual, and revolution are part of this plane of presence.... An installation without this intertwining of corporeal and conceptual transcendence would be nothing more than an exhibition, a site for learning knowledge always already known, transmitted by the authorities who know it—governments, corporations, schools, and other institutions of all kinds." Margaret Morse, "Video Installation Art: The Body, the Image, and the Space-in-Between," in *Illuminating Video: An Essential Guide to Video Art*, ed. Doug Hall and Sally Jo Fifer (San Francisco: Aperture, 1991), 165.

38. Ann Hamilton, *corpus*, MASS MoCA, 2003–4.

39. *The Stopping Mind*, Bill Viola (1991), Museum für Moderne Kunst, Frankfurt.

40. *Room for St. John of the Cross*, Bill Viola (1983), Museum of Contemporary Art, Los Angeles.

41. A. B. Kuhn, *Theosophy*, 100.

42. Leonid Andreyev, *Requiem* (1917), trans. Daniel Gerould, in *Doubles, Demons, and Dreamers: An International Collection of Symbolist Drama*, ed. Daniel Gerould (New York: PAJ Publications, 1985), 212.

43. Antonin Artaud, "Strindberg's *Dream Play*" (1928), in *Selected Writings*, trans. Helen Weaver (New York: Farrar, Straus and Giroux, 1976), 163.

44. August Strindberg, *Five Plays*, trans. Harry G. Carlson (New York: Signet, 1984), 209.

45. Artaud, "Strindberg's *Dream Play*," 163.

46. Andreyev, *Requiem*, 211.

47. Ibid., 220.

48. See Daniel Geroud, "The Art of Symbolist Drama: A Re-assessment," in *Doubles, Demons, and Dreamers*, 12.

49. Strindberg, *Five Plays*, 57.

50. August Strindberg, *To Damascus I* (1900), in *Eight Expressionist Plays*, trans. Arvid Paulson (New York: New York University Press, 1972), 163–64.

51. Strindberg, *Five Plays*, 271–72.

52. Charles W. Leadbeater, *Man Visible and Invisible: Examples of Different Types of Men as Seen by Means of Trained Clairvoyance* (1925; Wheaton, Ill.: Theosophical Publishing House, 1980), 22–23.

53. Strindberg, *Five Plays*, 212.

54. Ibid., 230–31.

55. Artaud, "Strindberg's *Dream Play*," 164.

56. Karl Marx, *Grundrisse: Foundations of the Critique of Political Economy*, trans. Martin Nicolaus (1858; New York: Random, 1973), 106–7.

57. Strindberg, *Five Plays*, 50–102.

58. Ibid., 227.

59. Ibid., 262.

60. Alexander Blok, *The Stranger* (1907), trans. Daniel Gerould, in *Doubles, Demons, and Dreamers: An International Collection of Symbolist Drama*, ed. Daniel Gerould (New York: PAJ Publications, 1985), 156–57.

61. Gaston Bachelard, *Air and Dreams: An Essay on the Imagination of Movement*, trans. Edith R. Farrell and C. Frederick Farrell (1943; Dallas: Dallas Institute Publications, 1988), 29.

62. Ibid., 261.

63. Strindberg, *Five Plays*, 273.

64. Ibid., 258.

65. Ibid., 259.

66. Ibid., 255.

67. Ibid., 258.

68. August Strindberg, *From an Occult Diary: Marriage with Harriet Bosse*, trans. Torsten Eklund (1900–1908; London: Camelot, 1965), 55.

69. Strindberg, *Five Plays*, 270.

70. Ibid.

71. Strindberg, *Occult Diary*, 47.

72. See *Easter* in August Strindberg, *Plays: August Strindberg*, trans. Elizabeth Sprigge (Chicago: Aldine Publishing, 1962).

73. *The Blue Bird*, dir. Walter Lang, Twentieth Century Fox, 1940.

74. Michael Atkinson, "Film Enchanté: Out of the Nursery, into the Night," *Film Comment*, November–December 1998, 35.

75. Ibid., 38.

76. Cited in Max Jammer, *Concepts of Space: The History of Theories of Space in Physics* (1954; New York: Dover, 1993), 143.

77. *My Neighbor Totoro*, dir. Hayao Miyazaki, Studio Ghibli, 1988.

78. *Kiki's Delivery Service*, dir. Hayao Miyazaki, Studio Ghibli, 1989.

79. *Princess Mononoke*, dir. Hayao Miyazaki, Studio Ghibli, 1997.

80. An excellent resource for those who wish to study these intersections further is Takashi Murakami's *Little Boy*, the catalog from his 2005 exhibition at New York City's Japan Society. See *Little Boy: The Arts of Japan's Exploding Subculture*, ed. Takashi Murakami (New Haven: Yale University Press, 2005).

81. *Sailor Moon*, dir. Juichi Sato, Cloverway International, 1995.

82. Victoria Newsom, "Young Females as Super Heroes: Superheroines in the Animated *Sailor Moon*," Femspec, http://www.femspec.org/samples/ sailormoon.html.

83. *Aeon Flux: Operative Terminus*, dir. Peter Chung, Colossal Pictures, 1997.

84. *Urotsukidoji III: Return of the Overfiend 1*, dir. Toshio Maeda, Anime 18, 1993.

85. While their age difference is significant, it is not remarked on except on fan Web sites (e.g., http://www.neonevangelion.host.sk/evangelionv2/en/ character.html); in fact, their cartoon physiques, added to the fact that Misato is characterized as impulsive and childish, make them seem more like contemporaries.

86. *Neon Genesis Evangelion*, dir. Hideaki Anno, Gainax/TV Tokyo, 1995.

87. Could we not say that, attuned to the dynamism of the future, anime implicates children in intense scenarios because the child is the symbol of the future par excellence? If these are not fourteen-year-olds we are identifying with, then perhaps they are icons of the virtual, pointing to a space of possibility—precisely that space that allows for remapping in times of change and anxiety. Moreover, if ontogeny recapitulates phylogeny, could it be that the child represents an earlier form of human consciousness that one would have to acknowledge in order to save the world? Or do these children promise another level of human consciousness that has yet to meet the challenges of adolescence?

88. *Dominion Tank Police*, dir. Takaaki Ishiyama, Central Park Media, 1988.

89. *Akira*, dir. Katsuhiro Ōtomo, Akira Committee Co. Ltd., 1998.

90. I am indebted to Kelly Joyce for her insights and unpublished work on *Sailor Moon* and its relation to New Age concepts of biopower.

91. *Maps 3 & 4*, dir. Shusumu Nishizawa, Tokyo Movie Shinsha, 1994.

92. *The Fifth Element*, dir. Luc Besson, Gaumont, 1997.

3. Radio, Ether, and the Avant-Garde

1. It should be noted right off that "radio" comprises only a portion of the electromagnetic spectrum that goes from long-wave radio emissions to gamma rays and includes, as it proceeds to shorter waveforms, the small

sliver of the visible, as well as the rays of the hypervisible (x-rays). There is a confusion of terms, however, because what is many times called "electromagnetic spectrum allocation" is merely radio frequency allocation by a more mystifying name. The "radio" band of the spectrum includes shortwave and commercial radio, television, and microwave frequencies, as well as space restricted for governmental use in warfare, astronomy, and, in some cases, extraterrestrial communication (SETI). Even though the late nineteenth century and the early twentienth were notable for discoveries in the electromagnetic spectrum proper (Roentgen's x-ray in 1896; the gamma ray by Rutherford in 1903), this chapter will concentrate on the radio sector of the electromagnetic ether because of its status as a well-known domain of culture, communication, and art. Suffice to say, though, many of the artistic practices discussed will evince a fascination for, or even an intimacy with, the larger system of vibrations to which the radio set serves only as a threshold.

2. See Susan Douglas, *Inventing American Broadcasting, 1899–1922* (Baltimore: Johns Hopkins University Press, 1987).

3. Ibid., 141.

4. James Joyce, *Ulysses* (New York: Random, 1946).

5. Enrico Prampolini, "Futurist Scenography" (1915), in *Futurist Performance*, ed. Michael Kirby and Victoria Nes Kirby (New York: PAJ Publications, 1986), 206.

6. Enrico Prampolini, "Futurist Scenic Atmosphere" (1924), in *Futurist Performance*, ed. Michael Kirby and Victoria Nes Kirby (New York: PAJ Publications, 1986), 230.

7. Velimir Khlebnikov, "The Radio of the Future" (1921), in *The King of Time: Selected Writings of the Russian Futurian*, trans. Paul Schmidt (Cambridge: Harvard University Press, 1985), 155–56.

8. Ibid., 157.

9. Velimir Khlebnikov, "Zangezi: A Supersaga in Twenty Planes," in *The King of Time: Selected Writings of the Russian Futurian*, trans. Paul Schmidt (Cambridge: Harvard University Press, 1985), 204.

10. In Italian, *fisicofollia*. F. T. Marinetti, "The Variety Theatre" (1913), in *Futurist Performance*, ed. Michael Kirby and Victoria Nes Kirby (New York: PAJ Publications, 1986), 183.

11. Jacques Derrida, *Of Grammatology*, trans. Gayatri Chakravorty Spivak (Baltimore: Johns Hopkins University Press, 1974), 26.

12. It is thus that contemporary radio artists are not above brooding over lost signals and missing signalers—the primal play of absence at the heart of all telepresence, the dead tapety-tap-tap behind electromagnetic foolness. The human disappears with radio, which stages, as Gregory Whitehead has pointed out, "nobody" dramas. "Where" it takes place, "who's" there, and "who" listens, Whitehead says, are the chance elements of this essentially nonhuman medium: "The real site of radio . . . is not in the studio or the sta-

tion, but rather in the highly provisional and politically delicate relationship of complicity that exists between an artist and listener—a relationship that is simultaneously enhanced and endangered by the potentially infinite, infinitely empty domain of abstract air" (12). *Logos* has become a chance operation, not a transcendental given. As Whitehead shows in his Rosetta stone of audio art, *Dead Letters*, while there is an infinite possibility for disconnection, there are also multitudes of angelic forces that devote themselves to delivering meaning out of the potentially meaningless. At the same time that Whitehead marshals disparate pieces of interview material to create the feeling of dismemberment, fragmentation, and inscrutability (people talk about fake fingers, the remains of Napoleon's penis, ancient texts, savage handwriting of the powerful), he also brings together materials that exemplify the human propensity to make things whole again (postal workers in a dead-letter office describe the care they take in redirecting or deciphering potential nixies; a woman describes her cosmic fantasy about Judy Garland's voice; a museum official marvels over the revivification of an entire ancient culture by means of the chance finding of a dreary stone). Not only is this dialectic between meaning and meaninglessness fundamental to the esoteric domain of radio art, but the implications it holds for the future of technologically mediated communication in general should be clear. Gregory Whitehead, "Who's There? Notes on the Materiality of Radio," *Art & Text* 31 (1989): 10–13; and *Dead Letters*, audiotape (San Francisco: Art Ear, 1994).

13. F. T. Marinetti et al., "The Futurist Cinema" (1916), in *Futurist Performance*, ed. Michael Kirby and Victoria Nes Kirby (New York: PAJ Publications, 1986), 214.

14. Ibid., 212.

15. Derrida, *Of Grammatology*, 13.

16. Ibid., 17.

17. Giacomo Balla and Fortunato Depero, "The Futurist Reconstruction of the Universe" (1915), Niuean Pop Cultural Archive, www.unknown.nu/futurism/reconstruction.html.

18. Velimir Khlebnikov, "Z and Its Environs" (1915), in *Collected Works of Velimir Khlebnikov*, vol. 1, *Letters and Theoretical Writings*, trans. Paul Schmidt (Cambridge: Harvard University Press, 1987), 304–6.

19. Khlebnikov, "The Radio of the Future," 159.

20. Velimir Khlebnikov, "Proposals" (1915–16), in *Collected Works of Velimir Khlebnikov*, vol. 1, *Letters and Theoretical Writings*, trans. Paul Schmidt (Cambridge: Harvard University Press, 1987), 360.

21. F. T. Marinetti, *The Founding Manifesto of Futurism* (1909), in *Futurist Manifestos*, ed. Umbro Apollonio (London: Thames and Hudson, 1973), 22.

22. Ibid.

23. Marinetti's idea of "absolute dynamism" describes a montage of ethers—Einstein meets Eisenstein—an irrational juxtaposing of ambiences

and environments: "The theatrical ambience in our inexhaustible reservoir of inspirations: the magnetic circular sensation invading our tired brains during morning rehearsal in an empty gilded theatre; . . . WE ACHIEVE AN ABSOLUTE DYNAMISM THROUGH THE INTERPENETRATION OF DIFFERENT ATMOPHERES AND TIMES. . . . In the Futurist synthesis, *Simultaneità*, there are two ambiences that interpenetration and many different times put into action simultaneously." The absolute for Marinetti lay in the dynamic, magnetic correlation of ambience, rather than some distant, ungraspable authority. F. T. Marinetti et al., "The Futurist Synthetic Theatre" (1915), in *Futurist Performance*, ed. Michael Kirby and Victoria Nes Kirby (New York: PAJ Publications, 1986), 200.

24. *Orpheus*, dir. and written by Jean Cocteau, Janus Films, 1949.

25. Jack Spicer, "Vancouver Lecture 1: Dictation and 'A Textbook of Poetry'" (June 13, 1965), in *The House That Jack Built: The Collected Lectures of Jack Spicer*, ed. Peter Gizzi (Hanover, N.H.: Wesleyan University Press, 1998), 17.

26. Jack Spicer, *The Heads of the Town Up to the Aether* (1960–61), in *The Collected Books of Jack Spicer*, ed. Robin Blaser (Los Angeles: Black Sparrow Press, 1975), 158.

27. Ron Silliman, *The New Sentence* (New York: Roof, 1989), 161.

28. Spicer, "Vancouver Lecture 1," 5.

29. Ibid., 16.

30. Spicer, *Heads of the Town*, 163–64.

31. Ibid., 170. "When I'm writing a poem, I always try not to see the connections. If you remember in the previous part I read, one of the poems ended with 'Teach.' And the next poem had 'Taught. As a wire. . . .' The pun did not occur to me while the poem was going on." Spicer, "Vancouver Lecture 1," 23.

32. The slippage between Martians and ghosts happens with a quiet regularity in many of the twentieth-century ether texts under consideration. However, the Martian is the ascendant image inspired by the otherworldly effects of high-tech communication, as the ghost falls out of currency once radio (a transcosmic device) hits the scene. From Khlebnikov, who promoted "participants in Futurian publications . . . from the ranks of human beings to the ranks of Martians" in his "Trumpet of the Martians," to the later work of Philip K. Dick and William Burroughs, which detailed paranoiac alien-colonization scenarios, the Alien, an allegorical figure of absolute exteriority or otherness, overthrows the Ghost, a figure of the human soul. Velimir Khlebnikov, "The Trumpet of the Martians" (1916), in *The King of Time: Selected Writings of the Russian Futurian*, trans. Paul Schmidt (Cambridge: Harvard University Press, 1985), 129.

33. Spicer, "Vancouver Lecture 1," 8.

34. Arthur C. Clarke, *2001: A Space Odyssey* (New York: New American Library, 1968), 109.

35. Ibid., 83.

36. Ibid., 185.

37. Ibid., 209.

38. Ibid, 219.

39. Ibid., 220.

40. Slavoj Žižek, *Looking Awry: An Introduction to Jacques Lacan through Popular Culture* (Cambridge: MIT Press, 1991), 81.

41. Philip K. Dick, *Radio Free Albemuth* (New York: Vintage Books, 1985), 127.

42. Ibid., 111–12.

43. Philip K. Dick, *Valis* (1981; New York: Vintage Books, 1991), 71.

44. Spicer, "Vancouver Lecture 1," 21, 24–25.

45. Steve McCaffery, "From Phonic to Sonic: The Emergence of the Audio-Poem," in *Sound States: Innovative Poetics and Acoustical Technologies,* ed. Adalaide Morris (Chapel Hill: University of North Carolina Press, 1997), 155.

46. Henri Chopin, "Why I Am the Author of Sound Poetry and Free Poetry" (1967), *UbuWeb: Visual, Concrete and Sound Poetry,* www.ubu.com/papers/chopin.html.

47. Pierre Garnier, "Position I of the International Movement" (1963), *UbuWeb: Visual, Concrete and Sound Poetry,* www.ubu.com/papers/Garnier01 .html.

48. Bob Cobbing, "Some Statements on Sound Poetry" (1969–72), *UbuWeb: Visual, Concrete and Sound Poetry,* www.ubu.com/papers/cobbing .html.

49. *2001: A Space Odyssey,* dir. Stanley Kubrick, MGM, 1968.

50. For an appreciation of "alien musics," see Kodwo Eshun, *More Brilliant than the Sun: Adventures in Sonic Fiction* (London: Quartet, 1998).

51. Woody Vasulka and Charles Hagen, "A Syntax of Binary Images: An Interview with Woody Vasulka," *Afterimage* 6, nos. 1–2 (Summer 1978): 20–31.

52. John Cage and Morton Feldman, "Radio Happenings: Recorded at WBAI, NYC 7/9/66–1/16/67," in *Exact Change Yearbook No. 1,* ed. Peter Gizzi (Boston: Exact Change, 1995), 256.

53. Among other work on Cage's *Imaginary Landscape No. 4,* see the chapter "Radio as Musical Instrument," in *Phantasmatic Radio,* by Allen Weiss (Durham: Duke University Press, 1995).

54. "After the concert, a procession of helpers lugged the golden throats and the percussion instruments out to the sidewalk. Richard Lippold drove up in his hearse, which carried them away into the night." ("Golden Throat"

was the brand name of the radios Cage used.) David Revill, *The Roaring Silence: John Cage; A Life* (New York: Arcade, 1992), 138.

55. Benjamin, *Reflections*, 156.

56. I have been unable to ascertain Mori's progress on the levitation machine cited in the following 1998 quote: "The interactive *Enlightenment Capsule*, when it evolves from its current prototype stage, will combine the Himawari device with a levitation system that causes the lotus leaf to float while bearing the weight of someone sitting on it. The artist has been speaking to several corporations about how to create the magnetic field required to achieve this effect." Lisa Corrin, "Mariko Mori's Quantum *Nirvana*," in *Mariko Mori* (Chicago: Museum of Contemporary Art, 1998), 19–24.

57. Douglas, *Inventing American Broadcasting*, 97.

58. Reed Ghazala is generally considered the central figure and earliest proponent of this art. For facts and "how to," see his site, www.anti-theory.com.

59. Walt Whitman, "Art-Singing and Heart-Singing," *Broadway Journal* 2, no. 23 (November 29, 1845): 318–19.

60. Lou Mallozzi, Hal Rammel, and Terri Kapsalis, untitled performance, Woodland Pattern Book Center and Gallery, Milwaukee, Wis., April 15, 2000. In other performances of the same sort at Woodland Pattern, including ones by Steve Nelson-Raney and Thomas Gaudynski, the e-bow (short for energy bow, a pocket magnetic device used to play strings without plucking) extends the electromagnetic jam further.

61. This term appears in Philip Dick's *Radio Free Albemuth*: "'What we receive,' Sadassa said, 'is pararadio signals, a radiation enclosure of the radio beam, so that if the radio message is decoded it signifies nothing.... The radio signal alone is only half the total information'" (175).

62. When tables are not used, it is usually in the realm of circuit bending, in which the desire is to create a more intimate, less rigid performance. The Milwaukee artist Andy Puls has performed his circuit-bending chamber music on a carpet, under the light of a living-room lamp, to create the feeling, both for himself and for the audience, that what is performed comes from that space of day-to-day discovery and private, understated innovation. Circuit benders are more apt, also, to have their instruments be self-amplified art objects in themselves, whereas sometimes the table is ultimately needed for more standard-issue mixers, turntables, and laptops.

63. Karl Marx, *Capital: A Critique of Political Economy*, trans. Samuel Moore (1867; New York: Modern Library, 1906), 81–82.

64. Ryan Schoelerman, personal e-mail, April 2000.

65. Shawn James Rosenheim, *The Cryptographic Imagination: Secret Writing from Edgar Poe to the Internet* (Baltimore: Johns Hopkins University Press, 1997).

66. Schoelerman, personal e-mail.

67. Matthew Burtner, "Regenerative Feedback in the Medium of Radio: *Study 1.0 FM for Radio Transceiver," Leonardo Music Journal* 13 (2003): 41.

68. Joyce Hinterding, "Aeriology," *Imago,* www.sunvalleyresearch.com/Luminoska/index2.htm.

69. Josephine Bosma, "Interview with Joyce Hinterding" (1998), *Soundsite,* www.sysx.org/soundsite/texts/02/hinterding.htm.

70. Zoe Beloff and Ken Montgomery, *A Mechanical Medium,* performance, CityMorph 2000 Festival of New Media, Buffalo, N.Y., March 2000.

71. Beloff and Montgomery, *A Mechanical Medium.*

4. Ether Underground

1. Yves Klein, *Yves Klein, 1928–1962: Selected Writings,* trans. Barbara Wright (London: Tate Gallery, 1974), 49, 73–77.

2. Ibid., 47.

3. Ibid., 63.

4. Ibid., 71.

5. Thomas McEvilley, "Yves Klein: Conquistador of the Void," in *Yves Klein, 1928–1962: A Retrospective,* ed. Institute of the Arts, Rice University (New York: Arts Publisher, 1982), 62–66.

6. Erik Davis, *Techgnosis: Myth, Magic and Mysticism in the Age of Information* (New York: Three Rivers, 1998), 144.

7. Ibid., 147.

8. In Norman Mailer's epic account of Apollo-Saturn, *Of a Fire on the Moon,* he tortures out this double nature of the mission: "The notion that man voyaged out to fulfill the desire of God was either the heart of the vision, or anathema to that true angel in Heaven they would violate by the fires of their ascent." Norman Mailer, *Of a Fire on the Moon* (Boston: Little, Brown, 1970), 103.

9. This question is played out precisely along these lines in Zemeckis's *Contact.* A machine for space travel built by way of a mysterious blueprint decoded from space noise is ready to be activated in the United States. The first machine is compromised because it is the center of a media circus that includes a religious terrorist who eventually blows up this craft on the sunny and wholesome launch day. The second machine has been built secretly, in a remote Eastern location. The mise-en-scène of this new complex is a mixture of old-time sci-fi and Japanese aesthetics. The launch is secretive and takes on the dignity of a Zen ritual. *Contact,* dir. Robert Zemeckis, Warner Bros., 1997.

10. Davis, *Techgnosis,* 145.

11. In fact, through a common concern with the technological experience of literally and metaphysically higher planes and in anticipation of this

ultra-event of a moon walk, this period evinced some of the great collabora-
tions between the counterculture and big business, art and technology. If
representing space became a common concern (witness, for example, the
unprecedented synergy between avant-garde visualization, electronic music
composition, space-age philosophy, and traditional Hollywood filmmaking in
2001: A Space Odyssey or the big-budget polyvisual environments of Expo
'68), it was not, however, noncontested "ground." Interestingly enough, while
the official space program had its well-publicized detractors, many revisionists
consider it as the outcome of the democratic process and the dedication of
thousands of workers and their families (as in the Tom Hanks–produced
miniseries *From the Earth to the Moon*). Meanwhile, it was the radical, indi-
vidualistic "space program"—the postwar inheritors of absolute art in film—
that was later smoked out of its high standing in the film world because of
blanket criticisms stemming from certain artists' alleged lack of politics, and
infelicities of character.

12. "Sputnik I took on a magical dimension—among highly placed
persons especially, judging by opinion surveys. It seemed to dredge up pri-
mordial superstitions about the influence of heavenly bodies. It gave birth to
a modern, i.e., technological, astrology. Nothing less than *control of the heav-
ens* was at stake." Tom Wolfe, *The Right Stuff* (New York: Farrar, Straus and
Giroux, 1979), 57.

13. Cited in Alexandre Koyré, *From the Closed World to the Infinite Uni-
verse* (Baltimore: Johns Hopkins University Press, 1957), 76.

14. As Arthur Koestler says in his Kepler-intensive account of the
philosophers and mathematicians who discovered the scientific laws of the
natural world without knowing it and as if sleepwalking, Kepler always con-
sidered his revision of ancient spherical harmonies more important than his
discovery of actual elliptical orbits. In effect, the first law of planetary
motion remained an embarrassment to Kepler throughout his life. Arthur
Koestler, *The Sleepwalkers* (London: Hutchinson, 1959).

15. Koyré, *From the Closed World*, 102.

16. *Apollo 11 Launch Coverage*, NBC News, 1969, Museum of Broadcast
Communications, Chicago.

17. Karl Marx, *Grundrisse: Foundations of the Critique of Political Econ-
omy*, trans. Martin Nicolaus (1858; New York: Random, 1973), 106–7.

18. Georg Simmel, *The Philosophy of Money*, trans. Tom Bottomore et al.
(1900; New York: Routledge, 1990), 146. Don DeLillo, in *Players*, his novel
of stock market intrigue, describes the acceleration of money into electronic
capitalism's ether-space of instrumental abstraction: "Inside some of the
granite cubes, or a chromium tower here and there, people sorted money of
various types, dizzying billions being propelled through machines, computer-
scanned and coded, filed, cleared, wrapped and trucked, all in a high-speed
din, that rip of sound intrinsic to deadline activities. He'd seen the encoding

rooms, the micro-filming of checks, money moving, shrinking as it moved, beginning to elude visualization, to pass from a paper existence to electronic sequences, its meaning increasingly complex, harder to name." Don DeLillo, *Players* (New York: Knopf, 1977), 109–10.

19. McKenzie Wark, *Virtual Geography: Living with Global Media Events* (Bloomington: Indiana University Press, 1994), 176.

20. It may be that as this "true picture of the past flits by," a deeper disappearance threatens, for, as Benjamin says in his *Theses on the Philosophy of History*, "every image of the past that is not recognized by the present as one of its own concerns threatens to disappear irretrievably." Walter Benjamin, *Illuminations*, trans. Harry Zohn (New York: Schocken, 1968), 255.

21. Mary Ann Doane, "Information, Crisis, Catastrophe," in *Logics of Television: Essays in Cultural Criticism*, ed. Patricia Mellencamp (Bloomington: Indiana University Press, 1990), 226.

22. See Arthur Lovejoy, *The Great Chain of Being: A Study of the History of an Idea* (Cambridge: Harvard University Press, 1966), 244–45.

23. Dale Carter, *The Final Frontier: The Rise and Fall of the American Rocket State* (New York: Verso, 1988), 2–5.

24. *Capricorn One*, dir. Peter Hyams, Capricorn One Associates, 1978.

25. *October Sky*, dir. Joe Johnston, Universal, 1999.

26. *Apollo 13*, dir. Ron Howard, Universal, 1995.

27. *From the Earth to the Moon*, executive producer, Tom Hanks, Clavius Base/Imagine Entertainment/HBO, 1998.

28. See Wark, *Virtual Geography*.

29. *Apollo 11 Launch Coverage*, NBC News, 1969.

30. *Outer & Inner Space*, Andy Warhol, 1965. The Andy Warhol Foundation, 1999.

31. Gene Youngblood, *Expanded Cinema* (New York: E. P. Dutton, 1970), 257. *Empire* (1964) is an eight-hour Andy Warhol film, which consists of a single shot of the Empire State Building.

32. Ibid.

33. Ibid., 46–47.

34. Pierre Teilhard de Chardin, *The Future of Man*, trans. Norman Denny (New York: Harper and Row, 1964), 181.

35. Youngblood, *Expanded Cinema*, 78.

36. Since many of these films exist in multiple versions or are not currently available for distribution, I have relied on archival prints whenever possible. One would assume these copies to be definitive; however, since many of the expanded cinema avant-garde embraced process over product, there is sometimes no clear notion of a definitive copy. However, it would be a mistake, for example, to use as a guide to Belson's oeuvre the sampling that Mystic Fire has distributed on video as *Samadhi and Other Films* (although, unfortunately for the casual consumer, Belson has restricted distribution of

the other versions, maintained by Anthology Film Archives). The video version overly reedits the "originals" to a sanitized New Age sound track, replacing Belson's earlier grungy psychedelic, tape loop, and reverb sound tracks. Anger's *Rabbit's Moon* was revised a number of times over the course of thirty years; in *Moonchild: The Films of Kenneth Anger*, ed. Jack Hunter (Creation Books, 2001), it is listed under "Lost, Fragmented, and Abortive Films." Of the two finished versions, it is the 1972 version of *Rabbit's Moon* that is more thoughtful and mysterious, to me, superior to the later sped-up version. My tastes here do not come from purist notions, because, in fact, of the multiple sound tracks that Harry Smith had for his *Early Abstractions*, I think the Beatles version is sublime. Yet the story goes that when Anthology Film Archives asked Smith what sound track he wanted for this work (which in earlier versions had Dizzy Gillespie, and originally was silent), he told them just to put on whatever was popular at the time.

37. *Re-entry*, Jordan Belson, Anthology Film Archives, 1964.

38. Wheeler Winston Dixon, *The Exploding Eye: A Re-visionary History of 1960s American Experimental Cinema* (New York: State University of New York Press, 1997), 147.

39. Jordan Belson, personal interview, August 2000.

40. *Cosmos*, Jordan Belson, Anthology Film Archives, 1969.

41. Scott MacDonald, *A Critical Cinema 3: Interviews with Independent Filmmakers* (Berkeley: University of California Press, 1998), 86.

42. This punctum is precisely the famous punctum of Barthes, who uses the term to elucidate the relation of desire to the anima of what, to all appearances, is an unmoving, dead object—the photograph: "I animate this photograph and . . . it animates me. The *punctum*, then, is a kind of subtle *beyond*—as if the image launched desire beyond what it permits us to see . . . toward the absolute excellence of a being, body and soul together" (59). Barthes's description, even though imbued with the imagery of space travel, is instead about erotic photographs and their distinction from the pornographic. It is here, at the end of part 1 of *Camera Lucida*, that he founders and admits, before embarking on the palinode of part 2, that his "pleasure was an imperfect mediator, and that a subjectivity reduced to its hedonist project could not recognize the universal" (60). He thus brings into the hermetic circle of the punctum the question of responsibility toward our animations of meaning, cosmic or otherwise, thus opening a debate both inherent to spirituality and to the feminist or psychoanalytic work on this cinematic movement. Roland Barthes, *Camera Lucida: Reflections on Photography*, trans. Richard Howard (New York: Hill and Wang, 1981).

43. *The Right Stuff*, dir. Philip Kaufman, special visual sequences by Jordan Belson, Ladd Co., 1983.

44. William C. Wees, *Light Moving in Time: Studies in the Visual Aesthetics of Avant-Garde Film* (Berkeley: University of California Press, 1992), 130.

45. *Allures*, Jordan Belson, Anthology Film Archives, 1961.

46. *Lapis*, James Whitney, Anthology Film Archives, 1963–66.

47. *Off/On*, Scott Bartlett, Filmmakers' Cooperative, 1967.

48. *Turn, Turn, Turn*, Jud Yalkut, Filmmakers' Cooperative, 1966.

49. Duchamp's *Anemic Cinema* has remote mesmeric thematics, from the spinning discs that reference hypnotic devices to a few obscure puns about baths, spas, and dubious cures.

50. *Powers of Ten*, Charles and Ray Eames, Pyramid Films, 1977.

51. *Moon 69*, Scott Bartlett, Filmmakers' Cooperative, 1969.

52. *A Trip to the Moon*, Scott Bartlett, Filmmakers' Cooperative, 1969.

53. *Rabbit's Moon*, Kenneth Anger, Anthology Film Archives, 1972.

54. *A Midsummer Night's Dream*, dir. Max Reinhardt, Warner Bros., 1935.

55. Robert A. Haller, *First Light*, ed. Robert Haller (New York: Anthology Film Archives, 1998), 76.

56. That Anger should reinject desire into spaceflight should come as no surprise, especially since Crowleyian sex magick informs his relation to film. Indeed, Anger associated with the Crowley disciple and father of spaceflight, Jack Parsons, who, while running Pasadena's Jet Propulsion Laboratory, maintained a mansion that became a demimonde of anarchists and bohemians in the 1940s and 1950s. Parsons developed the solid rocket fuel that eventually allowed us to exit the atmosphere. Along with L. Ron Hubbard, Parsons engaged in a variety of sex rituals, including centrally those with their "elemental"—Marjorie Cameron—who they decided was destined to bear an Apocalypse-heralding moonchild. Parsons would die in a mysterious explosion in 1952. The widowed Cameron would later appear in Anger's *Inauguration of the Pleasure Dome*. See John Carter, *Sex and Rockets: The Occult World of Jack Parsons* (Los Angeles: Feral House, 2000).

57. *Moondial*, Jud Yalkut, Filmmakers' Cooperative, 1966; *Fireworks*, Kenneth Anger, Anthology Film Archives, 1947.

58. Synthesizers were the result of technological "convergences" between sound modules that, before the 1970s, were disparate machines, manually patched together.

59. Cited in P. Adams Sitney, *Visionary Film: The American Avant-Garde* (New York: Oxford University Press, 1974), 271.

60. Rani Singh, "Published Talk, Anthology Film Archives" (1995), in *American Magus, Harry Smith: A Modern Alchemist*, ed. Paolo Igliori (New York: Inanout, 1996), 16.

61. Sitney, *Visionary Film*, 280.

62. As I have gathered from talking to Smith experts, Smith delegated this choice of sound track to the Anthology Film Archives—asking that the film be distributed with whatever music was popular at the time.

63. *Early Abstractions*, Harry Smith, 1946–57, Anthology Film Archives, 1964.

64. Lionel Ziprin, interview (May–June 1993), in *American Magus, Harry Smith: A Modern Alchemist*, ed. Paolo Igliori (New York: Inanout, 1996), 47.

65. Thomas McEvilley, in a description of Yves Klein, shows how Smith's stance was partly generational: "Yves Klein's brief artistic career (1955–62) falls precisely on the boundary between modernism and postmodernism. Many figures of his generation may be described as living partly in the spirituality of the earlier period and partly in the spirit of the later one, though perhaps none as much as Klein. He was the pivotal figure who stood at the transition point, one foot firmly planted in the modernism of the abstract sublime, the other as firmly planted in the postmodern parody and ironization of it.... So perfectly poised was he on that razor's edge that he felt and expressed the most sincere and honest awe and reverence toward the sublime, and at the same time the most sincere and honest ridicule and parody of it." Thomas McEvilley, "Yves Klein and the Double-Edged Sublime," in *On the Sublime: Mark Rothko, Yves Klein, James Turrell* (New York: Guggenheim Foundation, 2001), 69–71.

66. *Heaven and Earth Magic*, Harry Smith, Filmmakers' Cooperative, 1959–61.

67. Harry Smith, "On *Mahagonny*," in *The Avant-Garde Film: A Reader of Theory and Criticism*, ed. P. Adams Sitney (New York: New York University Press, 1978), 105.

68. As paraphrased by Sitney, *Visionary Film*, 273.

69. Lovejoy's term. Lovejoy, *The Great Chain*, 120.

70. Joscelyn Godwin, *Robert Fludd: Hermetic Philosopher and Surveyor of Two Worlds* (Boulder: Shambala, 1979), 14.

71. Cited in Lovejoy, *The Great Chain*, 125.

72. The term "ideoplastic," as Zoe Beloff has pointed out to me, originates in the parapsychical investigations of Gustave Geley and Albert von Schrenck-Notzing. Geley asserts that the existence of ideoplastic phenomena—such as ectoplasmic extrusions of mediums—signals "nothing less than the complete reversal of materialist philosophy": "It means the modeling of living matter by an idea.... In other words, matter—the unique substance—is resolved by final analysis into a superior dynamism which conditions it, and this dynamism is itself dependent on the idea." Gustave Geley, *From the Unconscious to the Conscious*, trans. S. De Brath (Glasgow: William Collins Sons, 1920), 66–67.

73. Saint-Pol-Roux, *Cinéma Vivant* (Rougerie, 1972), 24. English translation by Clark Lunberry with the author. "Nous arrivons au règne de l'Idéoréalisation que je prédis depuis près de cinquante ans (d'un demi-siècle) (*concrétiser l'abstrait, objectiver l'Absolu, etc.*). Réaliser l'Idée, la plastiseiser. *Idéoplastie*. / Appeler l'appareil: *l'idéoréalisateur*."

74. Ibid. "Les ondes carnifiées solairement."

75. Ibid., 17. "Finir sur Dieu...On retournera au soleil. *Notre double étant solaire, on sera dans le soleil.* Nos doubles seront nos maîtres, ils iront jusqu'à Dieu et par eux, où nous aurons glissé notre moi, nous parlerons à Dieu, nous le verons et il nous parlera sous la forme empruntée d'une bande de lions, de Bételgeuse, de l'Himalaya et du Cyclone et par le double nous lui enverrons un baiser comme nous venions de l'envoyer à notre maîtresse qui rêve tout là-haut parmi les fleurs de sa fenêtre."

76. Ibid., 15. "Le cinéma futur n'aura pas d'écran, ses royaumes constituant l'empire universel. / Le cinéma futur sera vivant, ses formes ressortissant aux forces extraordinaires que l'on découvre de jour en jour. / Le cinéma futur ne sera plus 'du soleil dessus', mais 'du soleil dedans'. Il ira par le monde, comme vous et moi."

77. Henry More, cited in Lovejoy, *The Great Chain*, 125.

78. Betty Jo Teeter Dobbs, *Alchemical Death and Resurrection: The Significance of Alchemy in the Age of Newton* (Washington, D.C.: Smithsonian Institution Press, 1990), 6.

79. This notion of returning fragments to the absolute finds an echo in the Kabbalistic tradition. In the cosmology of Jewish mysticism, Ein Sof—a primal etheric continuum—pervades all space. The first divine act was a contraction or withdrawal *(tsimtsum)*, which left the world as a structure of vessels, empty of Ein Sof. The second divine act was to send rays of light through these vessels. At one point, the vessels could no longer hold, and flaming sparks fell into the material world—the *shevirah*—while most of the divine light returned to its source. The process of the spiritual life is to take these fragments and restore them to divinity (*tiqqun*, or mending). It seems that this need to "raise the sparks" is what Benjamin was urging when he critiqued the "homogenous, empty time" of historicism (261). For the collage film, it also seems an apt metaphor, which Smith must have hit on, since his films prominently include images of the Sephiroth—commonly known as the Kabbalistic Tree of Life. Images of the Sephiroth—from Fludd's *Utriusque Cosmi* (1621) and Kircher's *Oedipus Aegyptiacus* (1653)—also dominate the mise-en-scène of *Neon Genesis Evangelion*, discussed in chapter 2. Walter Benjamin, *Illuminations*, trans. Harry Zohn (New York: Schocken, 1968). See also Daniel C. Matt, *The Essential Kabbalah: The Heart of Jewish Mysticism* (San Francisco: HarperCollins, 1995). For historical images of the Sephiroth, see Alexander Roob, *The Hermetic Museum: Alchemy and Mysticism* (Cologne, Germany: Taschen, 2001), 310–28.

80. Jean-François Lyotard, "Acinema," in *The Lyotard Reader*, ed. Andrew Benjamin (London: Basil Blackwell, 1989), 172.

81. Sigmund Freud, *Beyond the Pleasure Principle*, trans. James Strachey (1920; New York: Liveright Publishing, 1950).

82. Wilhelm Reich, *Ether, God, and Devil/Cosmic Superimposition* (New York: Farrar, Straus and Giroux, 1973), 166.

83. Ibid., 5.

84. Ibid., 10.

85. As described in the work of Klaus Theweleit, the fascist mentality reacts towards the "oceanic" by creating excessive shields against it, while at the same time, it directs abject violence toward these very shields of defense (to regain what was lost by loathing). Both Reich and fascists wanted to return to the ocean of primal, plasmatic sensations, but there is a big difference between Reich's desire and the fascist desire. The fascist mentality perceives the shield that it in no small measure has created, and engages in a kind of sadomasochistic shattering or fragmentation of it—the sexualized ultraviolence of the *Freikorps*. Reich's therapeutic cultivates a holistic form of bodily and intellectual suppleness, the desire for which extends back to the work of Henri Bergson. As Reich describes: "A large part of the brutality of the mystic is explained by the simple fact that while he feels life inside himself, he can neither experience it in reality nor develop it. Hence the impulse develops to conquer the mirror image by force, to make it tangible and palpable by force. The life in the mirror is a constant provocation that drives him into a frenzy. There it is, this motility; it lives, laughs, cries, hates, loves—but always only in a mirror. In reality it is as barred to the ego as the fruits were out of reach for Tantalus. From this tragic situation springs every murderous impulse directed against life." Reich, *Ether, God, and Devil*, 115–16. See also Klaus Theweleit, *Male Fantasies, Volume One: Women, Floods, Bodies, History*, trans. Stephen Conway (Minneapolis: University of Minnesota Press, 1987).

86. Reich, *Ether, God, and Devil*, 159.

87. Sigmund Freud, *The Future of an Illusion*, trans. James Strachey (1928; New York: Norton, 1961), 50.

88. Reich, *Ether, God, and Devil*, 88.

89. Ibid., 39.

90. Ibid., 93.

91. Ibid., 107.

92. Ibid., 12.

93. Stan Brakhage, *Window Water Baby Moving*, Canyon Cinema, 1959; Scott Bartlett, *1970*, Canyon Cinema, 1972.

94. Constance Penley, *The Future of an Illusion: Film, Feminism, and Psychoanalysis* (Minneapolis: University of Minnesota Press, 1989), 22.

95. Ibid., 12.

96. See *Theremin: An Electronic Odyssey*, dir. Steven M. Martin, MGM/UA, 1994.

97. *The Astronaut's Wife*, dir. Rand Ravich, New Line Cinema, 1999.

98. Sean Cubitt, *Digital Aesthetics* (London: Sage, 1998), 70.

99. See Jean-François Lyotard, "Acinema," in *The Lyotard Reader*, ed. Andrew Benjamin (London: Basil Blackwell, 1989), 169–80.

100. *Demon Seed*, dir. Donald Cammell, special visual sequences by Jordan Belson, MGM, 1977.

101. The Austrian experimental filmmaker Peter Tscherkassky takes an odd film with similar thematics as the starting point for his absolute film *Outer Space* (1999). The source film is *The Entity*, a 1981 picture about a woman who is sexually attacked by an immaterial force. Tscherkassky's film emphasizes the domestic locus of "inner space"—the suburban home—as it is about to be infiltrated (or, as implied by his optical processing, already is) by an otherworldly force. It would be merely a schematization of Freud's theory of the uncanny, were it not for the fact that Tscherkassky plays it contrary to the typical narrative convention, in which the shielded inner space of the home (and by extension the dubious category of "housewife") is bound to be usurped by its repressed double. He infiltrates the image of the home from the start with Belson-like plasma shimmerings. In a way, instead of siding with the psychologists of the original film, who would merely dub the main character a hysteric, Tscherkassky takes the invisible force seriously, making the supernatural natural. By linking this invading external force to filmic materiality—since by "outer space" Tscherkassky partly means the sprockets and optical sound designs revealed when he prints standard-format film onto Cinemascope—he exposes both the mechanical nature of cinematic illusion as well as the reality of illusion with which the film's main character must contend. Tscherkassky has not magically erased sexual violence and perhaps even admits a kind of dysfunctional relation between the male avant-garde filmmaker and his feminist peers—but the remix, in returning the images to the absolute, potentially opens up a new dialogue, creating a weird rapprochement between structuralist, absolute, feminist, and Hollywood filmmaking.

102. *The Core*, dir. Jon Amiel, Paramount, 2003.

103. For good descriptions and analyses of what constitutes the hacker's reimagining of the rhythms and ideologies of work, see Pekka Himanen, Linus Torvalds, and Manuel Castells, *The Hacker Ethic and the Spirit of the Information Age* (New York: Random, 2001).

104. Roger Ebert, "The Core," *Chicago Sun Times*, March 28, 2003.

105. Arthur C. Clarke, *The Promise of Space* (New York: Harper and Row, 1968), 43.

Conclusion

1. David Foster, *The Intelligent Universe: A Cybernetic Philosophy* (New York: G. P. Putnam, 1975).

2. Sprint advertisement, *Wall Street Journal*, March 16, 1998, B2.

3. I have analyzed this ad previously, for a different context. See Joe Milutis, "Think Again: Artificial Intelligence, Television, and Video," *Art-Byte: The Magazine of Digital Arts* 1, no. 5 (December 1998–January 1999): 44–52.

4. Nortel, Web banner, fall 1999.

5. See, for example, the Lucent advertisements in *Wired*, October 1998, 22–23; and in *Wired*, December 1998, 34–35.

6. "1984," television advertisement for Macintosh, dir. Ridley Scott, January 24, 1984.

7. Between writing this conclusion and finishing the book for publication, it seems there may have been a rapid swing back to politics in the throes of the current presidential administration.

8. Umberto Eco, from "La Bustina di Minerva," *L'Espresso*, September 30, 1994, trans. Adam Atkinson, www.bcs.rochester.edu/bcs/people/students/ eigsti/eco.html. In a more recent "Bustina" column, titled "There Are Two Big Brothers; We No Longer Need to Choose Just One," Eco gives further clues as to why the tactic of advertising competing operating systems as to-talitarian has worn off. Eco says that with the popularity of the *Big Brother* television series, we have cozied up to this image of fascist power, now given a democratic twist. "With the Big Brother of Orwell the few spied on the many. With this series, in contrast, the many are able to spy on few. Thus, we habituate ourselves to thinking that Big Brother is something very demo-cratic and extremely pleasing." He goes on to say that this Big Brother is a distraction from the real Big Brother that allows all of a person's data to be subject to surveillance on the Internet: "If this practice is not rigorously con-trolled, one would be able to accumulate behind everyone's backs a sum impression of data that would render us entirely transparent." Umberto Eco, "La Bustina di Minerva: There Are Now Two Big Brothers," *L'Espresso*, October 12, 2000 (translation mine).

9. George Gilder, *Telecosm: How Infinite Bandwidth Will Revolutionize Our World* (New York: Free Press, 2000), 11.

10. Ibid., 3, 5.

11. Hewlett-Packard advertisement, CNBC, spring–summer 1999; and Hewlett-Packard advertisement, *Wired*, August 1999, 33.

12. More recently, one pundit has floated the term "Chinacosm" in the financial press to describe Gilder's exuberance for Chinese laborers replacing his excitement about bandwidth angels. Russ Mitchell, "All the T in China: Get Ready for the Chinacosm," *SmartMoney.com*, October 3, 2002, http:// www.smartmoney.com/Techwise/index.cfm?story=20021003.

13. Susan Buck-Morss, "Envisioning Capital: Political Economy on Dis-play," in *Visual Display: Culture beyond Appearances*, ed. Lynne Cooke and Peter Wollen (Seattle: Bay Press, 1995), 124.

14. Compaq advertisement, *Wired*, December 1998, 1–2.

15. Of course, since first writing this, the rhetoric of globalization and technology has dramatically changed because of the issues surrounding American corporations outsourcing to labor markets in India and China.

16. Quentin Hardy, "Higher Calling: How a Wife's Question Led Motorola to Chase Global Cell-Phone Plan," *Wall Street Journal,* December 16, 1996, A1.

17. David S. Bennahum, "The United Nations of Iridium," *Wired,* October 1998, 135.

18. Ibid., 136.

19. For more description of this image (and other ad copy) in the context of ethereal emotions and the idea of property, see Joe Milutis, "Superflux of Sky," *Cabinet: A Quarterly Magazine of Art and Culture* 10 (Spring 2003): 71–76. This essay is also retrievable from http://www.cabinetmagazine.org/issues/10/superflux.php.

20. Ibid.

21. Kevin Maney, "Remember Those 'Iridium's Going to Fail' Jokes? Prepare to Eat Your Hat," *USA Today,* Money Section, April 9, 2003.

22. If he were still alive, Mark Lombardi might trace just such a connection, since his artwork visualizes the occult interconnections of multinational corruption. His large-scale diagrams of shady influences and illegal fund transfers blur the categories of informational and absolute art, since the experience of his work encourages less the thought that leads to action, and more the thought that leads to unthought—information overload tipping over into mute, blank, helpless awe. Lombardi's work precisely dramatizes what more commonly found visualizations of networks in the dot-com era leave out. See Independent Curators International, *Mark Lombardi: Global Networks* (New York: Independent Curators International, 2003).

23. Avital Ronell, *The Telephone Book: Technology, Schizophrenia, Electric Speech* (Lincoln: University of Nebraska Press, 1991).

24. Wilhelm Reich, *Ether, God, and Devil/Cosmic Superimposition* (New York: Farrar, Straus and Giroux, 1973), 42.

25. Antonin Artaud, *The Theater and Its Double,* trans. Mary Richards (1938; New York: Grove, 1958), 66.

26. Ibid., 63, 67.

Index

197

Joe Milutis is a writer, media artist, and assistant professor of art at the University of South Carolina.